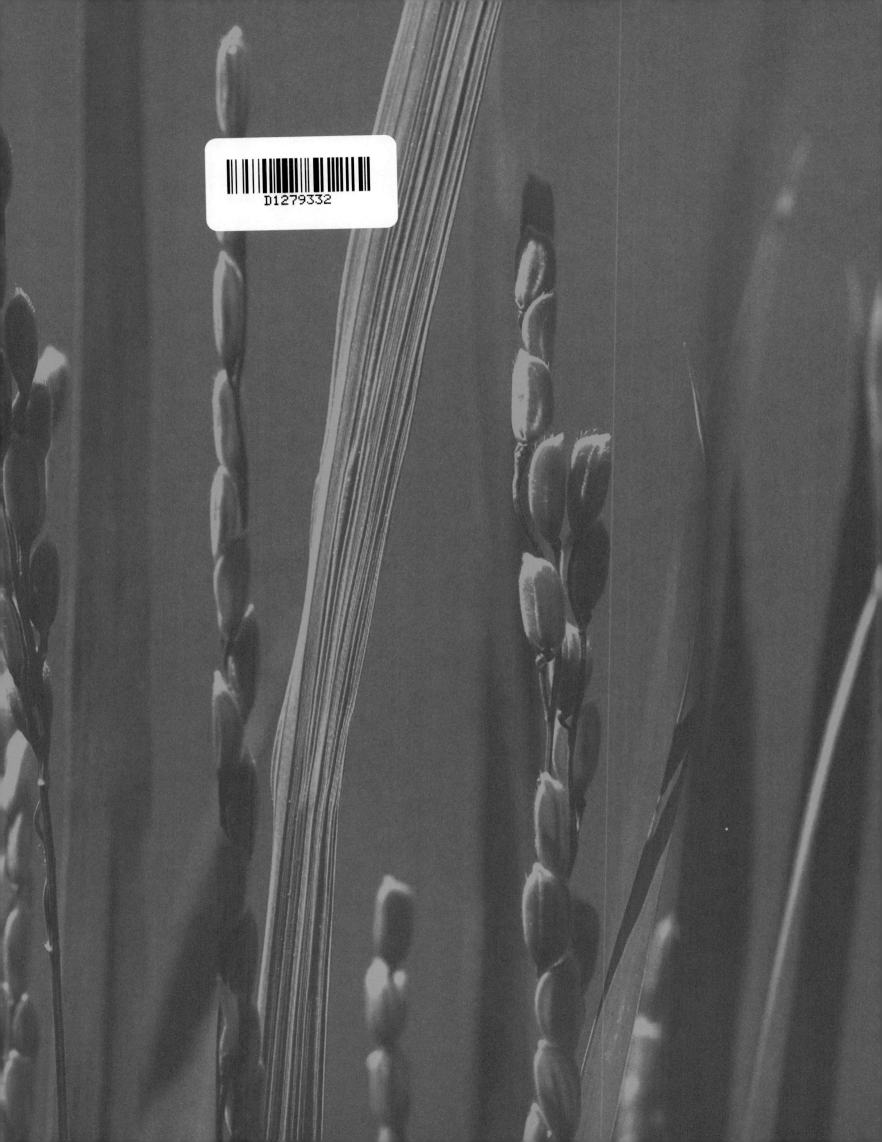

THROUGH MY EYES

The Remarkable Children of Senegal

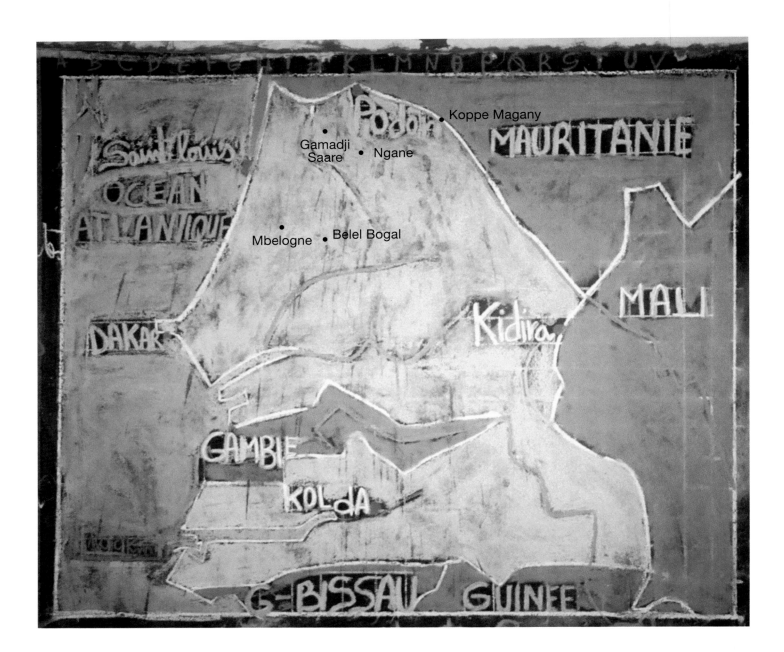

THROUGH MY EYES
The Remarkable Children of Senegal

Texts by Stephanie Meeks, Josephine Trenchard, Eva Haller, Susan Slack
Narratives and snapshots by students from the Mbelogne, Belel Bogal,
Gamadji Saare, Ngane, and Koppe Magany schools.

Photographs by Harvey Lloyd

Published by Ruder Finn Press, New York
in association with Counterpart International

RUDER FINN PRESS

COUNTERPART

Copyright © 2010 Ruder Finn Press in association with
Counterpart International

Editorial Director: Susan Slack
Creative Director: Lisa Gabbay
Senior Art Director: Salvatore Catania
Art Director/Designer: Jennifer Sanders
Production Artist: Rubén D. Mercado
Production Director: Valerie Thompson
Digital Imaging Specialist: Steve Moss

ISBN 10: 1-932646-42-6
ISBN 13: 978-1-932646-42-9

Printed in China

Contents

Acknowledgements

This book would not have been possible without the vision, enthusiasm, guidance and assistance of many individuals. We are grateful to Lelei LeLaulu, former director, Counterpart International, for his support and belief in the project from the outset; to Stephanie Meeks, president and CEO, Counterpart International, to David Cohen, vice president, Global Agriculture and Economic Growth, Counterpart International and to the Board and staff of Counterpart International for their continued encouragement; to Josephine Trenchard, Country Representative, Counterpart International for coordinating our trip every step of the way; to Cole M. Wolfson, former Program Development Coordinator/Food, Security and Sustainable Agriculture, Counterpart International whose vision and hands-on participation made it a reality; to Harvey Lloyd, photographer extraordinaire, whose searching eyes uncovered the intense beauty of the people and landscapes of Senegal; to Ahmadou Ndiade, Ph.D., Programs Manager, Counterpart International, whose knowledge of the area and gentle spirit made many dusty days exciting for us; to Erica Cummings, Environmental Education Volunteer at Peace Corps-Senegal, for providing invaluable translations; to Mame Kady and Joseph, Auberg Jardin du Fouta, Gamadji Saare, for their generous and gracious hospitality; and to the staff and drivers of Counterpart International, Ndioum, who became our constant companions, advisors and friends. We are also appreciative of the time we were able to spend with Minister Mordou Fall, Inspector General for Podor, and for his insights into education in northern Senegal.

We are also grateful for the efforts of the Ruder Finn Inc. and Ruder Finn Press teams to make the book a success. Thanks go to Gail Moaney, executive vice president, and director, Travel & Economic Development and to Susan Slack, vice president, Ruder Finn Press, who had boots on the ground throughout the project in Senegal; to the Ruder Finn Design team, Lisa Gabbay, creative director, Salvatore Catania, senior art director, Jennifer Sanders, art director/designer, Rubén Mercado, production artist, Valerie Thompson, production director and Steve Moss, digital imaging specialist; to David Katzive, executive producer, Ruder Finn Broadcast, for the DVD; and to Susan Roberts, photography assistant, Harvey Lloyd Studios.

Special thanks also go to Eva Haller, whose support, enthusiasm and commitment gave us this amazing opportunity.

And finally, the magic would never have happened without the wonderful, warm, joyous welcome we received from the children, parents and teachers at the schools in Belel Bogal, Mbelogne, Koppe Magany, Ngane, and Gamadji Saare.

Stephanie Meeks Foreword

Stephanie Meeks
President and CEO
Counterpart International

Senegal is a country of contrasts, of subtle beauty and stark need. It's the need most people notice first, the palpable sense of a country and a people clinging to survival on this harsh fringe of the Sahara Desert. But if you look deeper, beyond landscape and geography, you will see a people of extraordinary resilience whose vibrant hope in the future is simultaneously humbling and inspiring.

The photographs in this book offer a rare window into the lives of the children who are the hope of Senegal. I invite you to explore these remarkable images and see a distant world through the eyes of the boys and girls who roam its streets and gather in its school rooms. See them with their families and friends, going about the tasks that mark their routines and the circumstances that form the boundaries of their lives.

The camera does not flinch away from the truth these children live with daily – it captures the joys and the challenges with equal clarity. What we see is what they have chosen to show us and what we will allow ourselves to see.

During a visit to Senegal, I was privileged to share lunch with some of the 40,000 children we feed in that country every day. Over our communal bowl of potatoes and dried fish, I listened to them chatter and tease like schoolchildren of every age and every country. And like schoolchildren everywhere, they have hopes and aspirations and plans for their futures. And every day we help them move a little closer to realizing their dreams.

These are the children of Senegal and the children of Counterpart International. These are the children who will inherit the world we are fashioning. And this book makes me proud of the work Counterpart does to make that world a better place.

THROUGH MY EYES

Our work spans the globe and our assistance transcends the spectrum of people in need: from feeding hungry children to supporting emerging democracies. Though our projects are diverse, they share a common objective: improving the lives of those in need by giving people and local institutions the tools necessary for sustained social, economic and environmental progress in their communities.

Since 1965, we have worked in more than 70 countries. Every person we touch has a story and photographs help us understand those stories. They transcend language and culture and show us that even in our differences, we are often very much the same.

Thank you for your interest in the children of Senegal and for your support of Counterpart International.

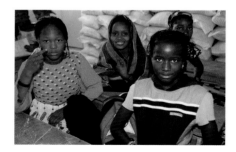 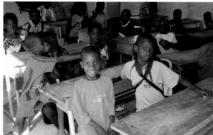 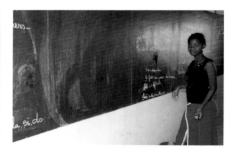

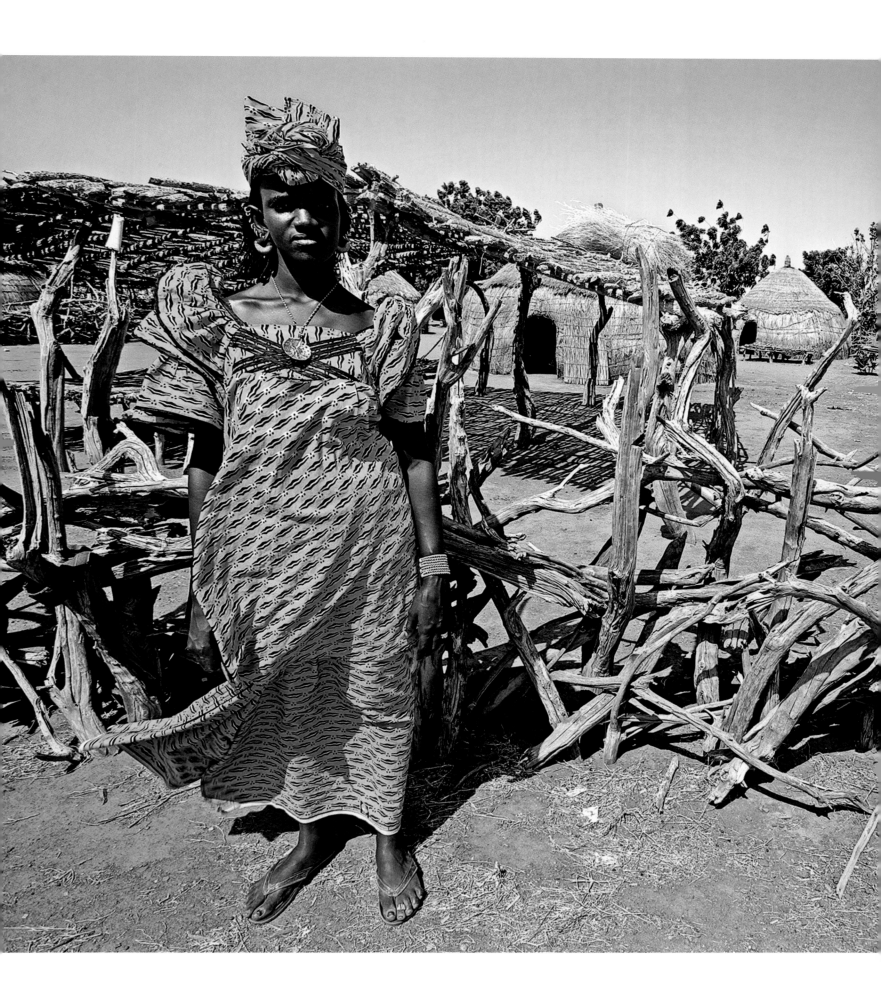

Josephine Trenchard Preface

Josephine Trenchard
Regional Coordinator, Africa
Country Representative, Senegal
Counterpart International

A former French colony, Senegal is a place known for its rhythmic music and warm, friendly people. Though the proverbial expression of "giving the shirt off one's back" is a fitting tribute to the West African Senegalese culture, in fact, the extreme poverty in much of the country dictates that most have little to spare.

That is what Counterpart International found when it began working in northern Senegal in 2001 implementing programs to feed hungry, malnourished children; providing proper nutrition to those afflicted with HIV/AIDS; giving access to credit and training to micro-entrepreneurs; and working with villages to identify and remedy their most pressing agricultural production and livestock problems.

Malnutrition is an everyday fact of life for many in northern Senegal. Lack of food, a harsh Sahelian climate, where rainfall is virtually nonexistent and temperatures that can rise above 120 degrees Fahrenheit, mean daily life is always on the edge. Counterpart works with the Center for Nutritional Recuperation, trains local healthcare providers, and donates medical supplies, deworming medicines and food to overcome these burdens. Prior to our interventions, a malnurished child's average stay at the Center was about three weeks; deaths from malnutrition were common. Today, no one dies from malnutrition and the average stay at the Center is only twelve days.

Children are always the most vulnerable. Many families in this region are nomadic, constantly herding their livestock across the plains in search of fodder. This lifestyle makes it difficult for children to have a stable education. Oftentimes, the children go hungry. Working with donors and hundreds of Senegal's public schools, Counterpart offers an alternative. In 2010, we are serving hot, nutritious lunches daily to some 40,000 children. For many, this is their only meal each day. While the hot meals keep children in school, Counterpart also teaches life skills like growing school gardens, understanding the value of good nutrition,

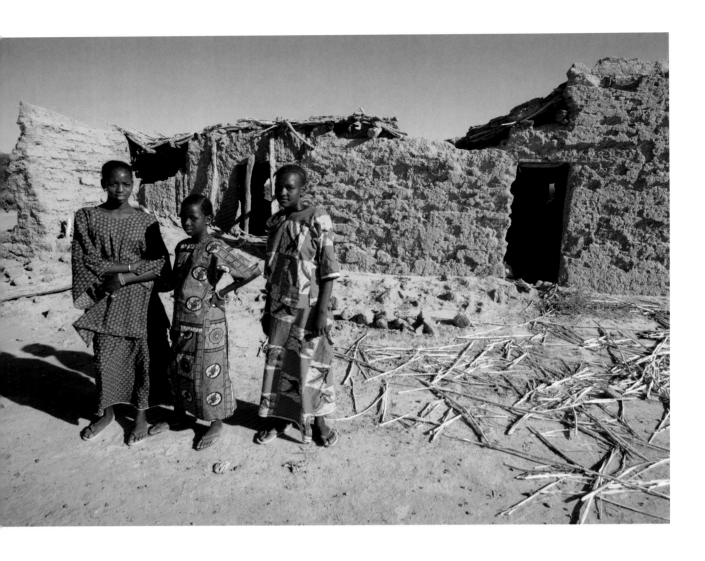

and understanding proper sanitation and hygiene. School lunches raise the standard of living in the poor communities in countless ways, but they benefit girls the most. Without a school lunch program, families are unlikely to send their daughters to school. When they do, the result is striking: girls stay in school longer and marry later. In Senegal, girls marry as young as twelve years of age. But with an education,when they do marry, they have fewer children and their children are healthier.

No less affected by their poverty are the children who attend the faith-based Koranic schools, called Daaras. These children board at the school because their families are too poor to feed them and send them to school. The young children beg in the streets each day to pay for their school meals. When Counterpart became aware of their plight we began providing daily hot meals, medical supplies, bedding, mosquito nets to prevent malaria, and vocational skills, such as carpentry, plumbing, sewing and literacy training to these children. Today, these children are being given opportunities that would otherwise simply not exist.

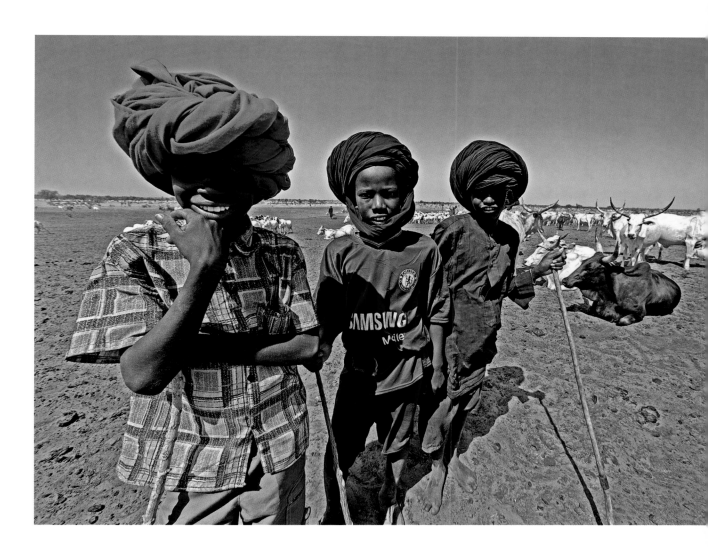

Providing proper nutrition is not only about children; it is also about creating the local capacity to access safe, abundant supplies of nutritious food without outside support from groups like Counterpart. To that end, we teach village farmers, mostly women, how to improve crop and fresh water fish production. The introduction of fish farming, for instance, within rice and vegetable gardens, provides both a means of sustenance, particularly protein, and income, when local farmers sell their excess production in the local marketplace. Indeed, the tilapia fish that are raised year round contribute importantly in ways not even intended. The fish eat mosquito larvae that breed in the man-made ponds which, in turn, decreases new malaria outbreaks.

In the end, our approach, working hand-in-hand with those Counterpart seeks to help, is to find holistic, sustainable ways that will yield a future without hunger and want. Thanks to our donors, an incredibly dedicated staff, and the wonderful people of Senegal, we are marching ever closer to achieving that promise.

Eva Haller Introduction

Eva Haller
Former Board Member
Counterpart International

When I was approached by Counterpart International to be a sponsor of this book I leaped at the opportunity. I have had a long history with Counterpart and knew that this was a special project that could be used to further the good the organization is doing for local villages, families, and especially children. I was also excited because this book provided me with an opportunity to continue my work with children around the world. After seeing *Through My Eyes: The Remarkable Children of Senegal,* I am convinced that this is very unique project. I am proud to be a part of it.

Though this book is about the children of northern Senegal, in fact, it could be about children anywhere. One thing I've learned over my many years traveling around the world, working side-by-side with the rich and the poor; with untold numbers of ethnic and religious sects; and with those blessed to be born in places abundant with natural resources and those not so lucky, is that, in the end, we are all human beings, with the same essential needs, wants and desires. A child in Senegal is not so different from a child in Russia or in Vietnam or even in the United States.

As I turn the pages of this volume I am humbled by the dignity of the people of northern Senegal. This is surely a hard place in which to live, on the edge of the Sahara Desert, where the temperatures can routinely reach 120 degrees or more. But, the people of the region have made full and complete lives for themselves; their days are filled with family, community, prayer, and work. These populations — all close to the bottom of the world's income ladder— are getting by, even if only marginally by our standards. They seem to meet the hardships they face with determination, even hope. Counterpart is doing its part, as well, empowering local people and their communities to determine their own futures with training, technical assistance, access to affordable credit, better healthcare, and the ability to grow nutritious food sustainably.

Despite the obvious differences between our lives in the West and theirs, expressed in the faces and images in this book, I also see similarities and connections in the photographs, not detachment. I see the variations on the everyday tasks of cooking and cleaning. I see the children on their way to school, eager to learn. And I see the constant striving for betterment, the pride of a family, and the reliance of a community on its members amid difficulty. Half a world away in a strange and different land, it is easy to see that we are all not so different. Despite the color of our skin, the amount of money in our pocket, or how much food we have in our bellies, this book demonstrates vividly how much more alike we are than we may appear.

What strikes me most about this book is its beauty. The beauty of the images and particularly, the beautiful children. The book shines a light on a slice of Africa that is filled with color, energy and hope. The photographs — by world class photographer, Harvey Lloyd, and the children themselves, whose snapshots tell their own story better than any outsider could — offer a reality of Senegal that is both extraordinary and humbling. A picture truly is a worth a thousand words. Each of these images is one of a kind. I am proud to be part of this book and to share these compelling images with those unable to see first hand the future of Senegal.

The children in the pages that follow are the ones who must live with the hardships. They are the ones who must be educated despite the oftentimes less than enviable school facilities. And, they are the ones who must carry on the traditions of their land and their culture. I am hopeful that this book and the work of Counterpart International can make the road these children have to travel a little easier both for them and for their children.

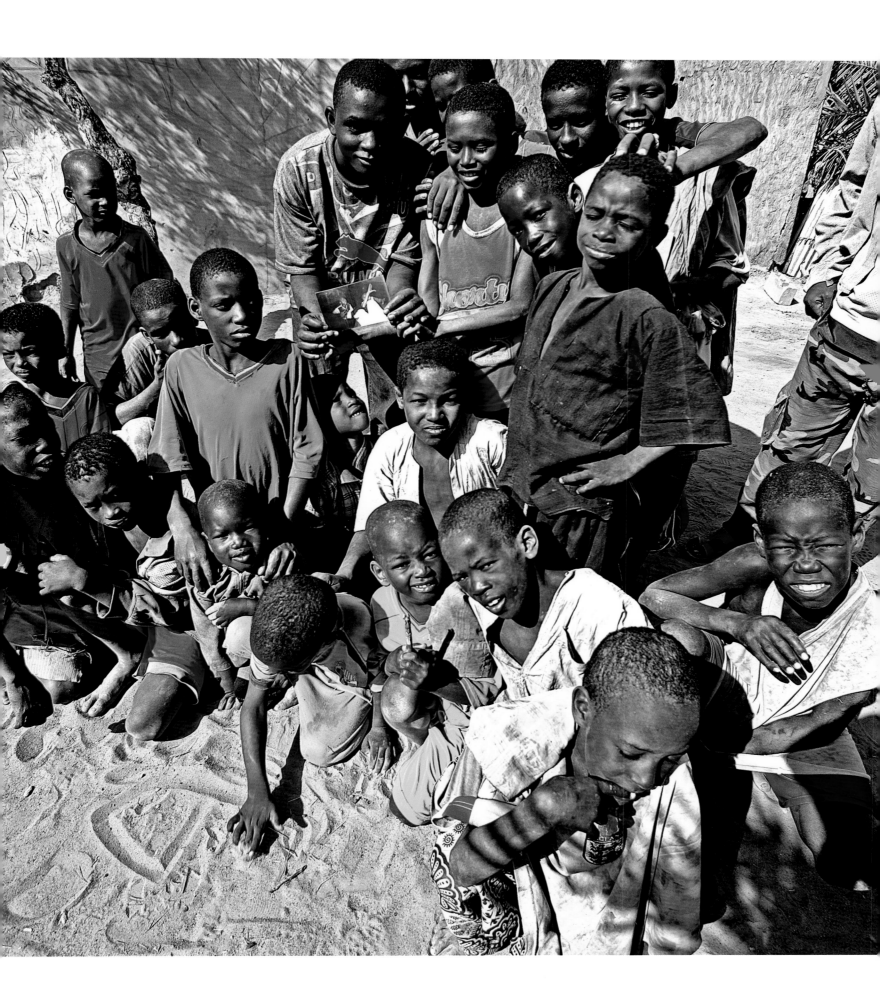

Susan Slack The Project

Susan Slack
Vice President
Ruder Finn Press

As the sky slowly lightened from the deepest black over the countryside – a velvet blanket glittering with countless stars – the stillness gave way to the awakening day. The mournful cry of countless sheep; the neighing of cart horses beginning their daily tasks; the soft persistent chittering of crickets, beetles, and other insects; the scurrying feet of tiny gekkos; the unfamiliar and haunting calls of unseen birds; the slow, intriguing melody of the Iman summoning the faithful to prayer; the laughter or tears of children. And behind it all, the gritty smell of charcoal fires burning under numerous cook pots. A rooster's crow, the irritable braying of a donkey cutting the air, the rhythmic sound of brooms on soil and the shuffling of soft slippers all marked the beginning of another day.

In the bustling capital city of Dakar, or in the historic former capital, St. Louis, this concert is almost overshadowed by the sounds of modern city life – car and bus horns, the persistent cries of street vendors, the incessant rise and fall of music and conversation. But the quiet sounds are always there. They form the essence of Senegalese life and disclose the most important aspects – family, friends, farming, herding, religion. These are the supports we found over and over again in the stories and photographs taken by the children of northern Senegal.

Inspired by the vision of Cole M. Wolfson, former Program Development Coordinator/Food, Security and Sustainable Agriculture, Counterpart International, this remarkable photo project became a reality. Photography can convey everything from emotion and vision to unflinching reality and all variations in between; it is always the one who holds the camera, however, regardless of skill or technique, conscious effort or serendipity, who chooses what is or is not shown.

In this instance, single-use cameras were given to 56 students ranging in age from 7 to 15, in five schools in northern Senegal, near the town of Ndioum. Most, if not all, of the students had never taken a picture before. They received a basic lesson on how to use the cameras – nothing more than 'put what you want to photograph in the viewfinder and push the

button' – and were instructed to take pictures of things that were important to them or significant in their lives. After they were developed, each student received a copies of his or her pictures and was asked to pick out their favorite images and explain why. These images, coupled with those brief narratives, are the soul of this book.

The results were stunning. Although raw and often somewhat askew, the photographs contain the focus, intensity and innocence of vision that only young, unencumbered eyes possess. They are as close to pure documentation of the environment in which these young people live as is possible. They show us things we would not ordinarily see. They focus on details the Western mind might easily overlook as insignificant. They tell us a story of the lives of the young photographers and their community. They show us pride, they show us love, they show us appreciation for the environment, they show us respect for religion and for elders, they show us humor and laughter. They show us that despite the miles between our lives and theirs, the values we share are surprisingly similar.

Coupled with these photographs are images taken by renowned photographer Harvey Lloyd. Lloyd's many years experience photographing around the world, and his exuberant personality, made him the obvious choice to photograph the young photographers, as well as capture in exhilarating style the landscapes of northern Senegal. Lloyd's photographs reflect the physical beauty of the region as well as the spirit of the people. As Cole Wolfson aptly stated, "[Harvey Lloyd] imbued these images with his own love of the people, their kindness, beauty, and strength; his love of the land, parched yet teaming with life; and his own ecstatic energy compounded by his gratitude to witness a place that, to him, was new and undiscovered."

Although this project started with the simple idea of showing northern Senegal through the eyes of those who live there, it has become much more. It has opened a door to understanding. The images and the narratives show us how these people would like the world to see them. Certainly by Western standards the villages are poor and the lifestyle is rigorous. But looking more deeply, we find incredible richness – in the strength of family and community; in the love and thirst for education, made attainable by the joint efforts of Counterpart International and the communities themselves. There is pride, there is hope, and there is determination. And every face, every smile calls out "Welcome!"

The Area

Located on the west coast of Africa, Senegal is bordered on the north by Mauritania, on the east by Mali, on the southeast by Guinea, on the south by Guinea-Bissau and on the west by the Atlantic Ocean. Its capital city, Dakar, marks the western-most tip of the African continent. The northern part of Senegal sits on the lower edge of the Sahara Desert. This area, called the Sahel, is a semi-arid zone between the desert and the more humid savannas to the south. It has been subjected to increasing desertification – the continual expansion of the Sahara south – and it supports scattered scrubby grasses, shrubs and trees.

The Sahelian climate, characterized by hot and dry winds (known as Harmattan), an eight-month dry season and a rainy season stretching over a 2-1/2 to 3 month period, governs the lifestyle of its people. The weather pattern is marked by distinct seasons: a rainy season from July to October; a dry and cold season from November to January; and a dry and hot season from March to June, with temperatures hovering around 113 degrees Fahrenheit.

To the north of Dakar lies the city of Saint Louis, the original capital of the country. It is in this region that the Department of Podor is located. Covering an area of 12,948 km, it is home to approximately 289,880 people, and is made up of 285 villages divided administratively into 4 communes and 10 rural communities. The rural population makes up 89% of the Department's total population.

Traditionally a land of cattle breeders and fishermen, the Department of Podor is part of the larger Fouta region, which includes communities on both sides of the Senegal River (portions of which are now part of Mauritania). Early in contact with the Islamic world thanks to its strategic position between north and sub-Saharan Africa, the Fouta was run by an Islamic theocracy as early as 1776. Today, Islamic culture is closely intertwined with the local lifestyle of the area, and produces some of the most erudite Islamic scholars in the region.

In general, Podor is extremely poor in terms of infrastructure, such as roads and health facilities. The Route Nationale No.2 , which crosses the Department in an east-west direction, is the only paved road. Despite the need for farmers and cattle breeders to bring their products to the main road or to local markets, there are few secondary roads. As a result, communities tend to be isolated, and urban development is lacking.

There are three distinct ecological zones in the area. The Walo, made up mostly of clay enriched with silty materials from the Senegal River, constitutes a very fertile agricultural land. It is gradually taken over by the middle Diery, a transitional area of clay and sand, as one moves away from the river banks, and finally the Diery, made up of sand dunes, which covers about 70% of the Department's area, and is mainly a cattle breeding zone. Not surprisingly, the Walo tends to be more densely populated, due to its water source (the Senegal River and its tributaries) while the Diery is scarcely populated.

In Walo villages, where the fields are at a reasonable walking distance, many parents have altered the way they plan their family's daily trek between home and the lands they are cultivating to accommodate the schooling of their children. Before Counterpart set up their school canteens, these parents used to take their children with them to avoid long daily commutes to the fields. With the school canteens providing a nutritious midday meal, many parents feel comfortable leaving their children at home. They are able to stay in the fields longer knowing that their children are not hungry during the day.

For Diery villages, the time necessary to move livestock between different grazing lands is greater and involves longer distances. For these villagers, the search for pasture is a constant preoccupation that lasts for a good part of the year. Without any predetermined destination, traditionally the entire family would migrate together, following their herds to favorable spots. The Counterpart canteens offer viable alternatives. In some cases, the Diery herders reduced the number of family members migrating with the herds to allow their children to attend school. Most commonly, an older family member, usually a woman, was left in the village to look after the children. Since breakfasts are minimal (biscuits and coffee) and lunches are supplied at the canteen, family expenses were reduced to a minimum. The reduced family size also allowed more flexibility in managing the distances required to follow the herds. Some families even chose to move from far outlying villages to those with canteens, closer to the school.

Of the five schools visited, two were located in the Diery, Belel Bogal and Mbelogne; two were Walo villages, Koppe Magany and Ngane; and the last, Gamadji Saare, was located on Route Nationale No.2.

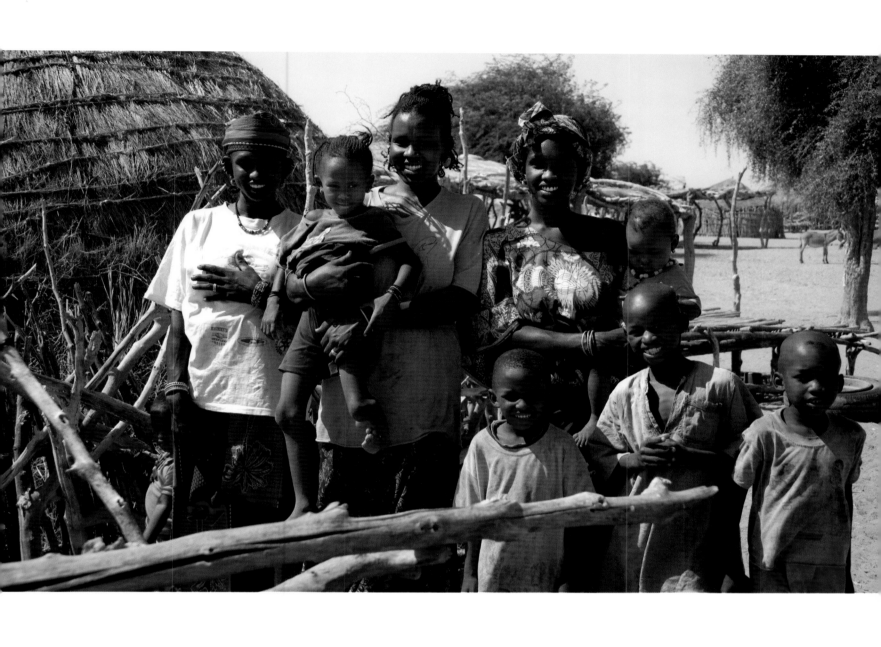

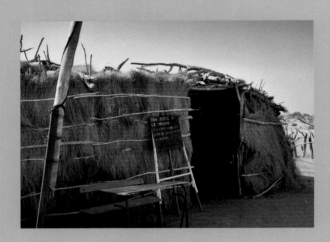

Located in the Diery, Mbelogne is a small school with an enrollment of 56 students: 11 boys and 45 girls, drawn from six neighboring hamlets, whose total population numbers approximately 2,000. The two teachers, Cheikh Sy (director) and Abdoulaye Diop, teach five grades. It is a nomadic, herding community.

Many of the students at this school were away on the day we visited, as their teachers were taking a certification exam. Children who lived nearby were sent for, while the Counterpart van went to pick up others who were further afield, working with their families. Unfortunately, only five of those children who took part in the project were able to have their portraits taken by Harvey Lloyd.

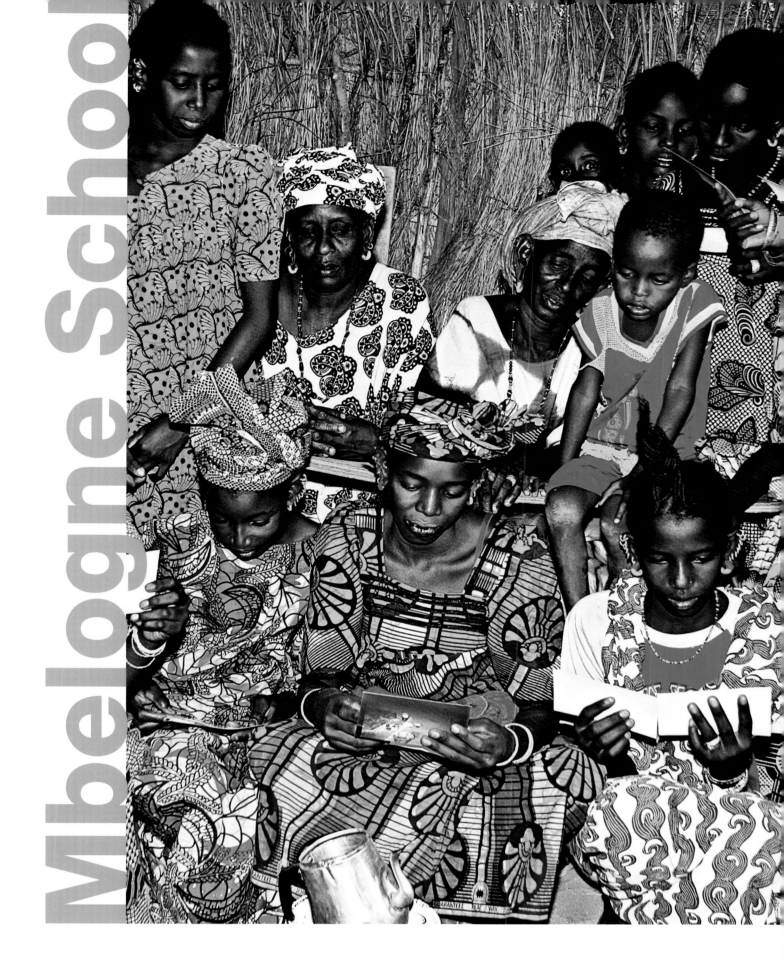

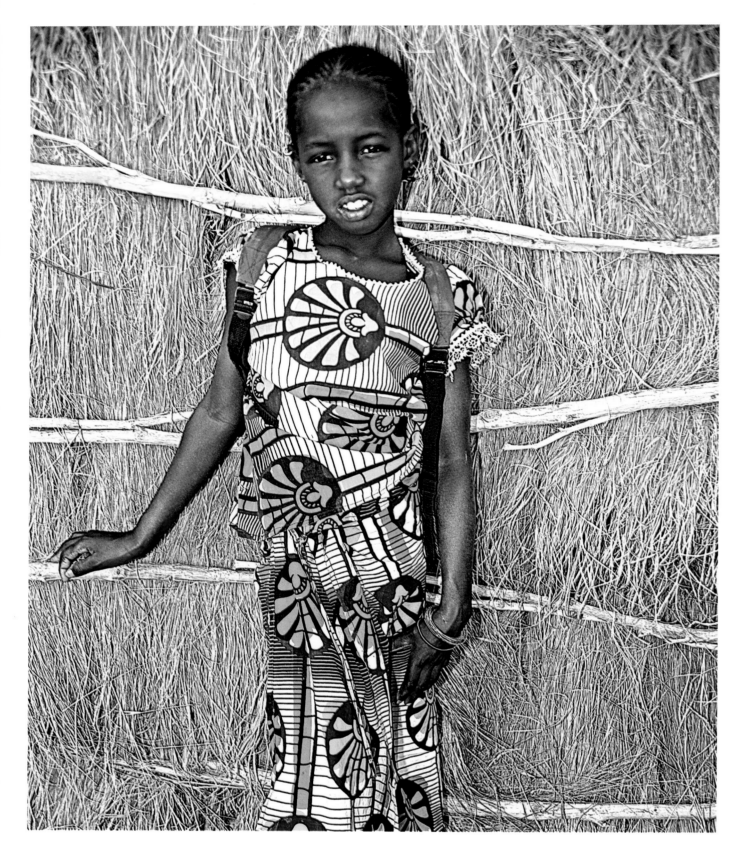

Hadia Moussaly

age 9

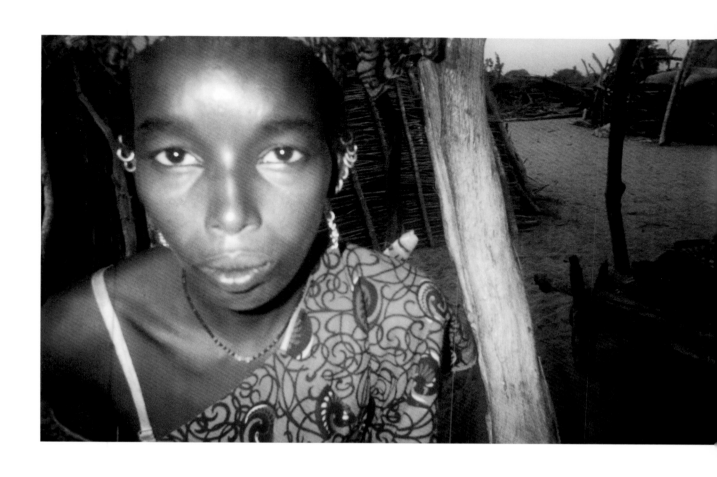

Above: This is my friend in our house.

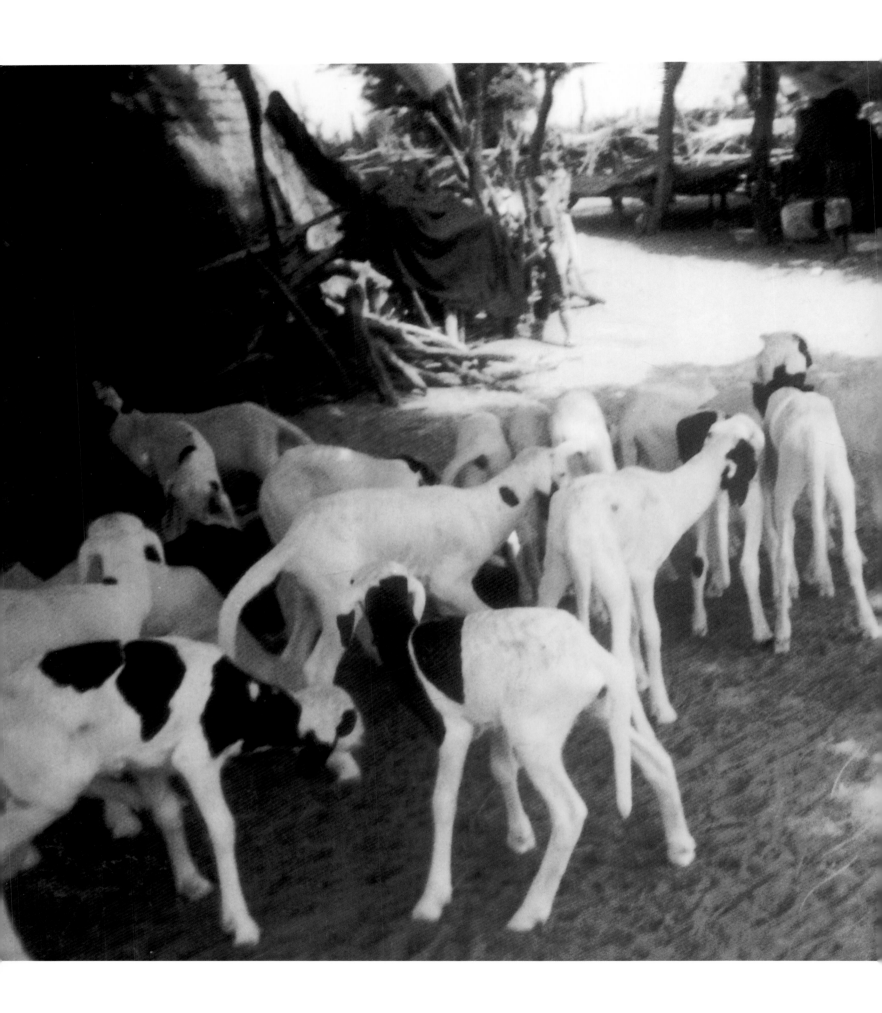

Left: Our goats are milked every morning before they go to pasture. They are kept near the family's home.

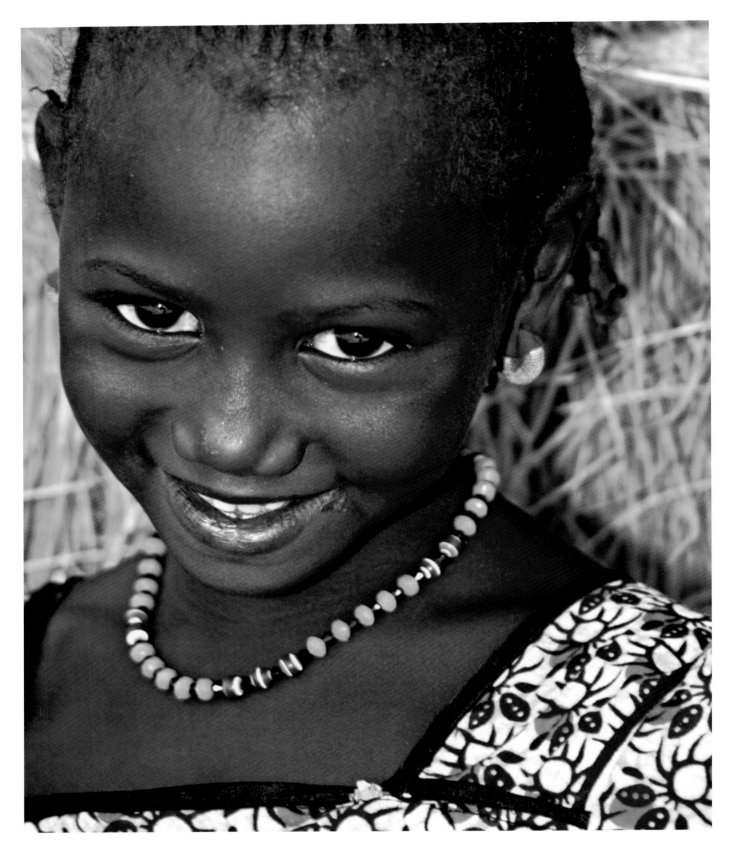

Diarry
Mamadou Ba

age 7

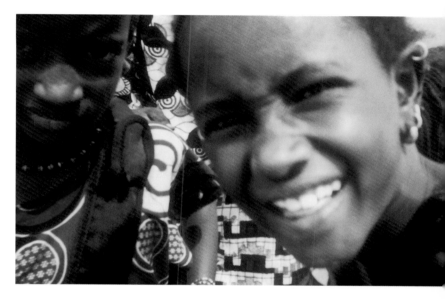

Left: My friend in our compound.

Right: Some more of my friends.

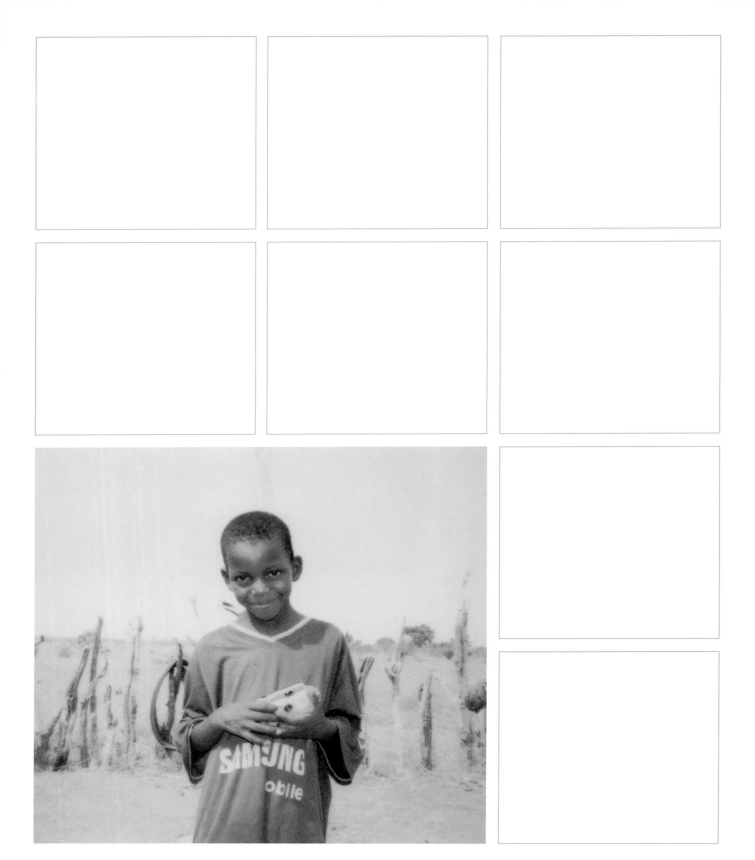

Amadou
Abdoul Ba

age 9

Above: A friend with her little boy.

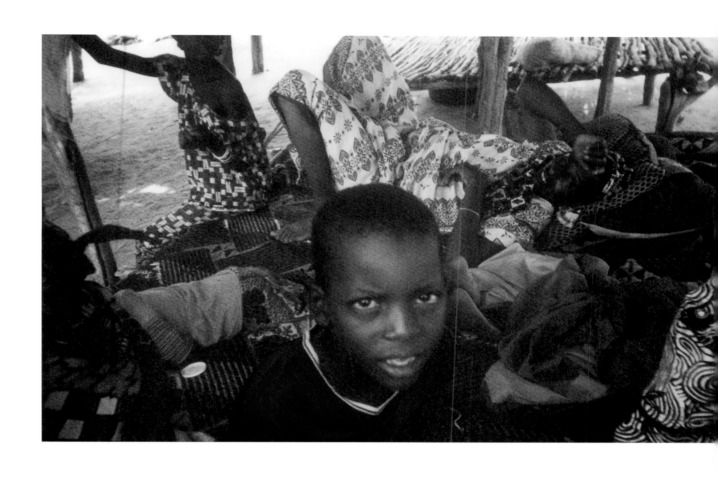

Left: The little girl is looking at her Mom's gri-gri [*amulet*].

Above: Inside our house.

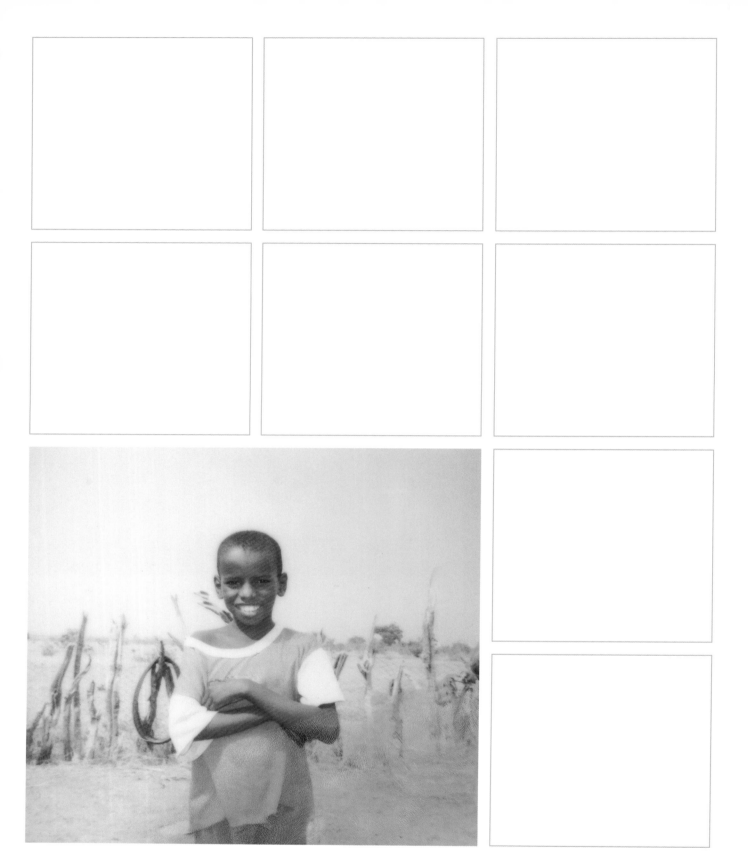

Oumar
Aliou Diallo

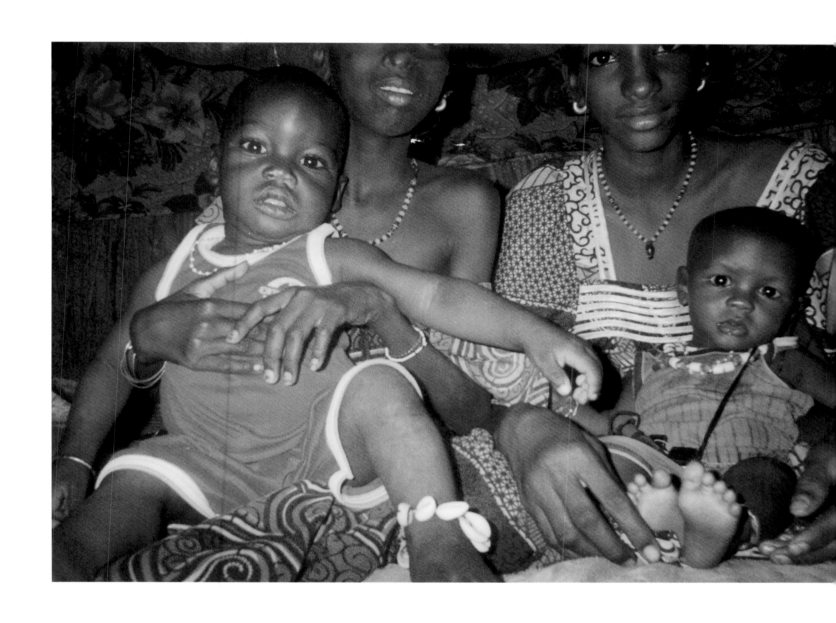

Above: This is my family at home.

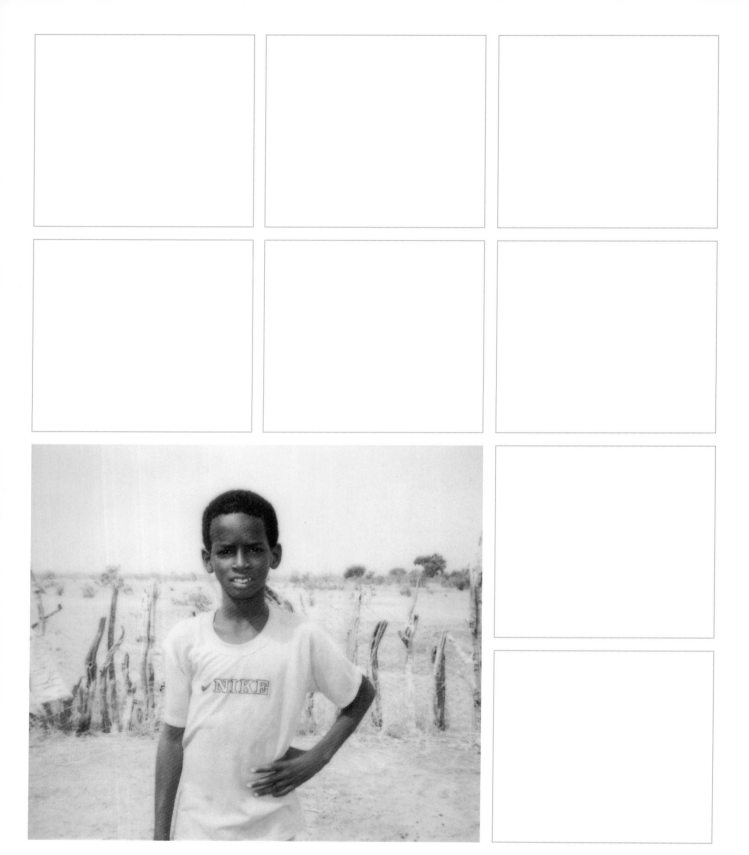

Diour Sow

age 11

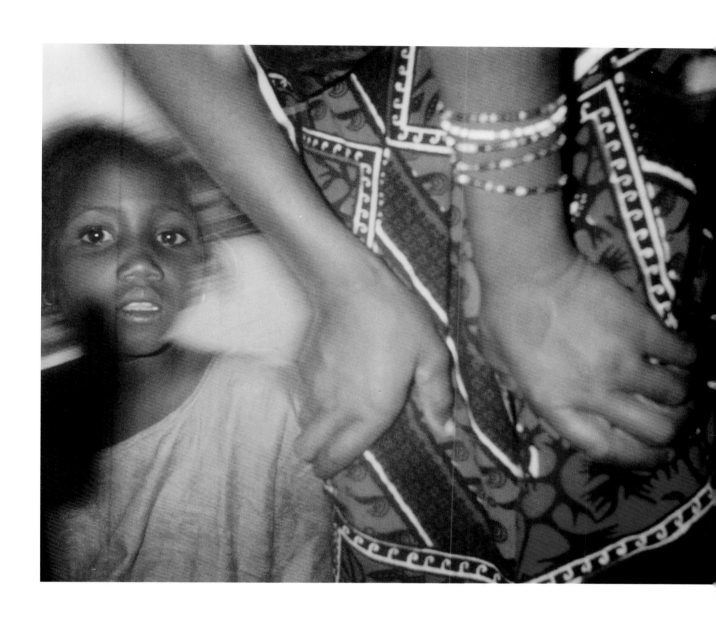

Above: I just liked this girl's bracelets.

Next Page: All the kids are playing around in the compound outside of school.

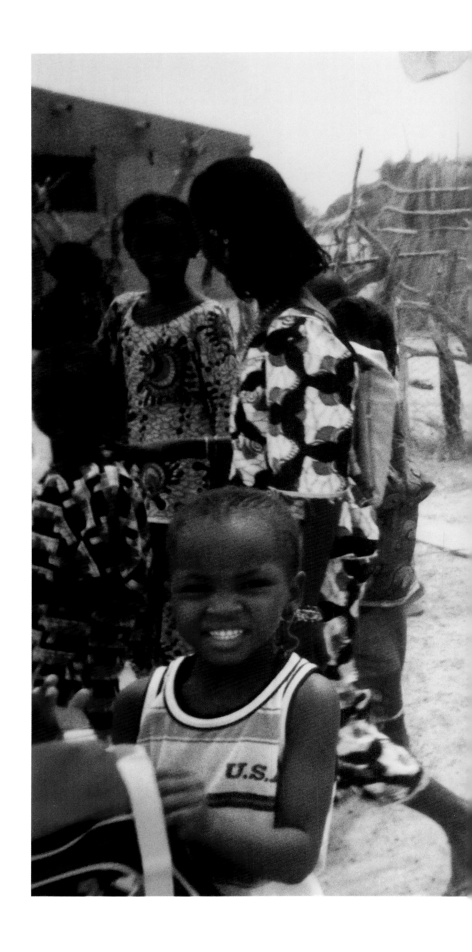

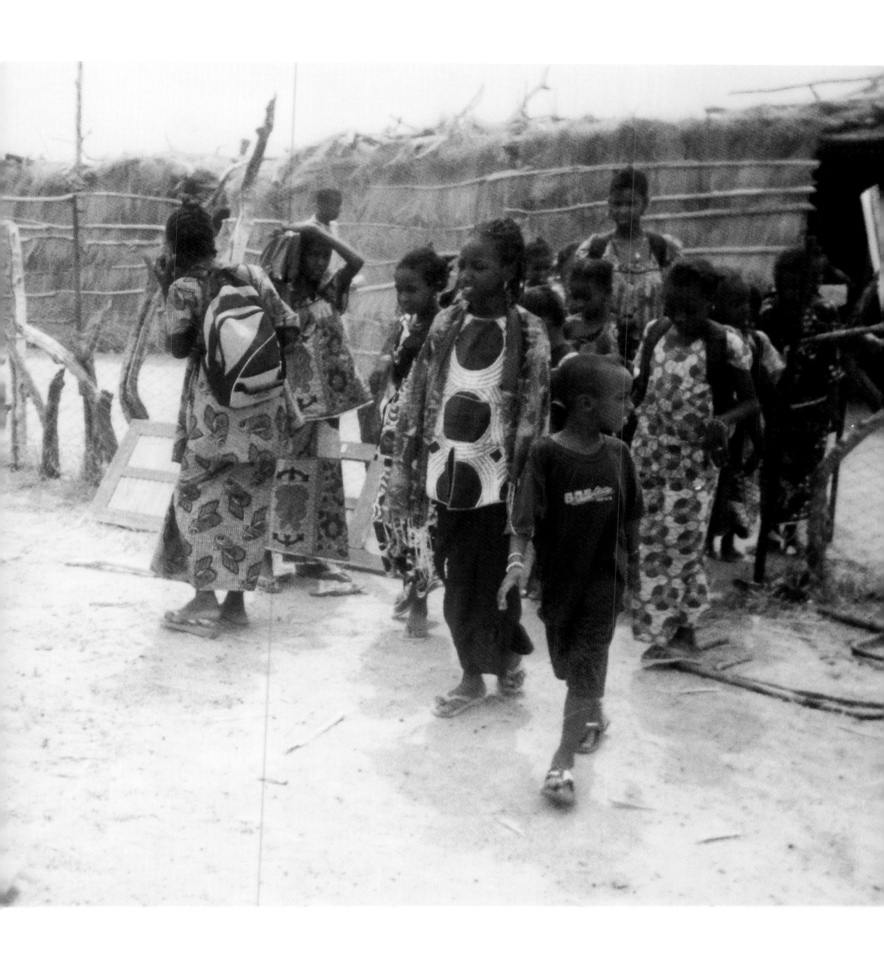

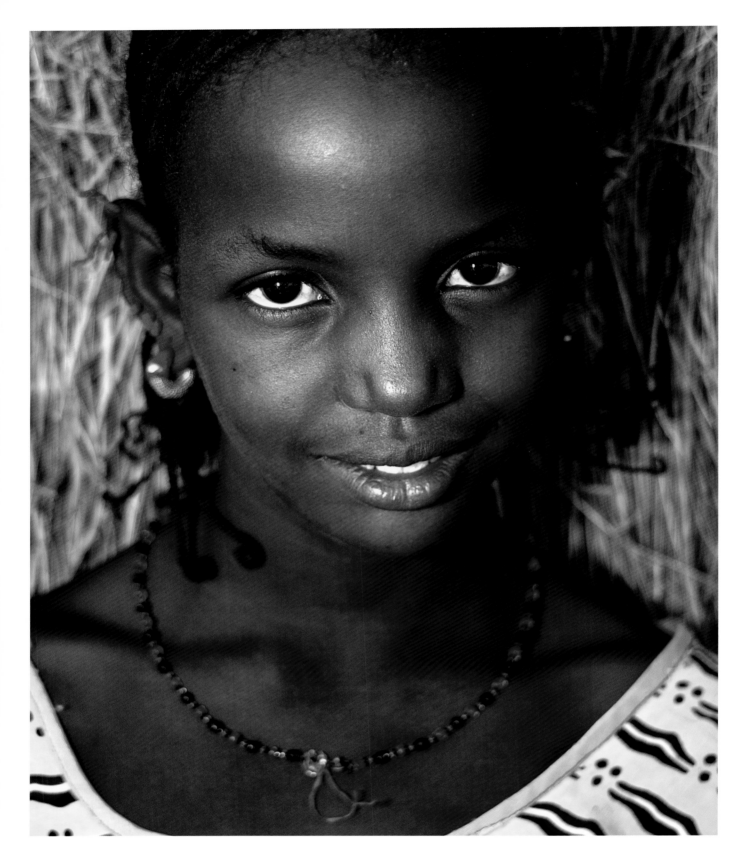

Mariata
Abdoul Ba

age 11

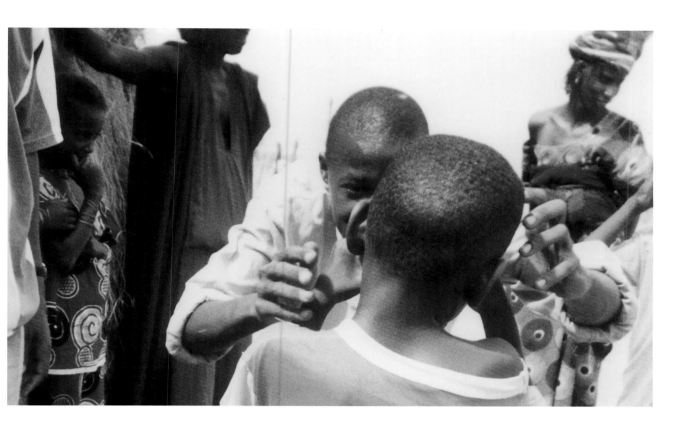

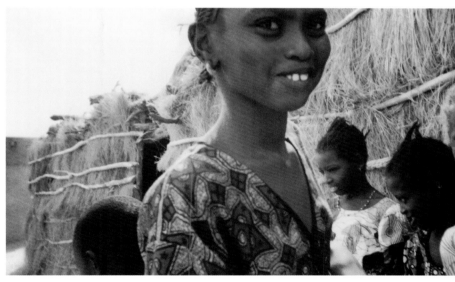

Above: Sometimes boys can be silly.

Below: This is my friend from school, Dieynaba Abdoulaye Ba.

Next Page: Friendship is very important: these are my good friends Salamata Ba, Mariam Ba, Mariam Selba and Aissata Mariam Ba. It was fun to take their picture.

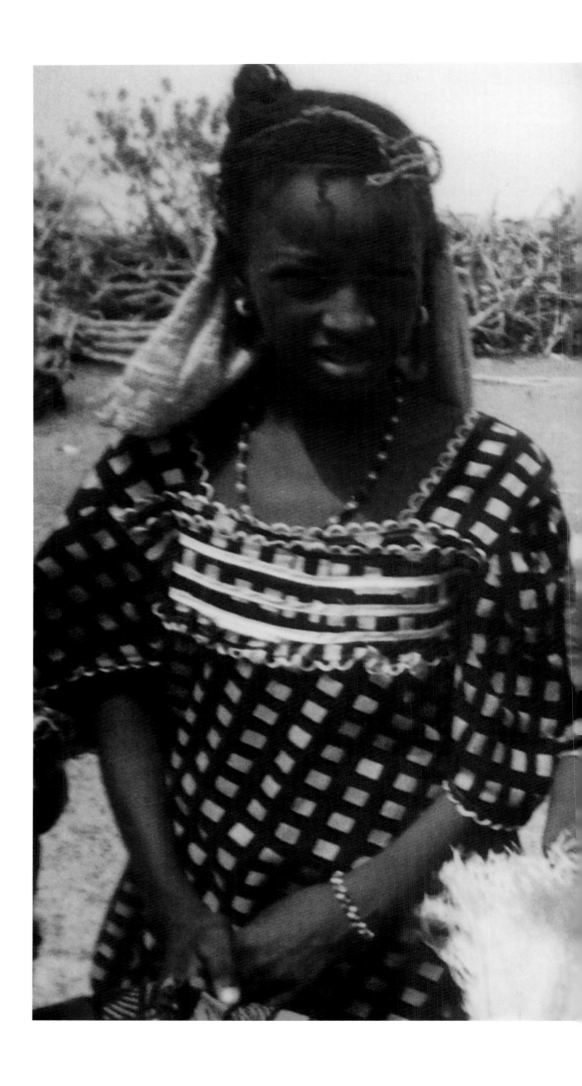

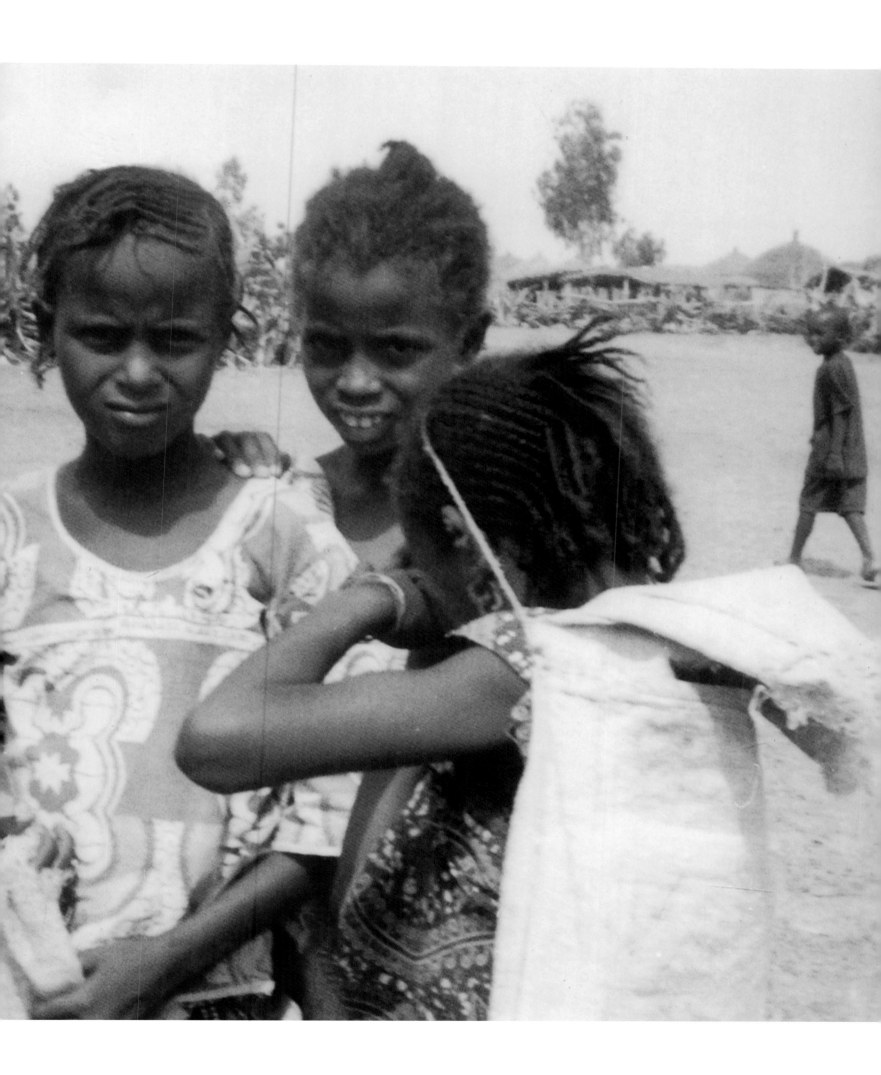

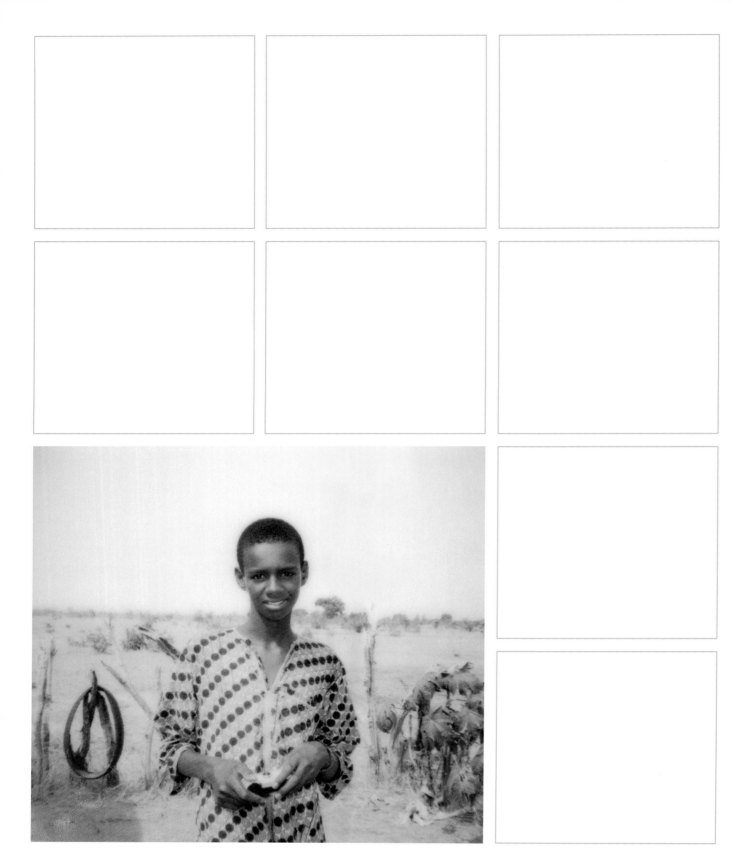

Mamadou
Malick Ba

age 12

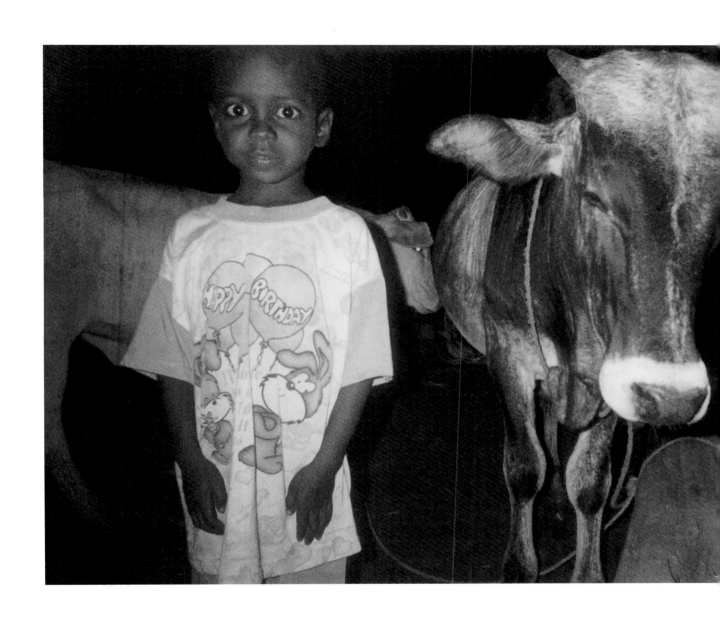

Above: My brother and our cow.

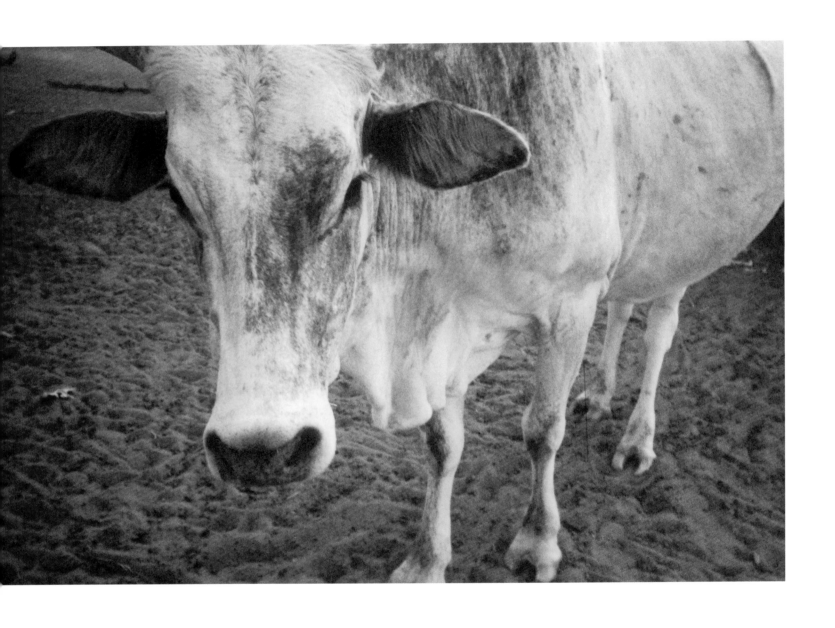

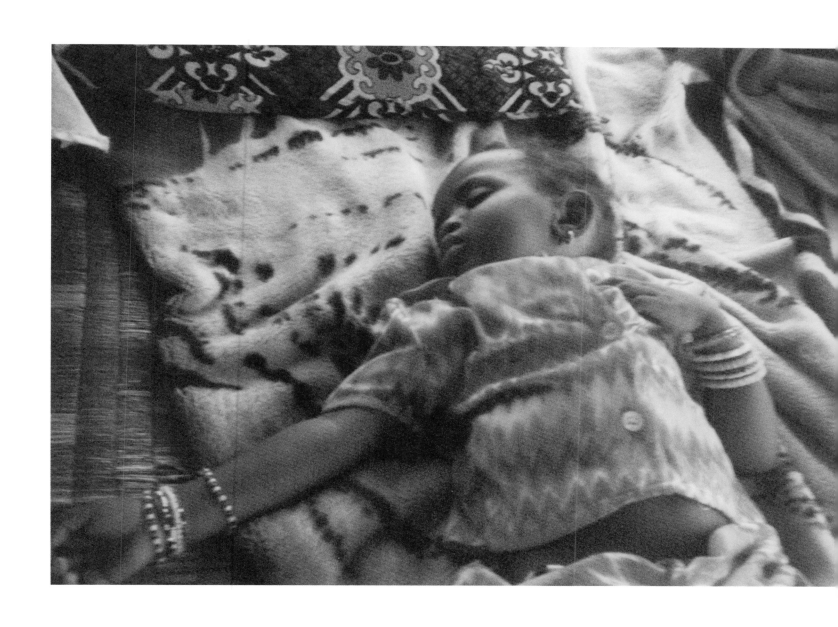

Left: Our cow. She looks mean but she's really not.

Above: My sister sleeping.

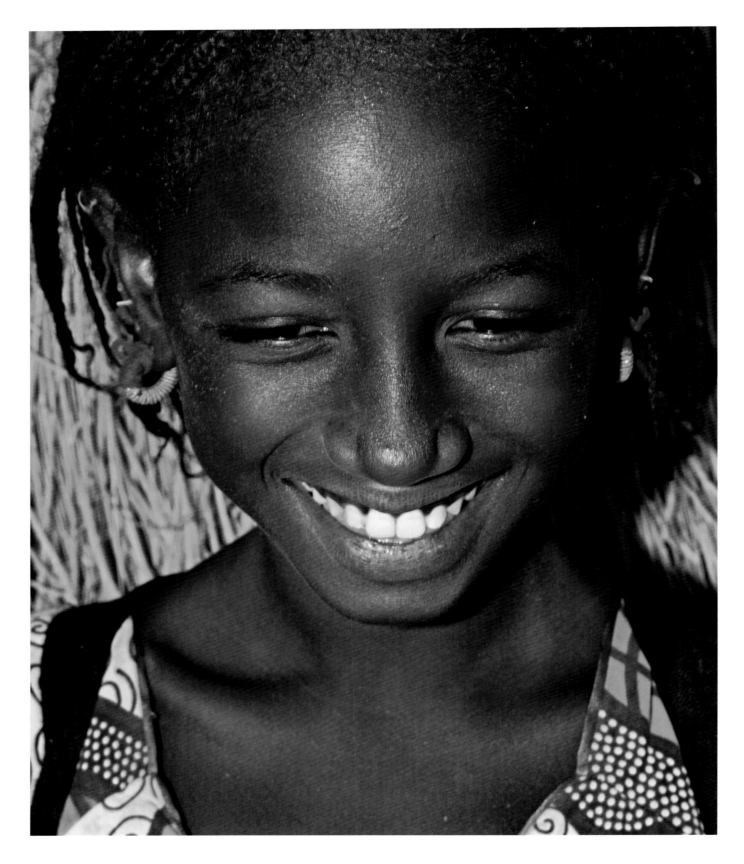

Aissata
Adama Ba

Left: This is my younger sister.

Right: This is my mother. She takes good care of me.

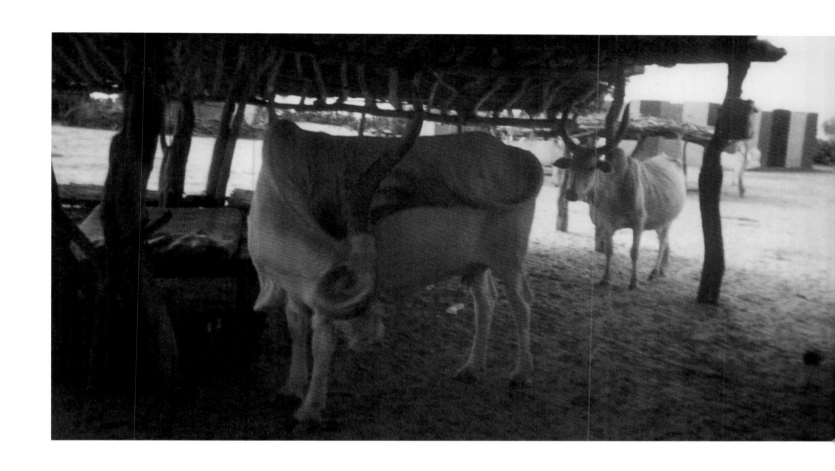

Left: People's feet. I didn't do this photo very well!

Above: These are our cows. I love them and help feed them every day.

Dieynaba
Abdoulaye Ba

age 12

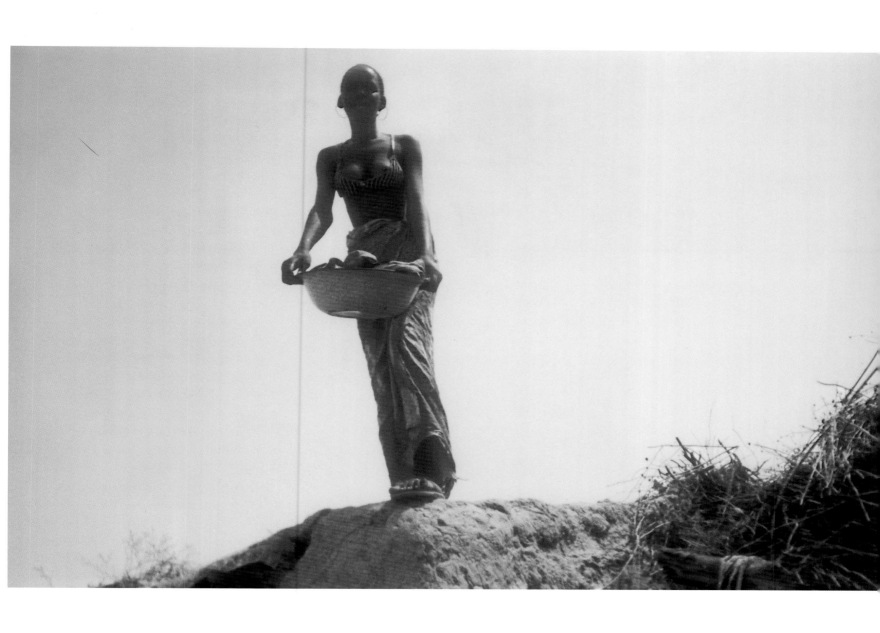

Above: I asked my friend to pose with her basket.

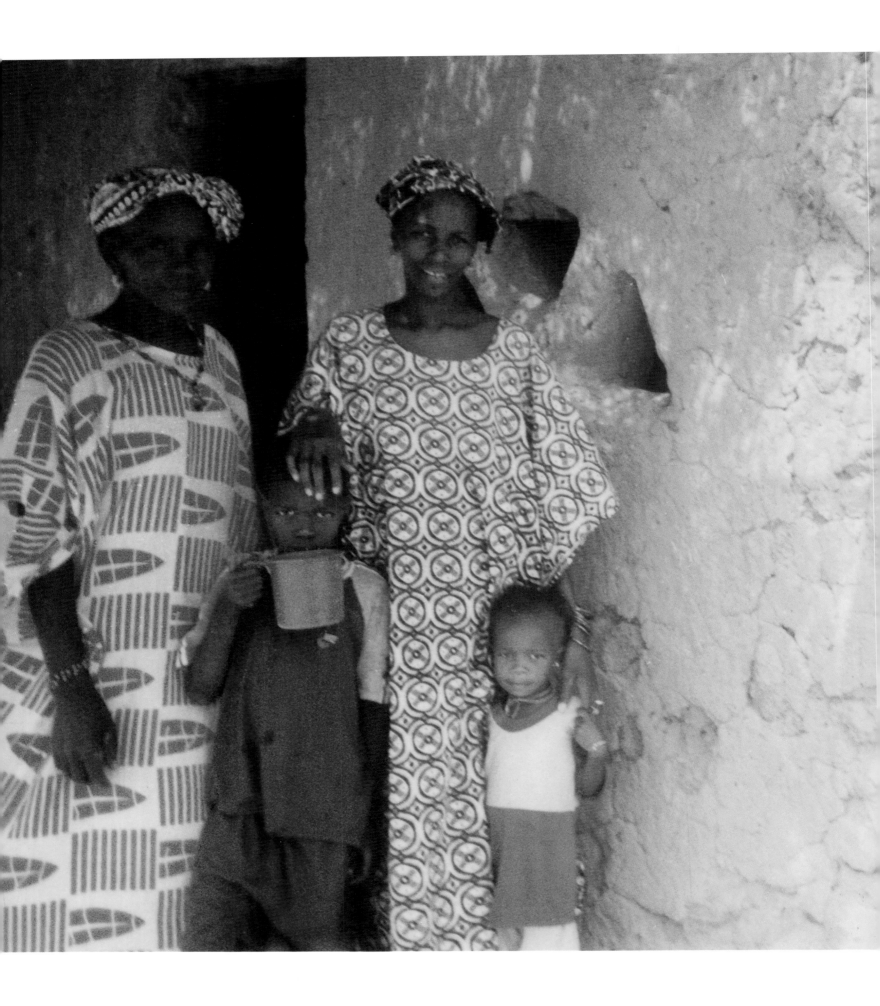

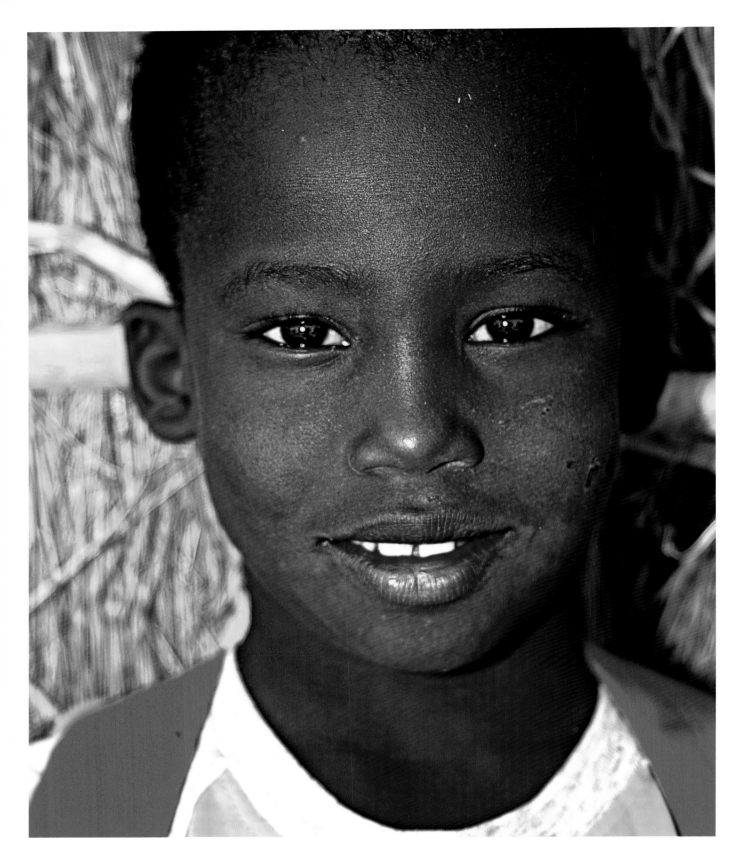

Alpha
Mamadou Ba

age 7

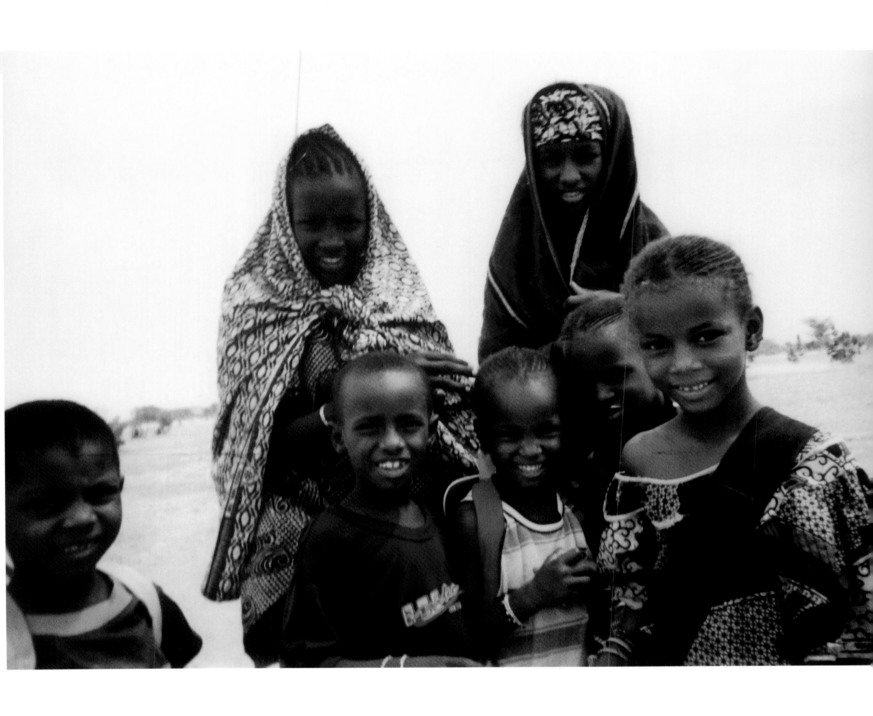

Above: This is my family: my older sisters and my younger brothers and sisters.

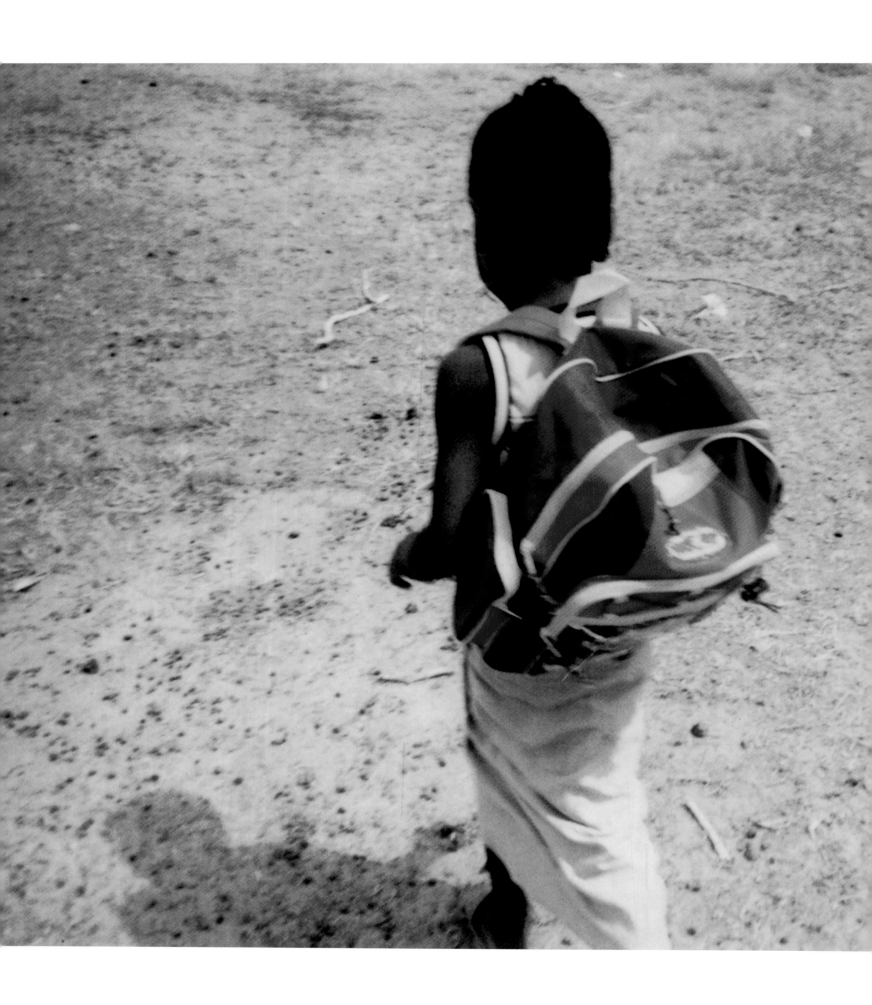

Left: My sister, Aissata Mamadou Ba, coming home from school.

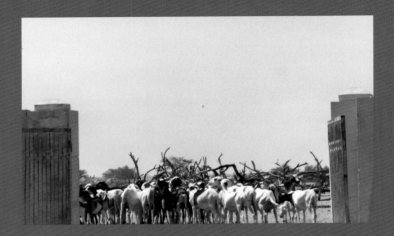

Belel Bogal is a Koranic school, located in the Diery. Headed by a Marabout, it has an enrollment of 60 students, drawn from ten hamlets with a population of approximately 1,400. The six teachers, Bocar Sall, Cheikh Tijan Sy, Alhouseinou Ndong, Alhassan Diop, Aliou Sy and Abu Sy were aided by six women who looked after the children and prepared the meals: Fatimata Sow, Fatimata Sy, Racky Ly, Fatimata Kelly, Aminata Diallo, and Djenaba Diop.

An enlightened leader, the Marabout cited the healthy food (Bulgar, rice, lentils, oil, tomatoes, dried fish), mosquito nets and health kits, slates to write on, and the construction of shelters and latrines as special benefits to participating in the Counterpart program.

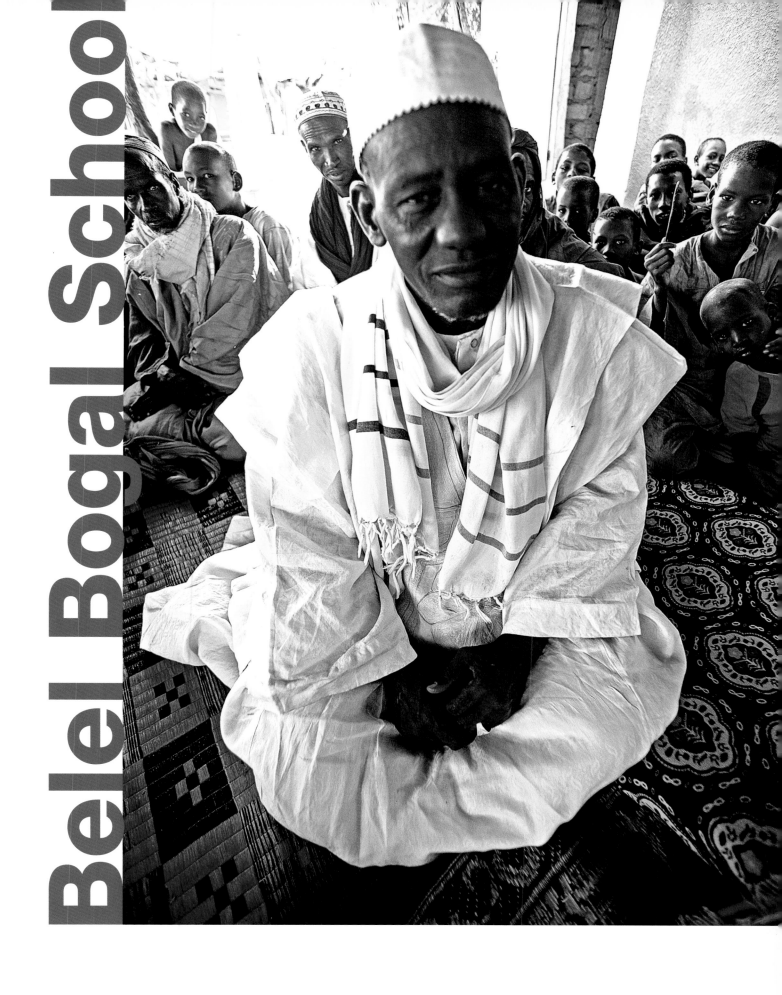

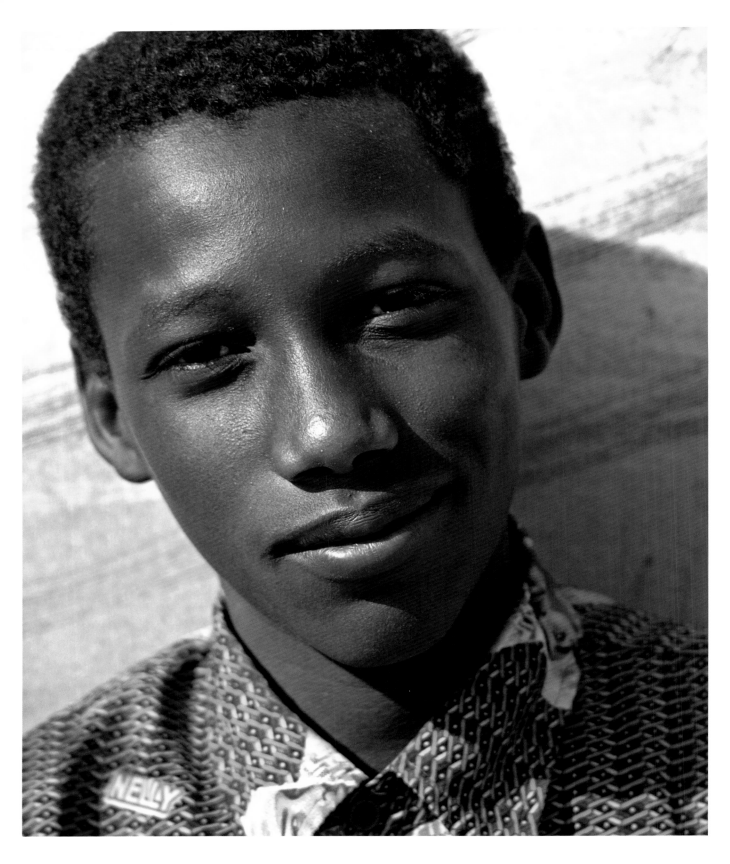

Abou
Sow

age 15

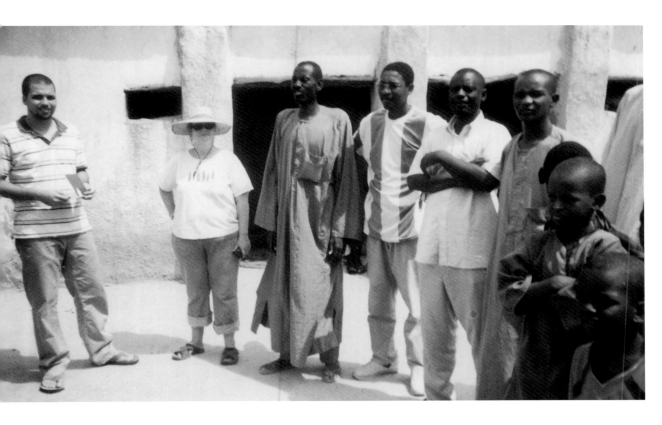

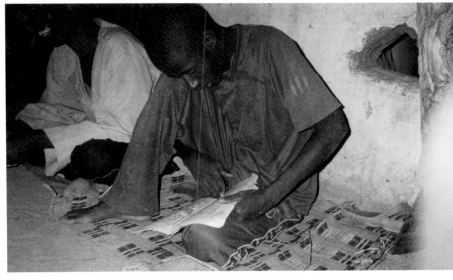

Above: These are some of our friends, Cole [Wolfson] and Erica [Cummings], our Thierno, and Ahmadou [Ndiade].

Below: He is studying the Koran.

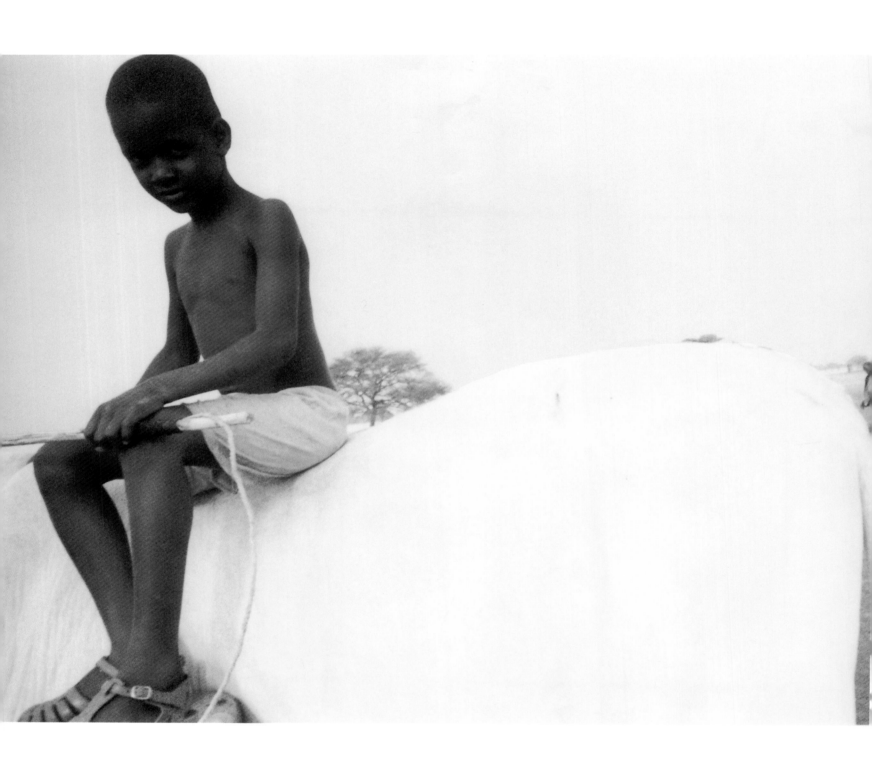

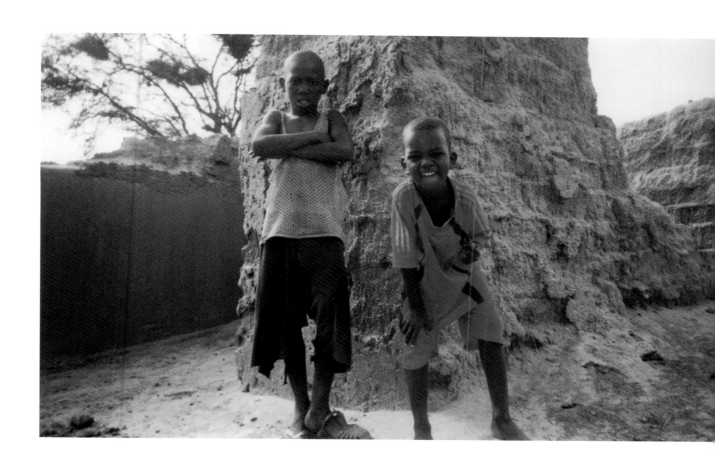

Left: This little boy is riding his cow.

Above: A couple of boys playing in our compound. They wanted me to take their picture.

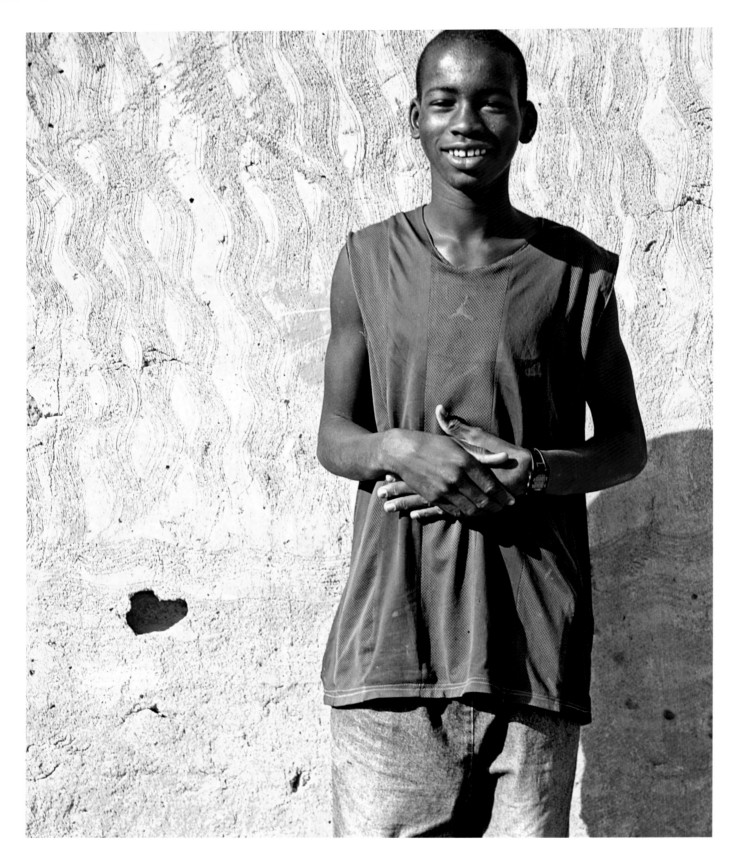

Seyni Sy

age 15

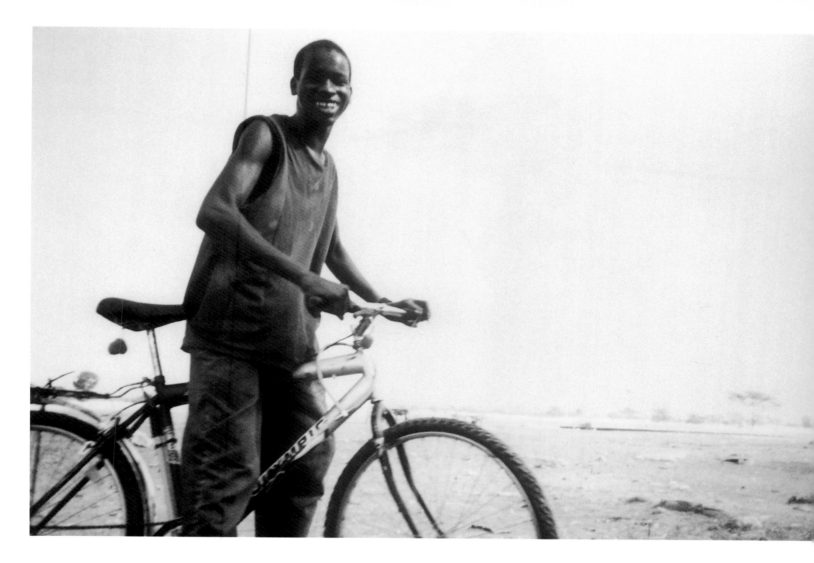

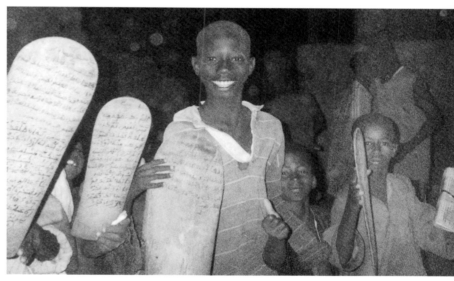

Above: This is me on my bicycle. I use it to go to town.

Below: These are the tablets we write on when we are studying the Koran.

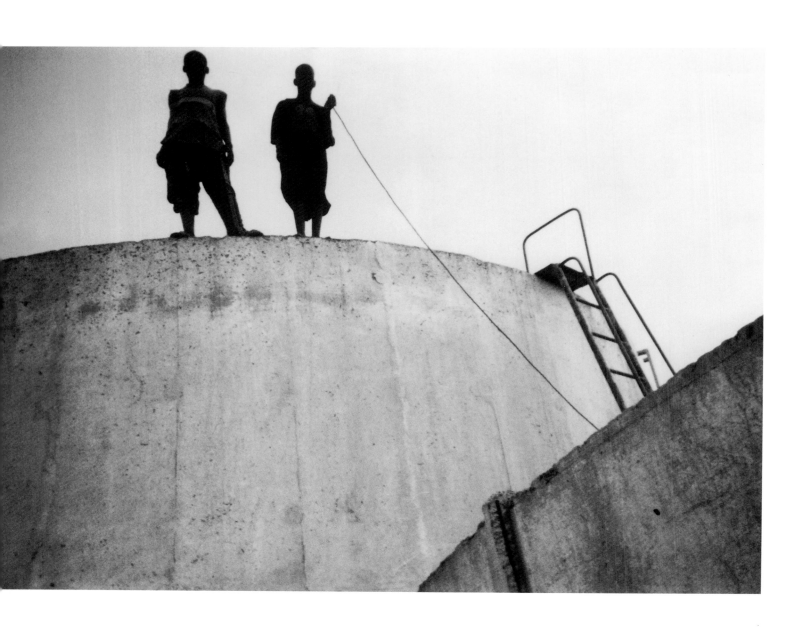

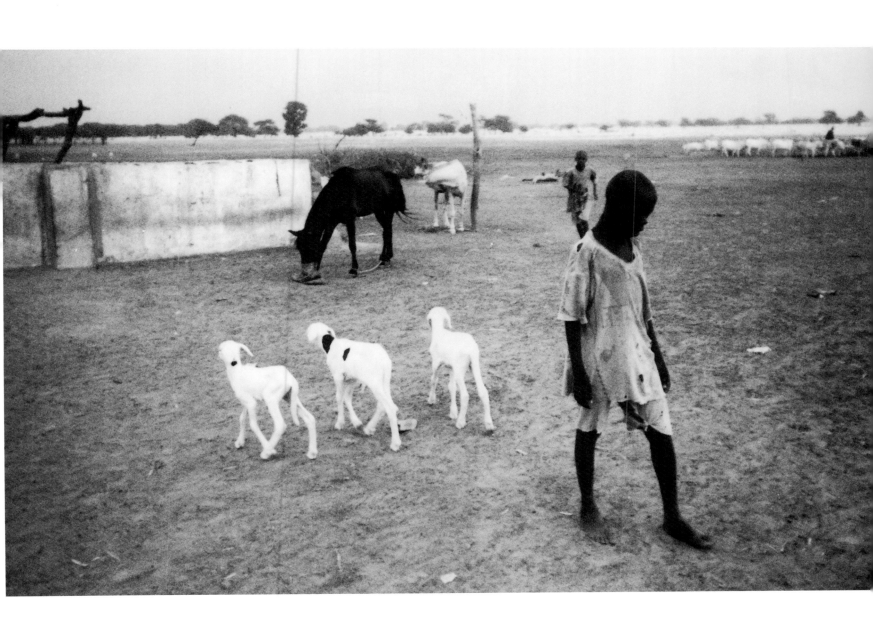

Left: My friend Moussa on the water tower, getting water.

Above: This is our compound, with goats and a horse by the well,

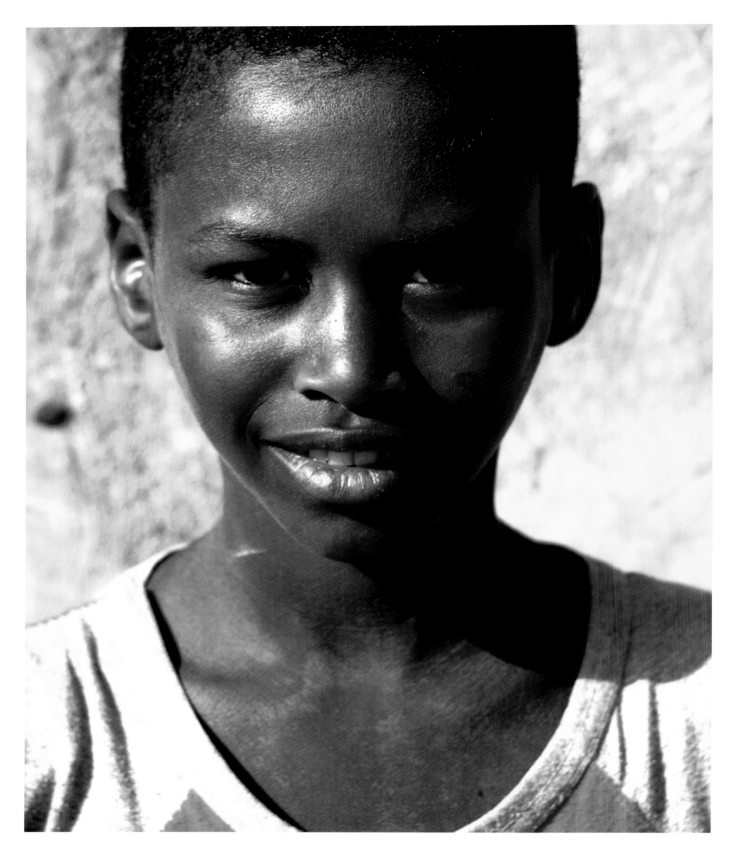

Hadrume
Sow

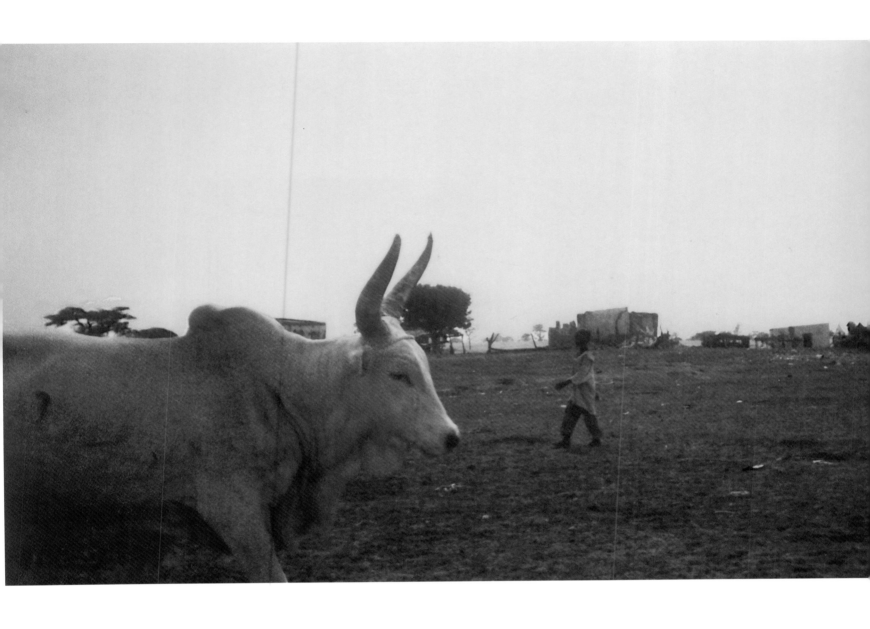

Above: This is my cow.

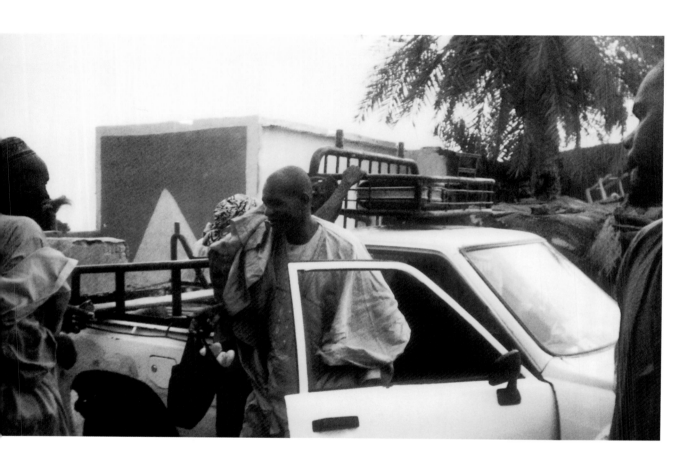

Right: This is me with my camera.

Above: Our Thierno getting out of the car. He is our religious leader.

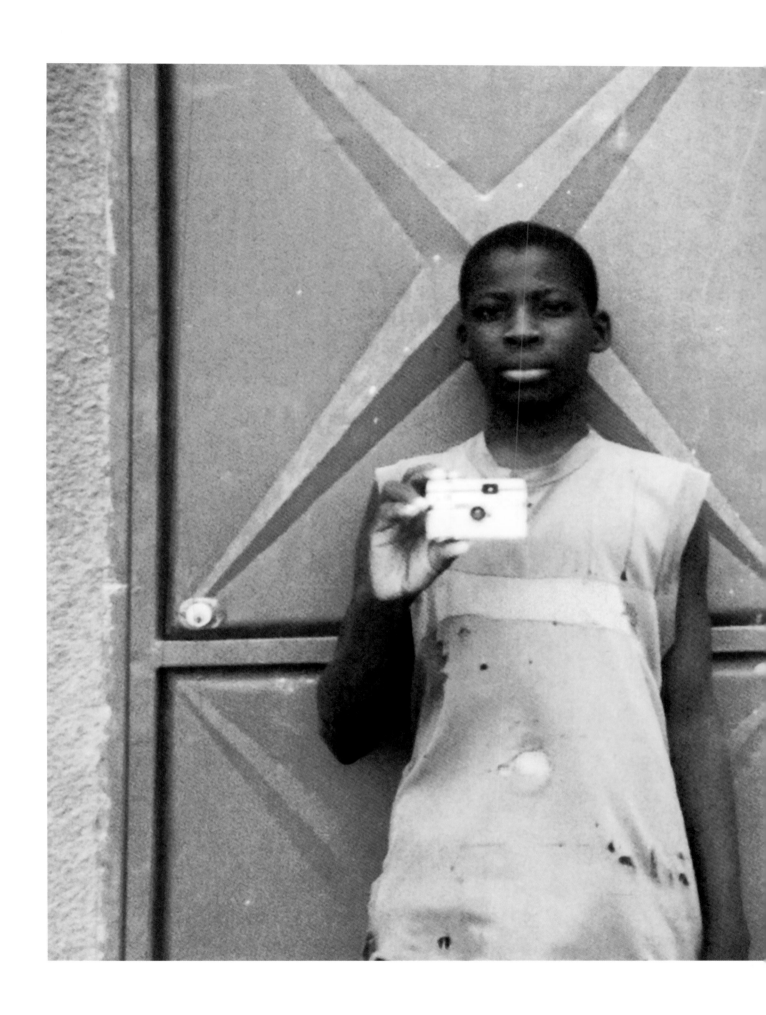

Elimane
Diop

age 14

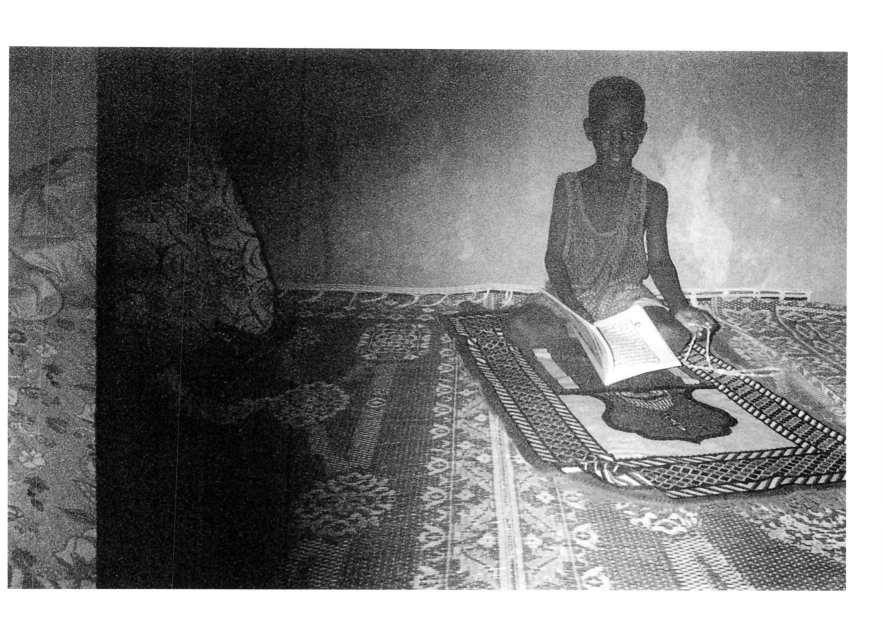

Above: My little brother, Abdoullai, studying the Koran on a prayer rug, with his prayer books around him.

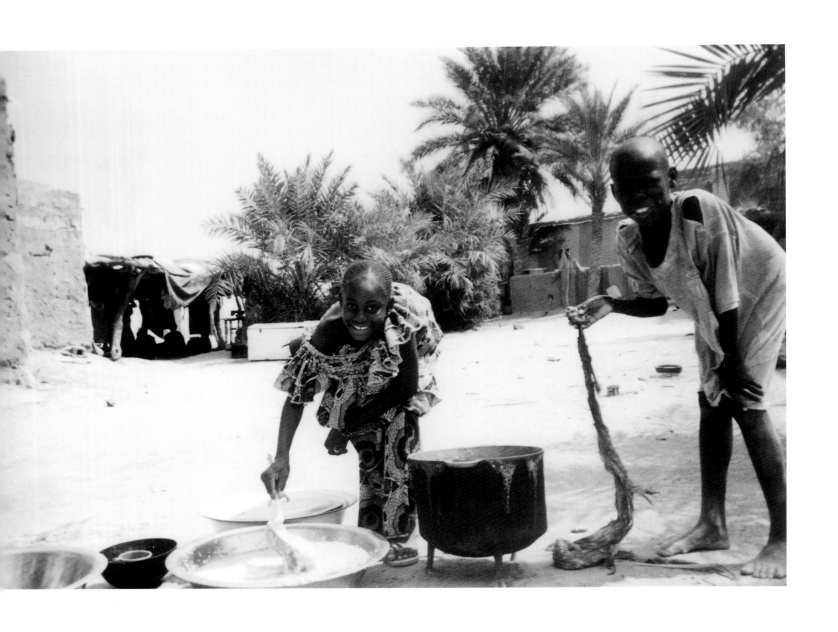

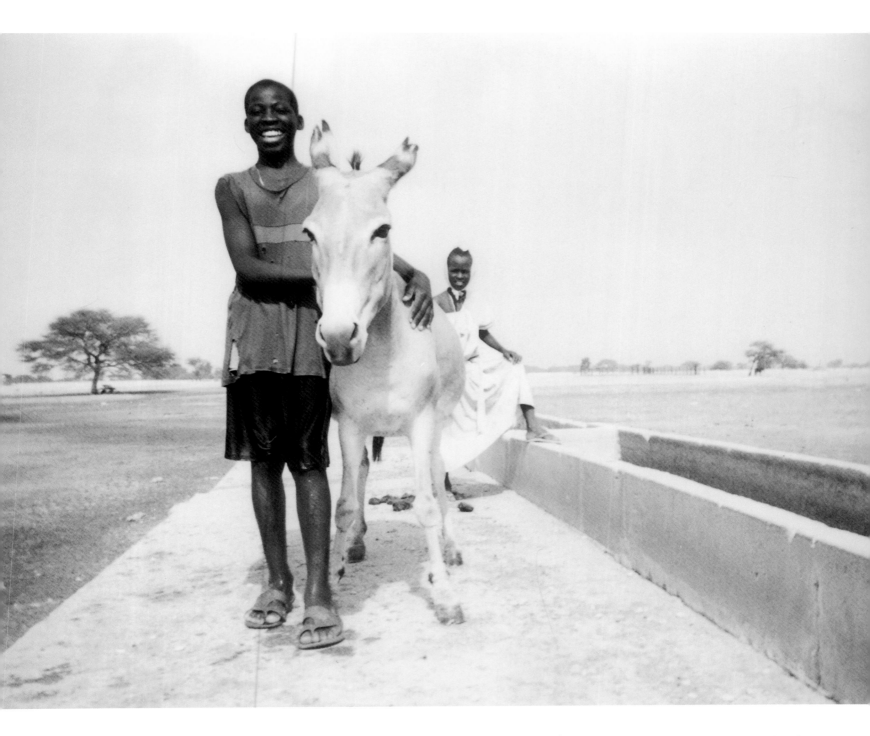

Left: Fatimata, my little sister, is a good cook. Here she is preparing meat and rice.

Above: Me and my cow.

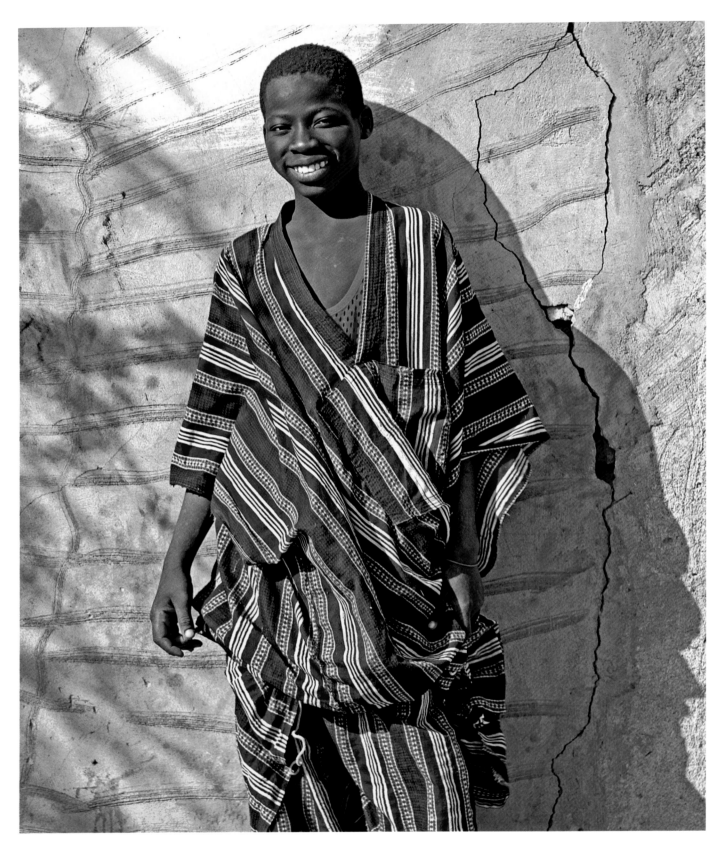

Amadou Sy

Left: This is a wood pile with the cow pen at night

Right: My friend Mounta and a sheep. Behind him is the Thierno's car.

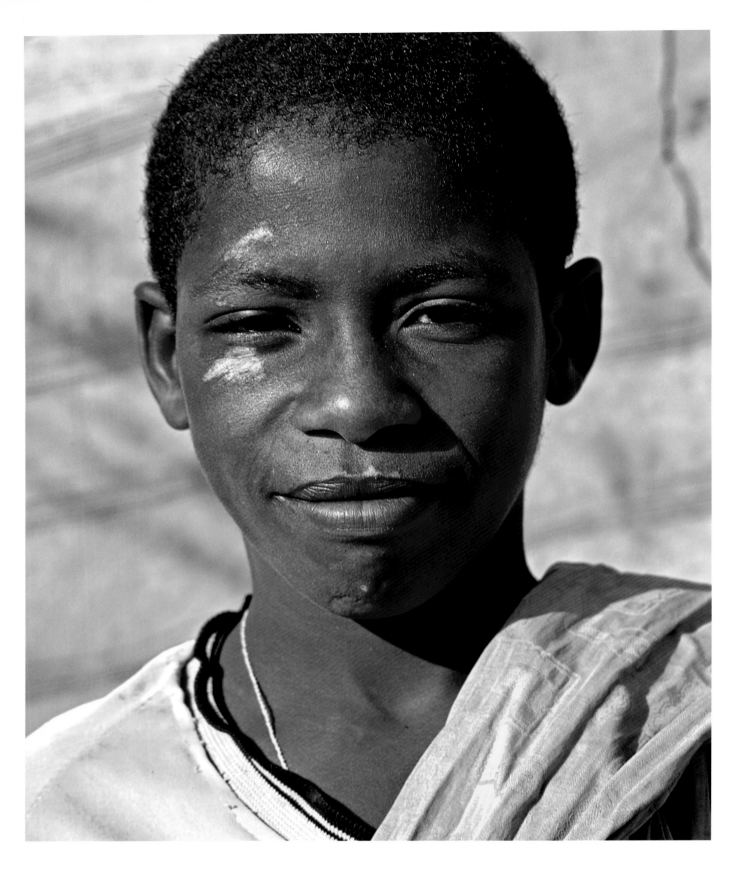

Mboderi
Diallo

age 15

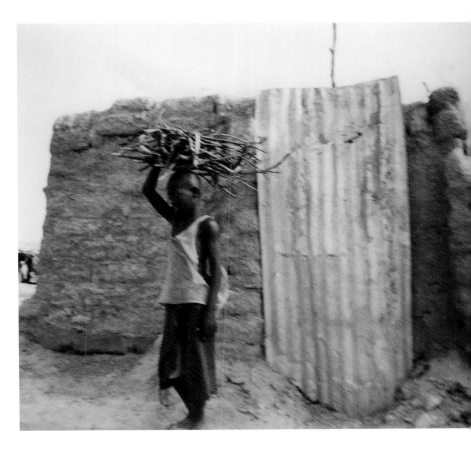

Left: The field with the tiller and the millet and rice plants

Right: This is my friend collecting wood to build a fire so we can see to study and to cook with.

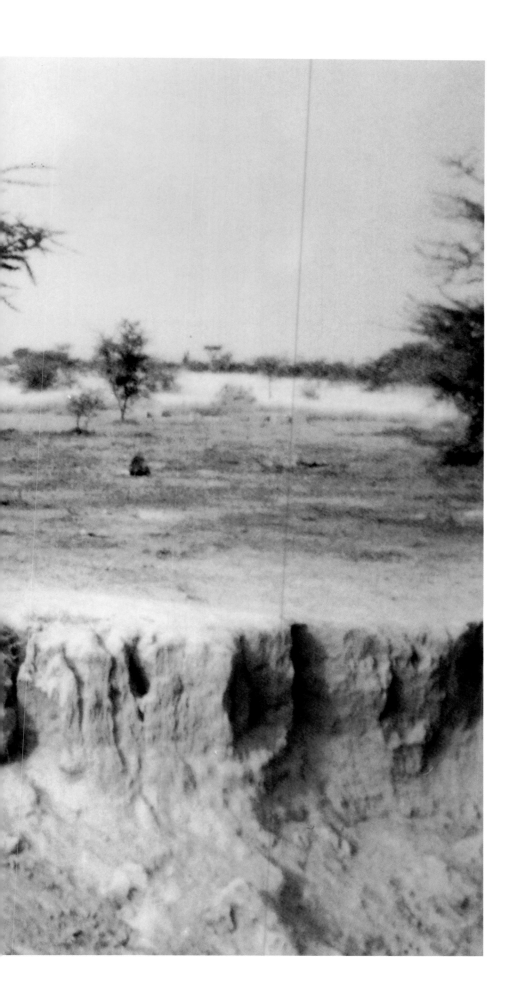

Left: Sheep! They are always climbing somewhere.

Mountaga
Diallo

age 14

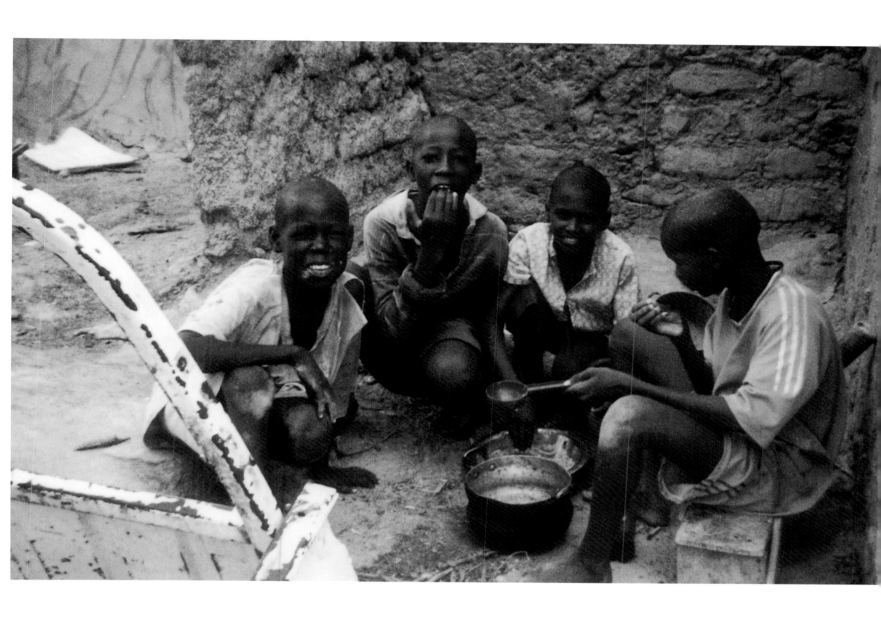

Above: These are my friends. They're eating a lunch of fish and rice.

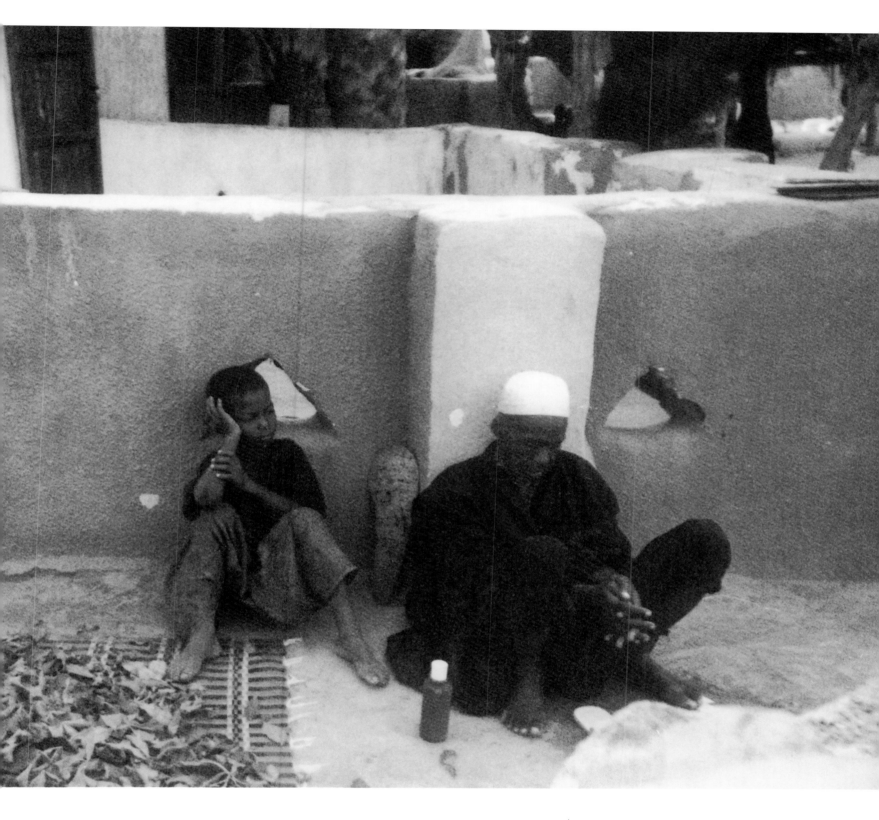

Left: Our Koranic school books.

Above: People resting near the house.

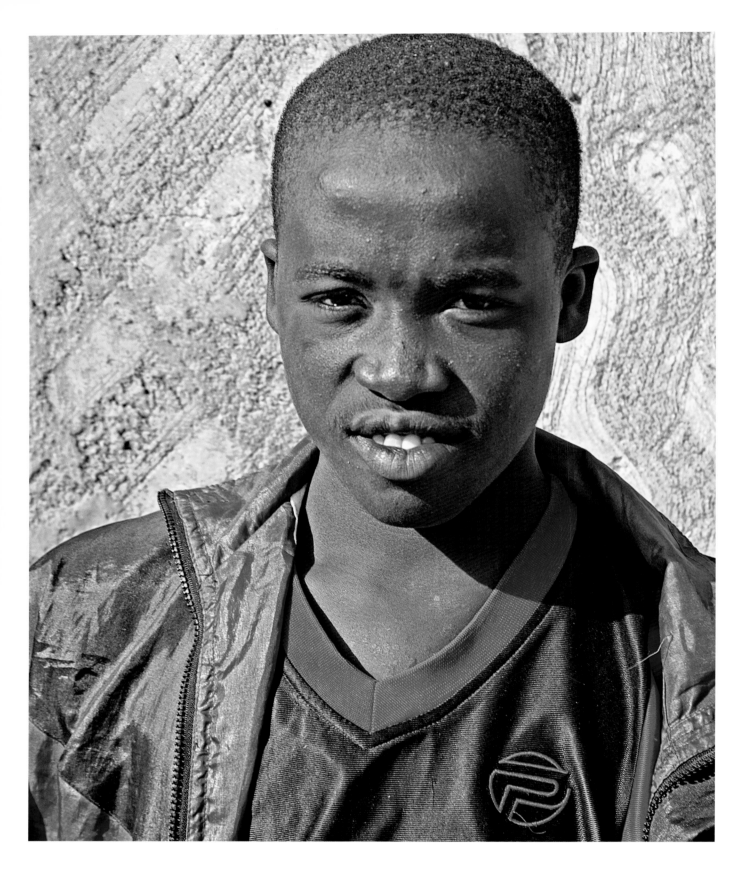

Bocar Kane

age 18

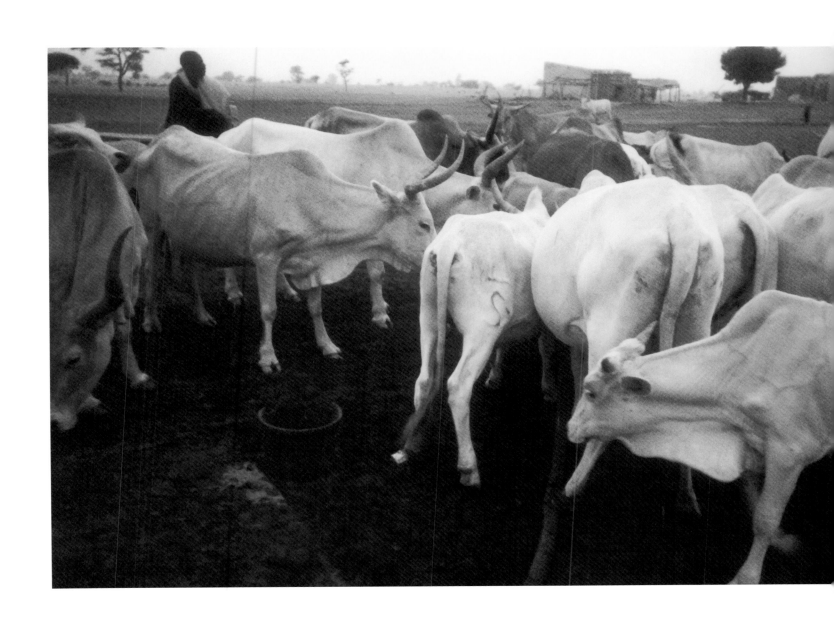

Above: These are the Thierno's cows.

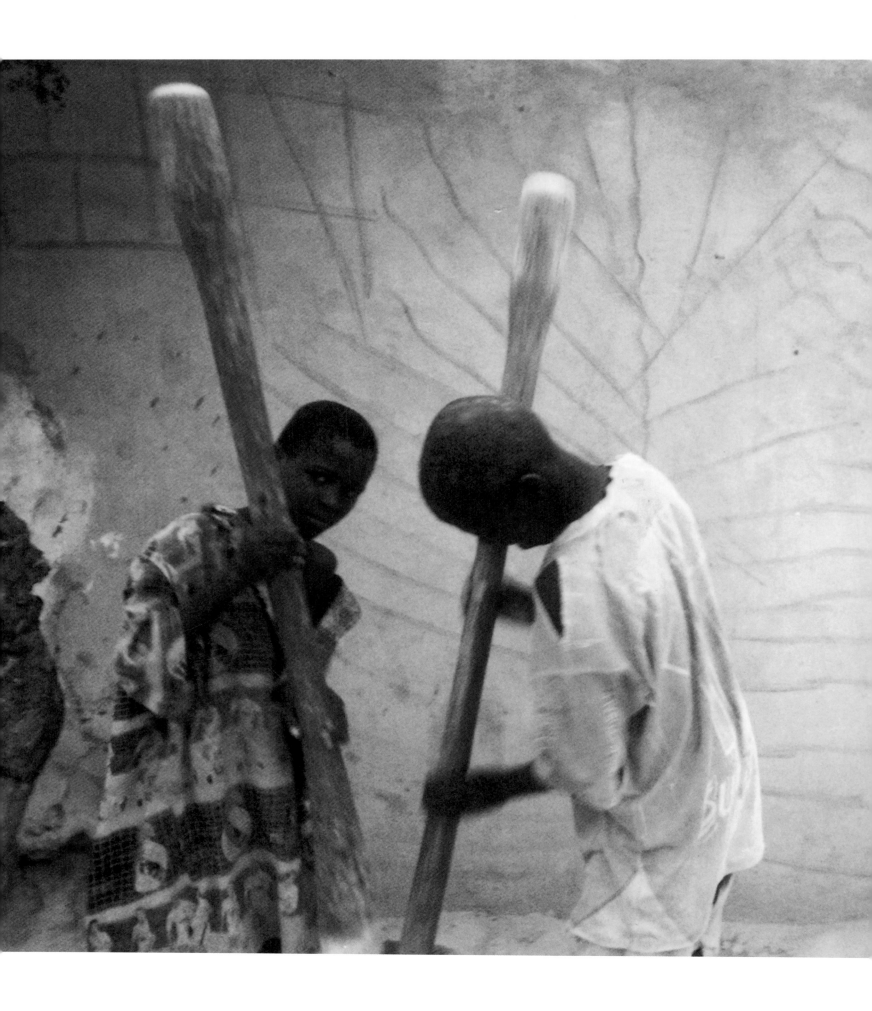

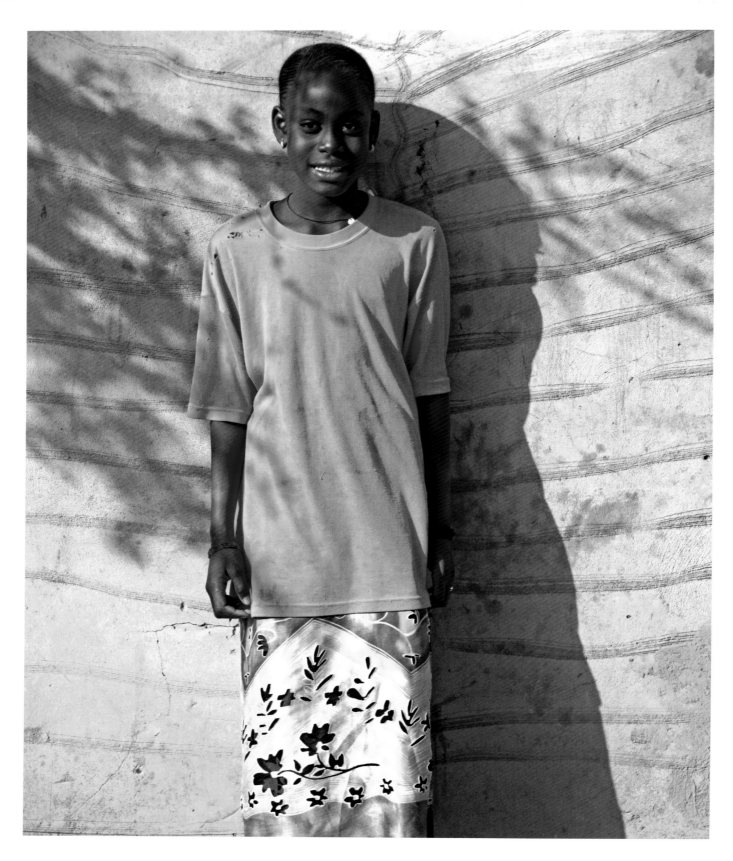

Fatimata
Sy

age 12

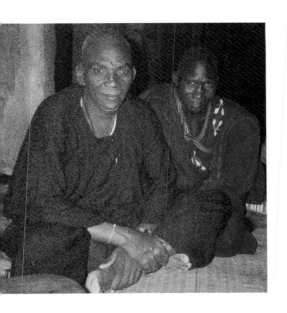 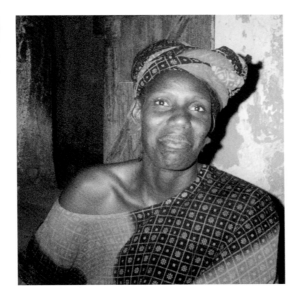 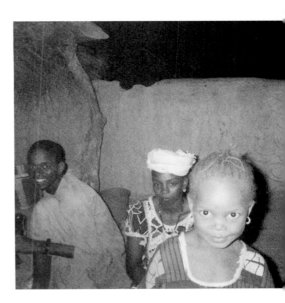

Left: This is my Dad and a friend. They are reading the Koran.

Middle:: This is my Mom.

Right: This is my older brother, a friend and my little sister, in our house.

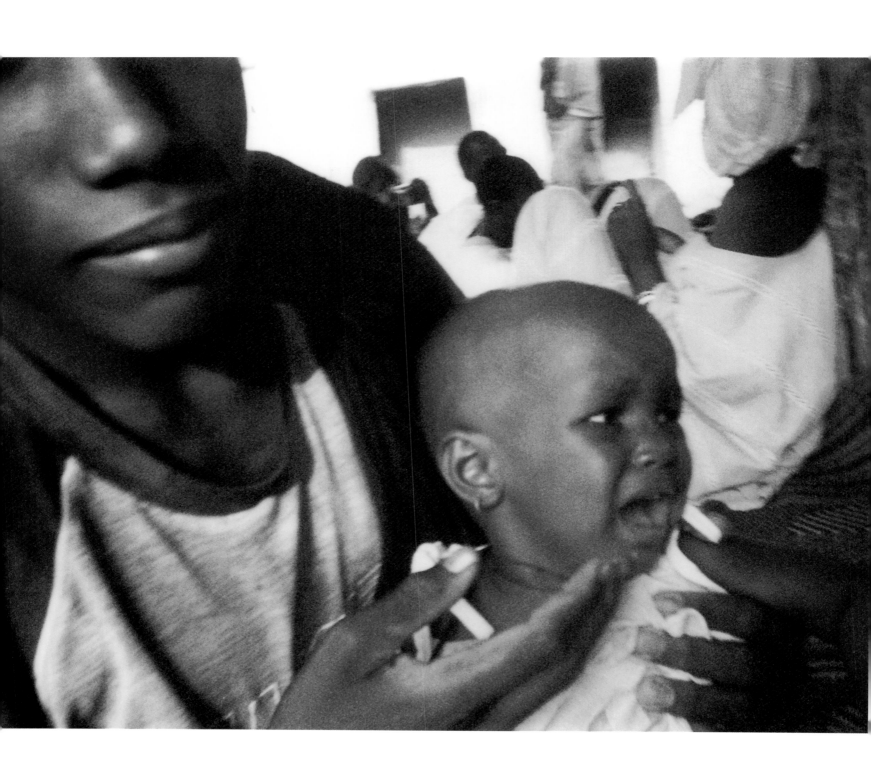

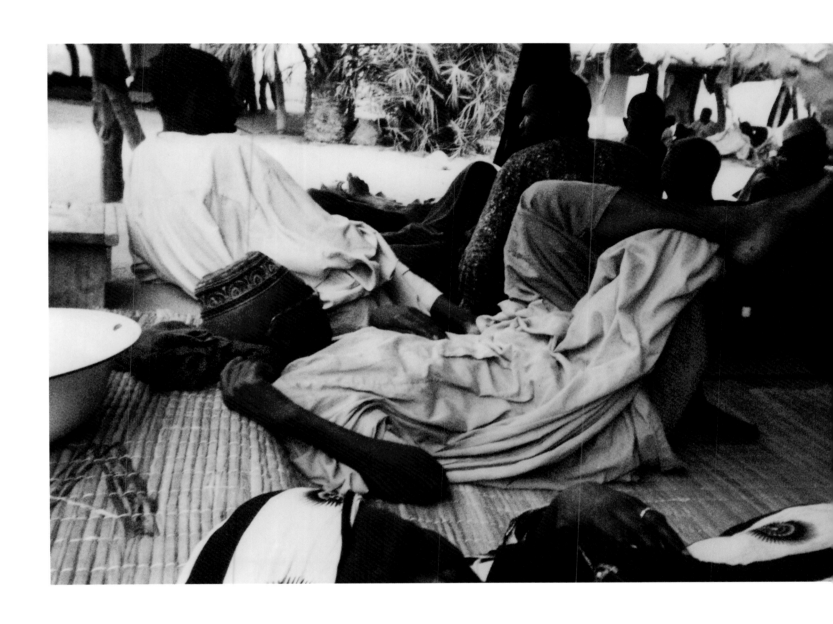

Left: The baby started to cry when I tried to take the photo.

Above: Some of the older men resting on mats out of the sun.

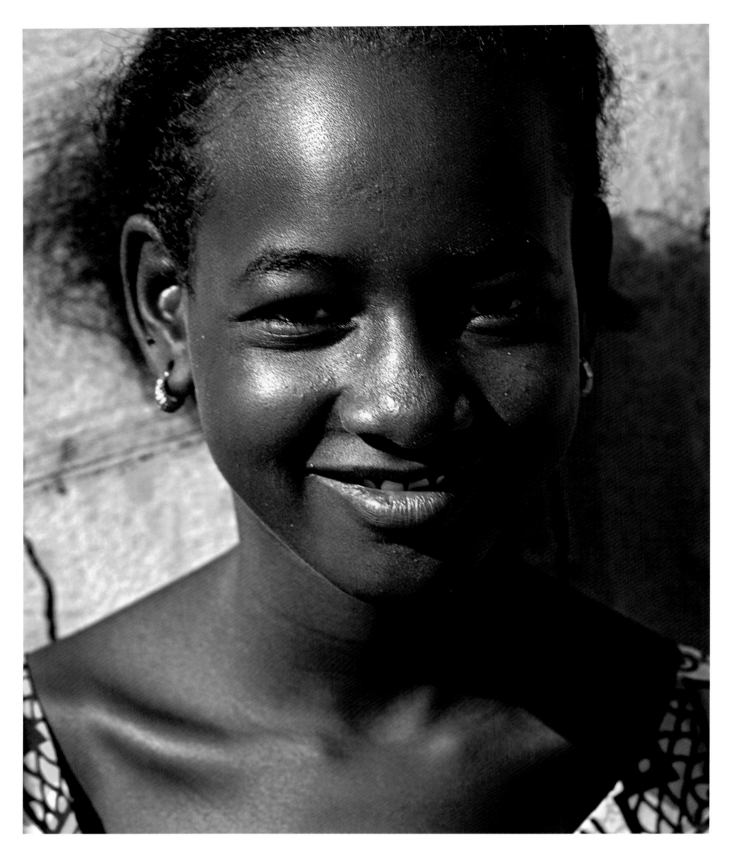

Kardiata Sy

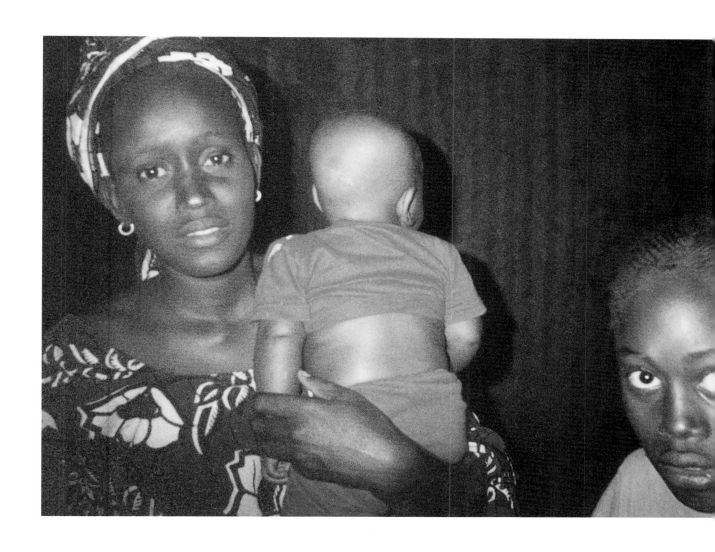

Above: My older sister and her baby and my little sister to the side.

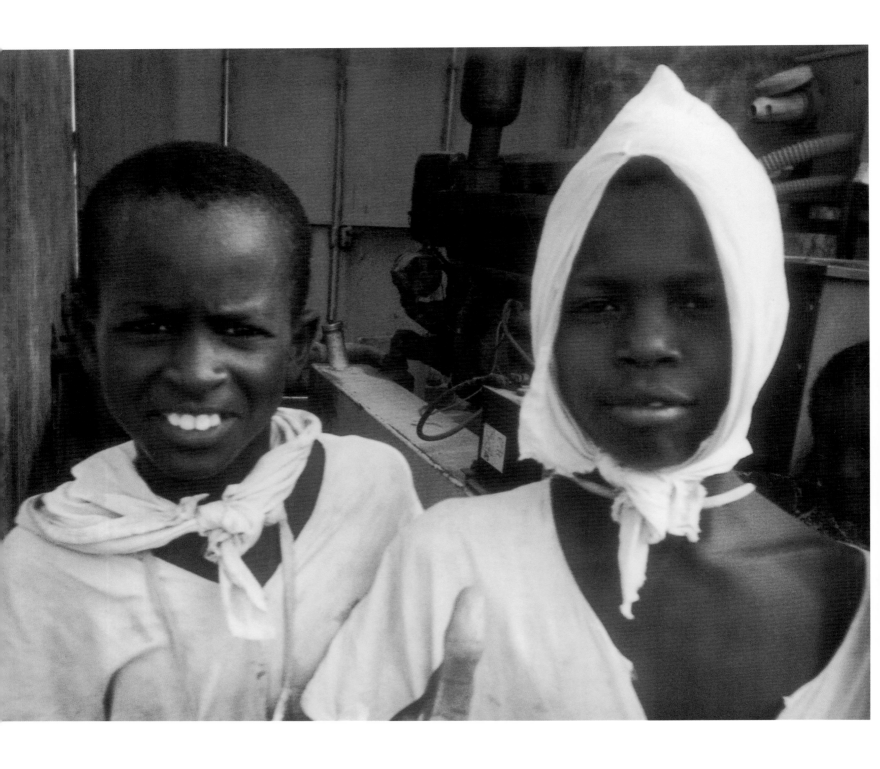

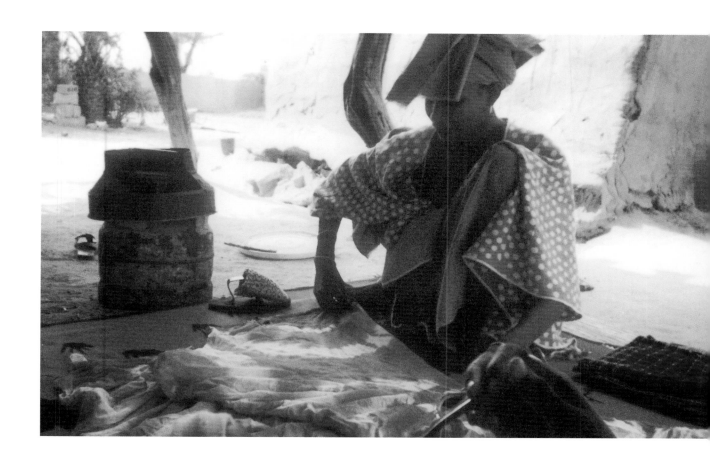

Left: My older brother, Halisane Ndongo, who also lives here.

Above: My older sister ironing her boubou [*the traditional body-length gown*].

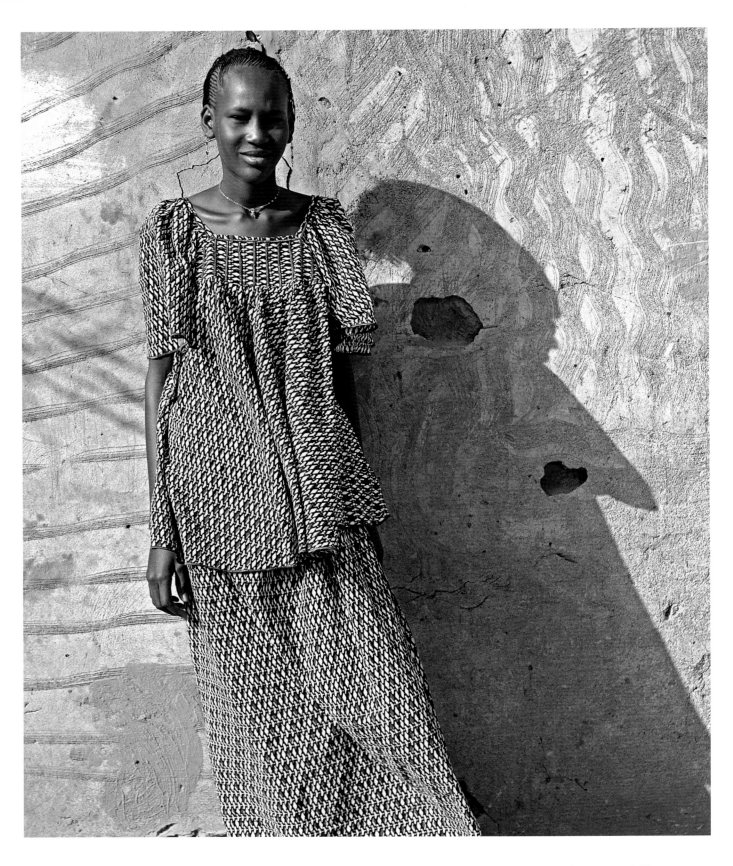

Rocky
Sy

age 15

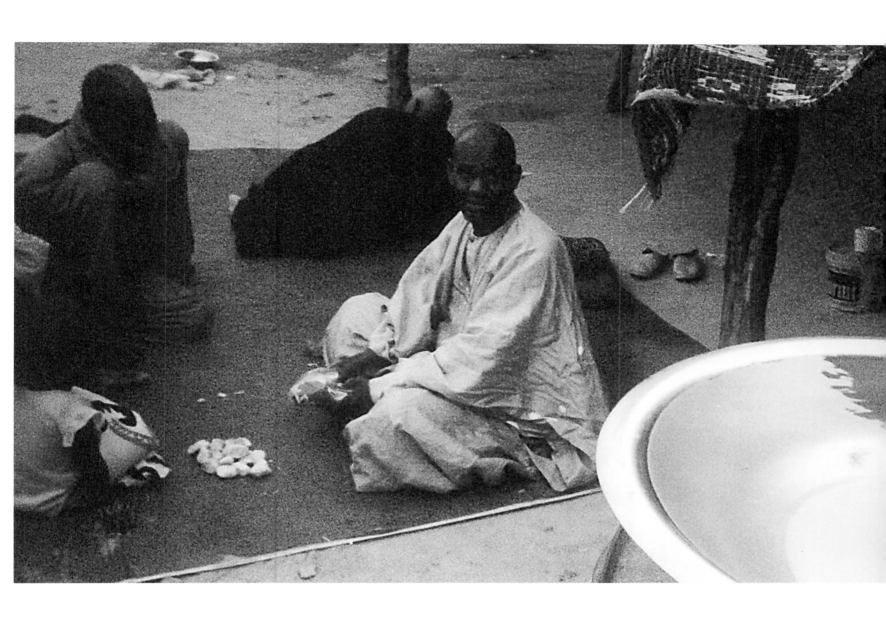

Above: My father (in yellow) eating biscuits.
Near him is a basin of cold water,

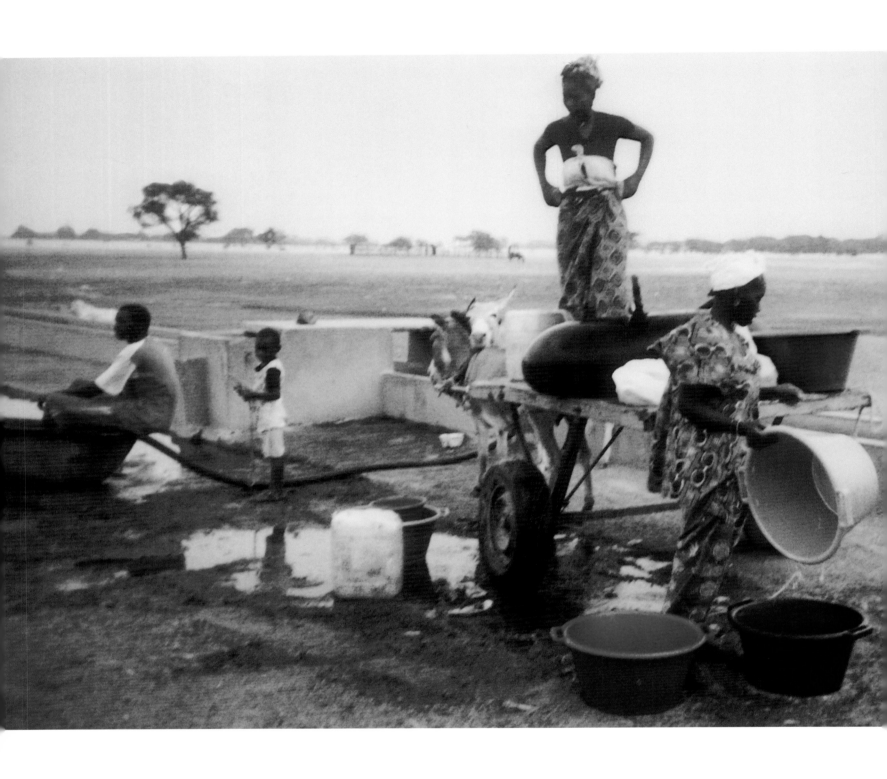

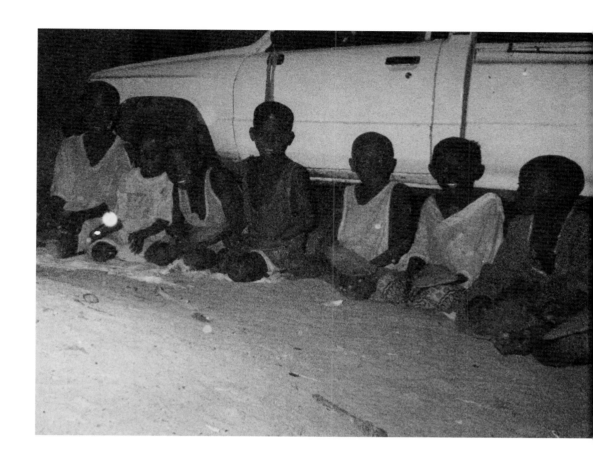

Left: My older sister is standing. The women are collecting water for washing clothes.

Above: These little boys are in a line, studying the Koran.

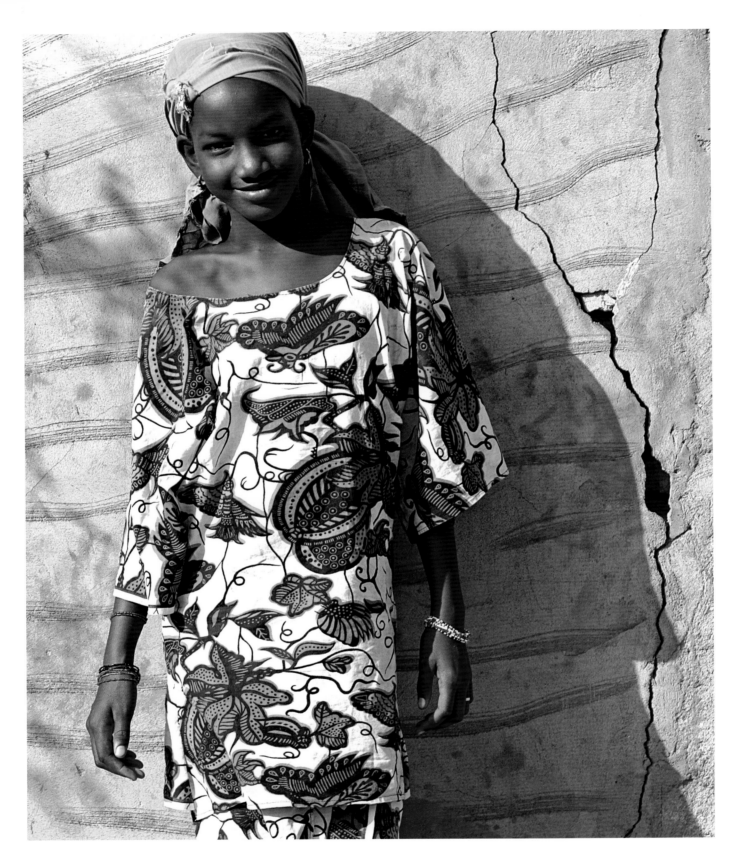

Fatimata
Thieu Sy

age 13

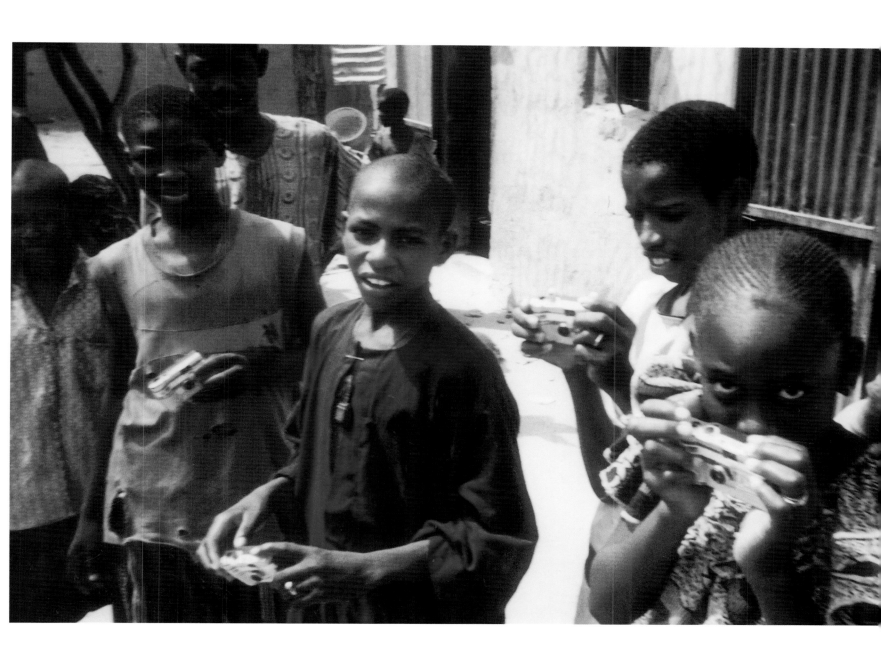

Above: My friends with the cameras they just received.

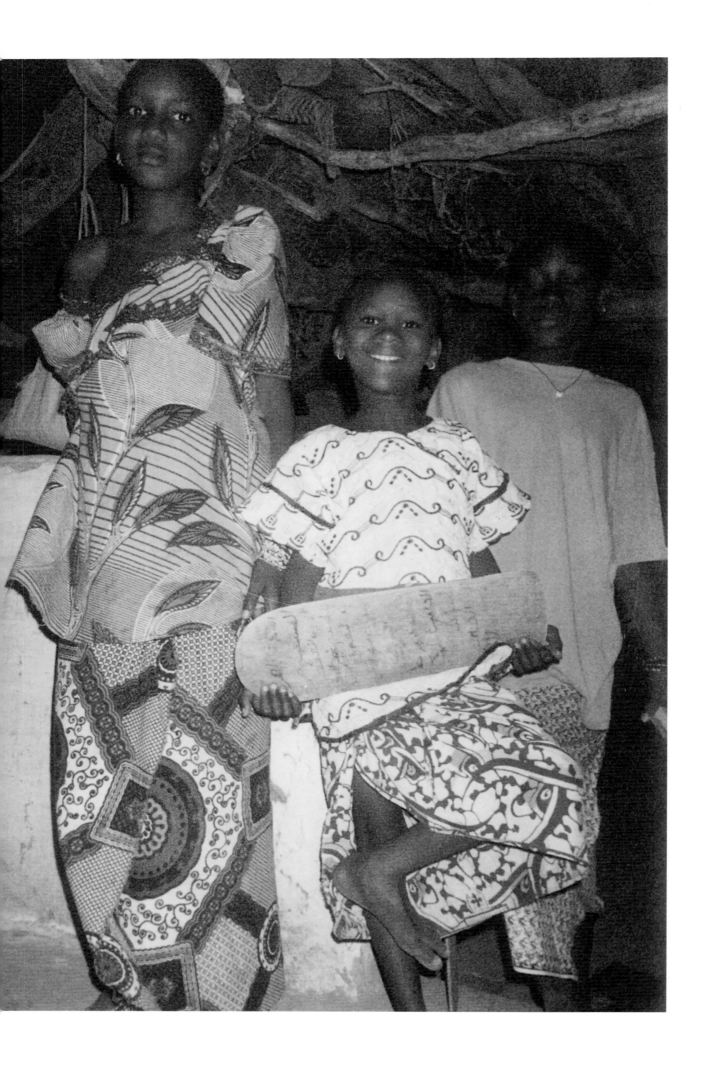

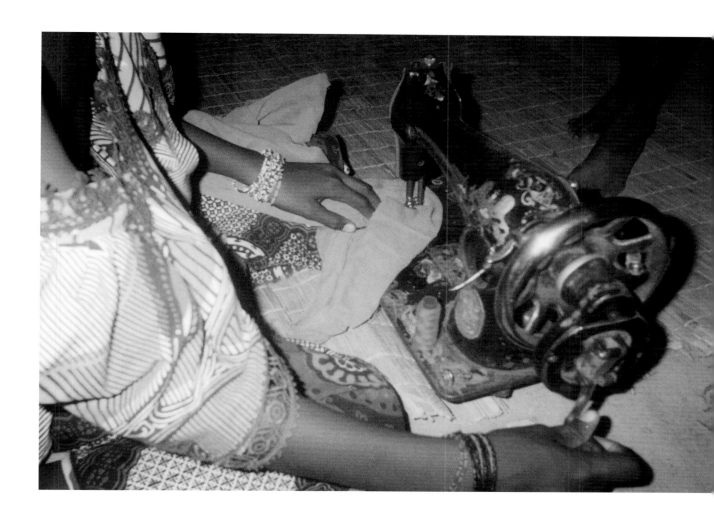

Left: My older sister and my younger sister with her study tablet.

Above: This is me, using a sewing machine to make a head wrap.

Located on Île à Morphil, a long, thin island between the main Senegal River and a channel that runs parallel to it for about 100 km, it was necessary to use two ferries, one motorized and the other hand drawn, to reach the village.

A Walo school, Koppe Magany has 89 students in five grades. The students came from two villages, with a general population of approximately 1,200. There were three teachers, one of whom was Seydou Barry. The director of the school was Souleyman Thiam, and the assistant director, Ibrahim Ba. The school had a rotating cooking crew made up of local mothers, including Aissata Omar Diallo and Maimouna Ahmadou Ba.

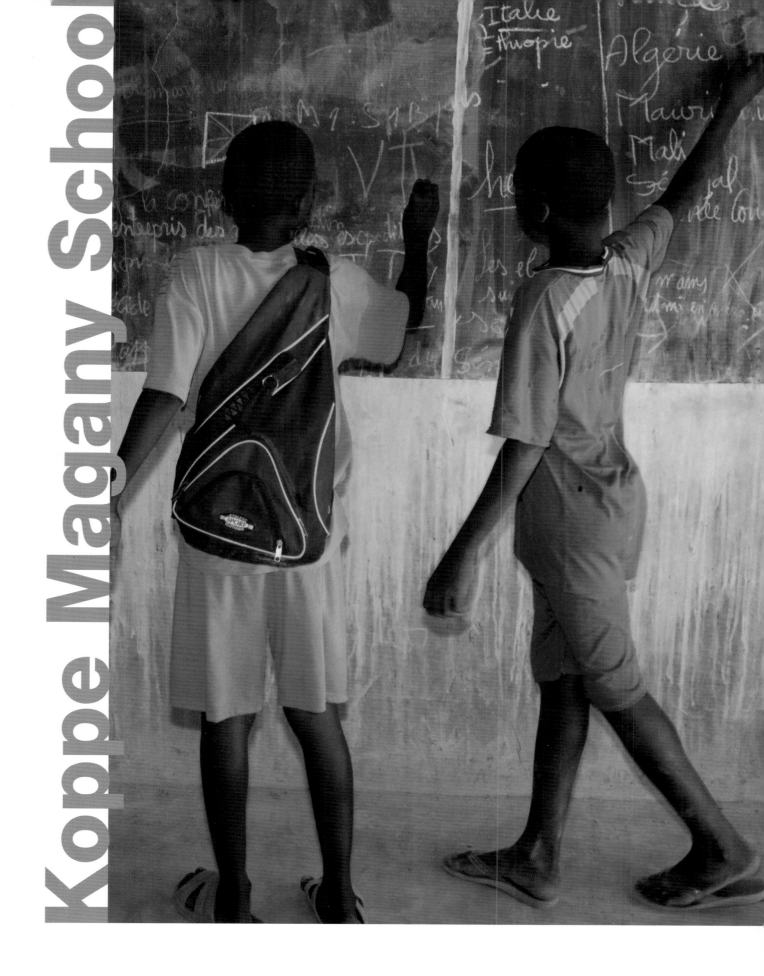

Koppe Magany School

Yaya
Sow

age 13

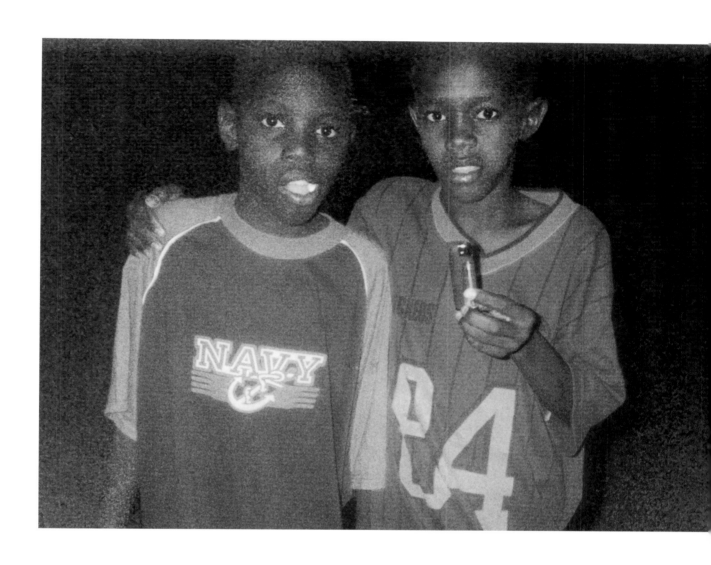

Above: My best friend, Abdo Ba, on the left, and me.

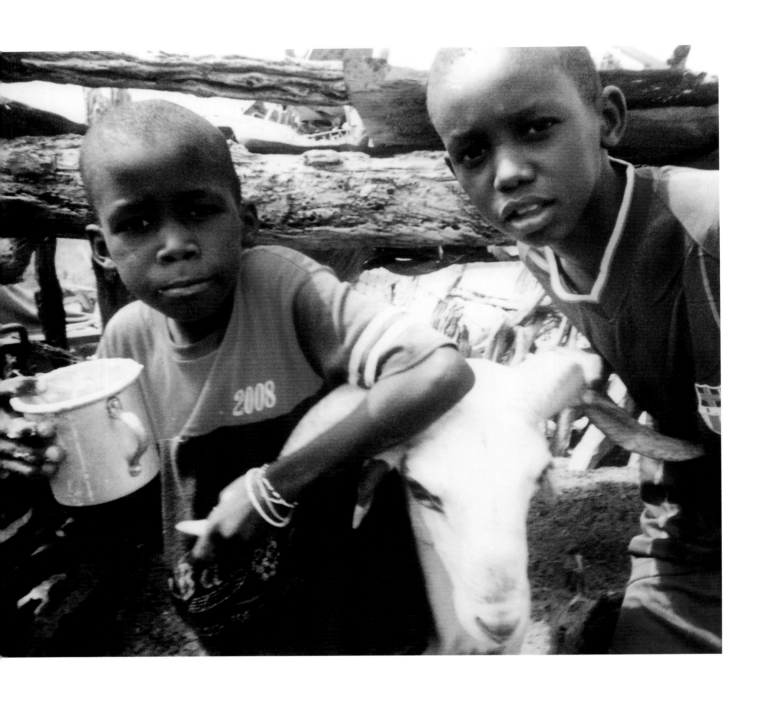

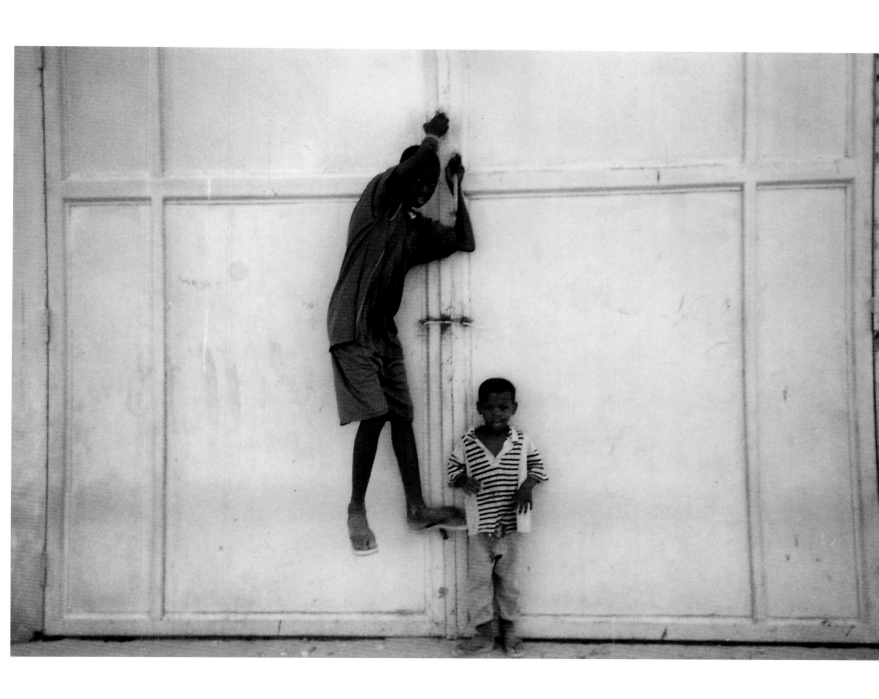

Left: Friends with one of our goats.

Above: I asked my friends to do something –
so one climbed up the door.

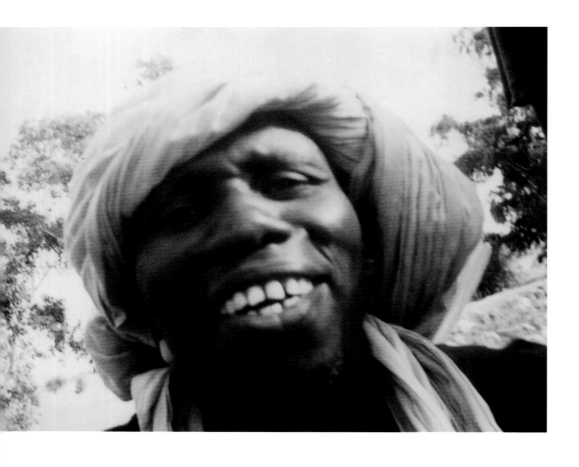

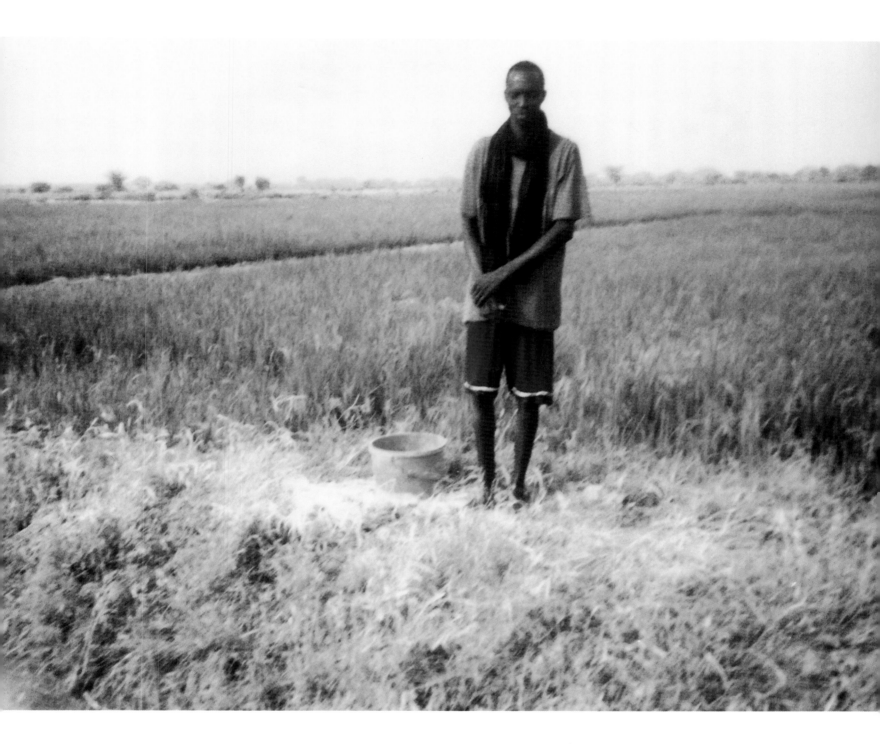

Left: This man likes to smile!

Above: The person in the field is Arison Sall. I took the photo because it is a rice field and I like to eat rice.

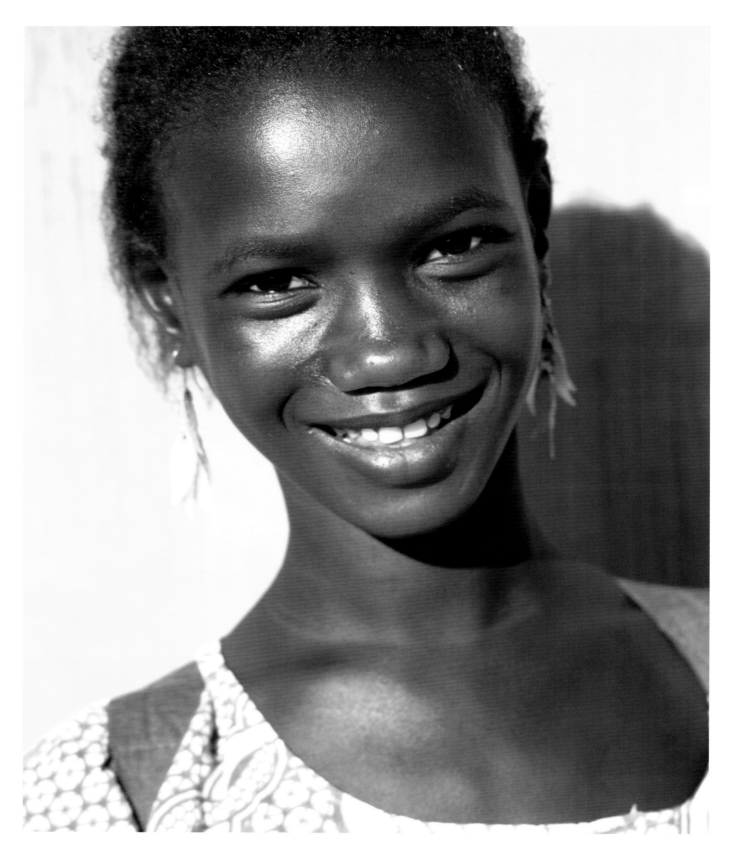

Aissata
Dah

age 12

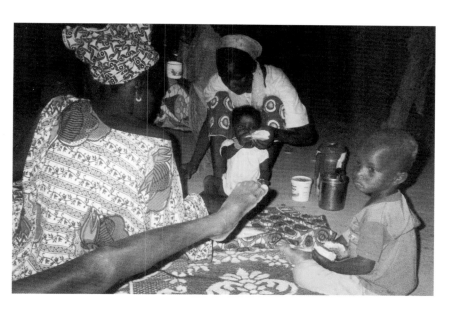

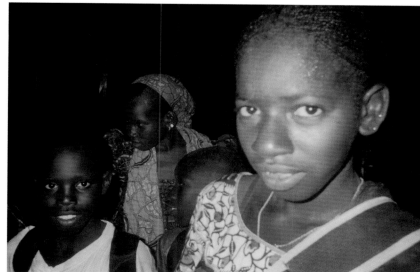

Left: These are my aunt, my little brother and two sisters. They are breaking the fast after Ramadan, eating bread and drinking coffee.

Right: On the right is my friend, Dhadia Sow.

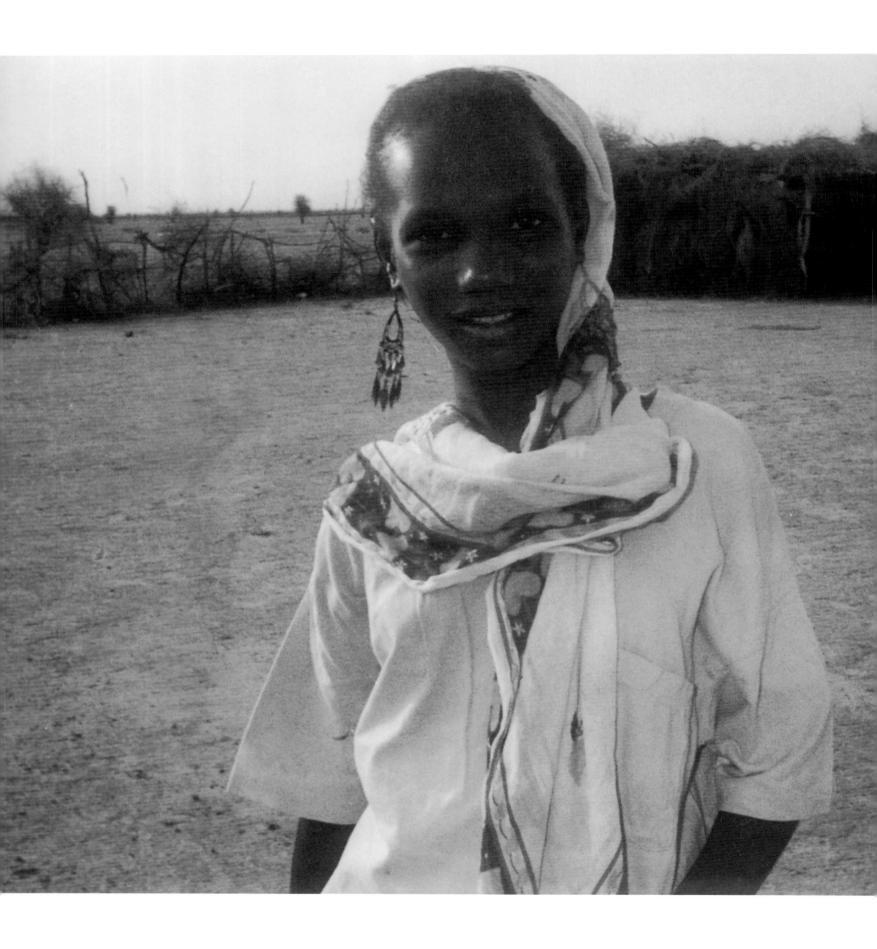

Left: This is a portrait of me! One of my friends took it.

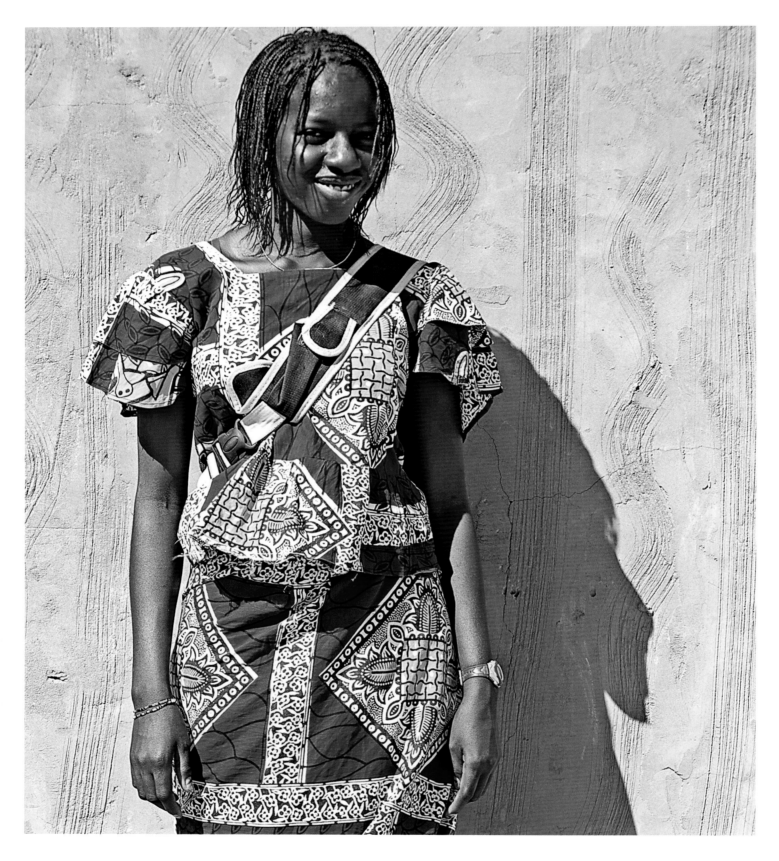

Diariata
Sall

age 13

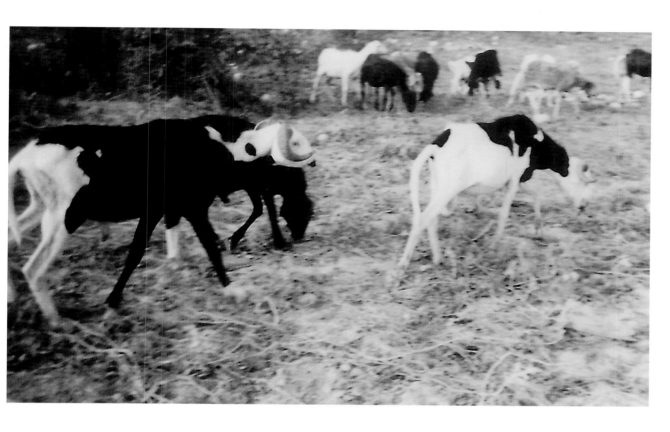

Above: These sheep are crossing a field where melons are growing. They should not be grazing there!

Below: Our family grows white watermelons in this field. We use the seeds to make haako [*soup*] in the rainy season.

Left: This is the compound where I live.

Above: My friend, Rabiata Sando Ba, posing for me in the rice field where she is working.

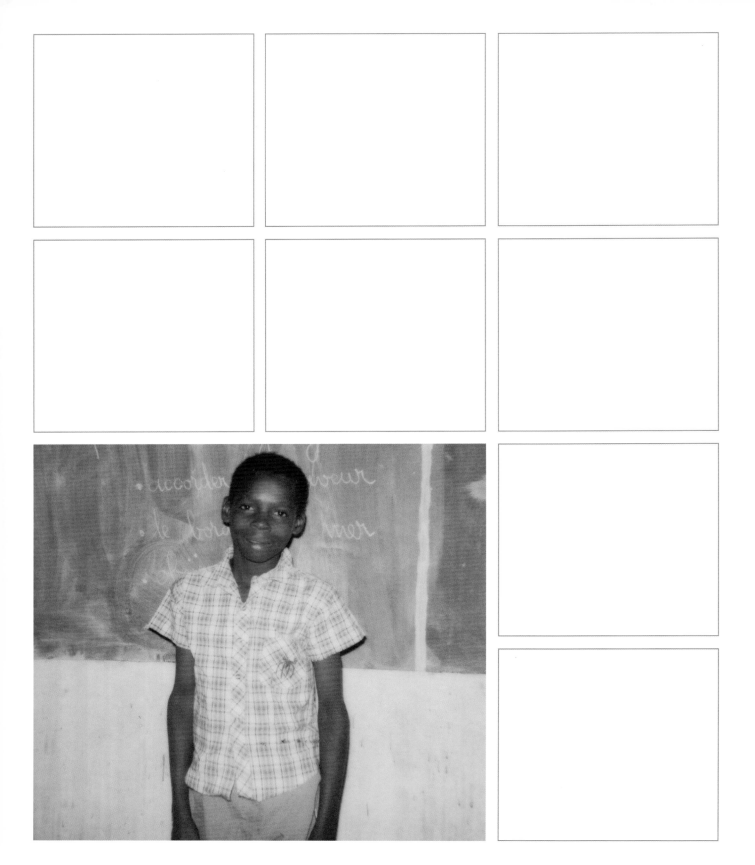

Seydou
NDia

age 12

Left: My little sister Saphara standing in my Mom's room.

Right: This is the owner of a boutique in the village. He opened it up so I could take his picture.

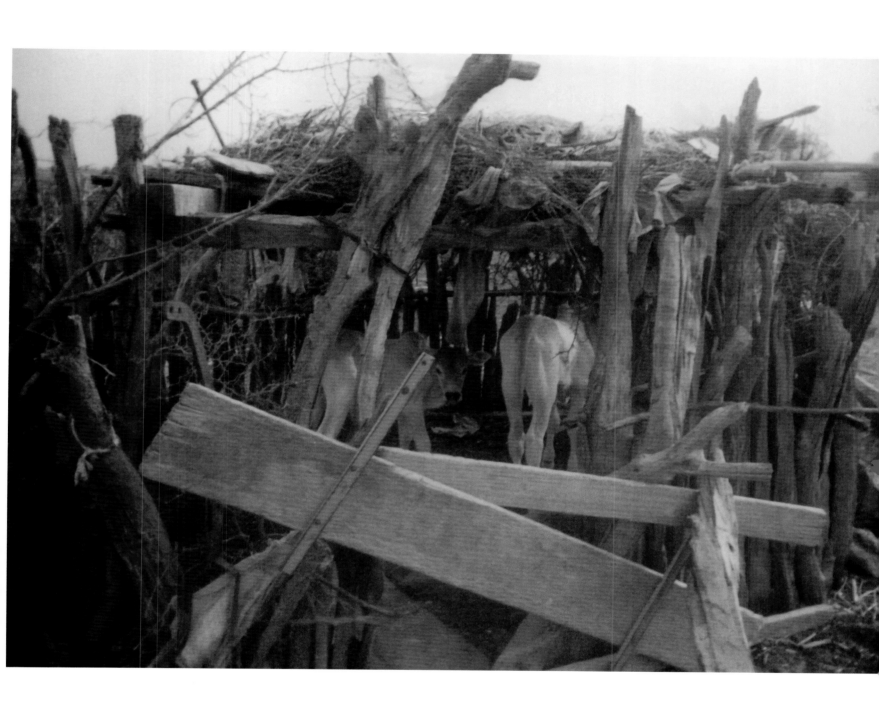

Left: This is while we are breaking the Ramadan fast. My aunt is breaking a watermelon by bouncing it on the ground. She usually sings a little rhyme as she does it.

Above: The cattle pen.

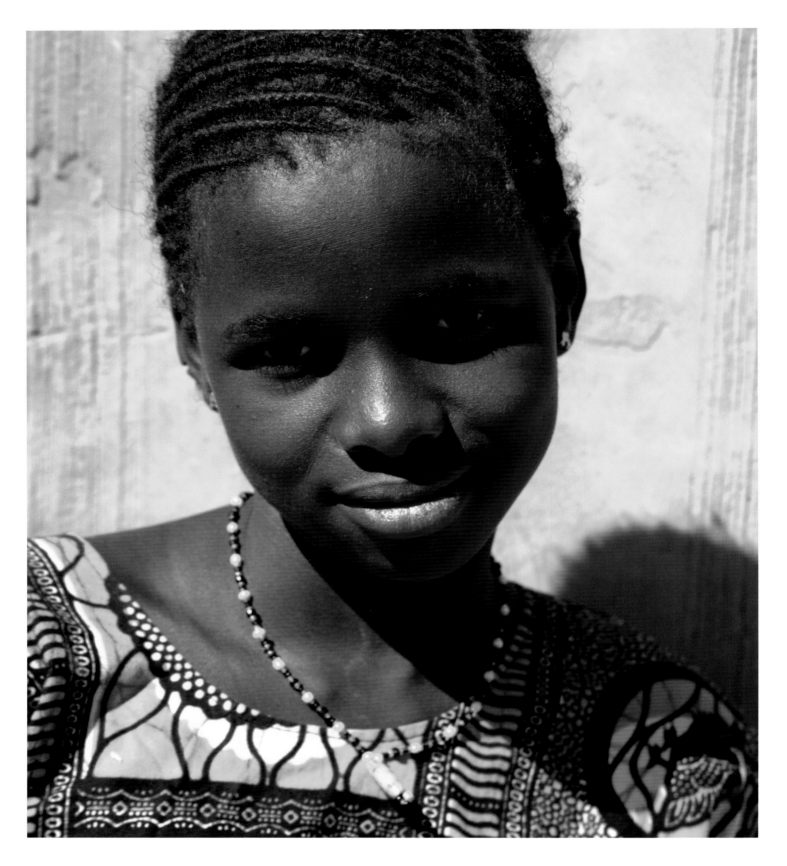

Dieynaba Wah

age 9

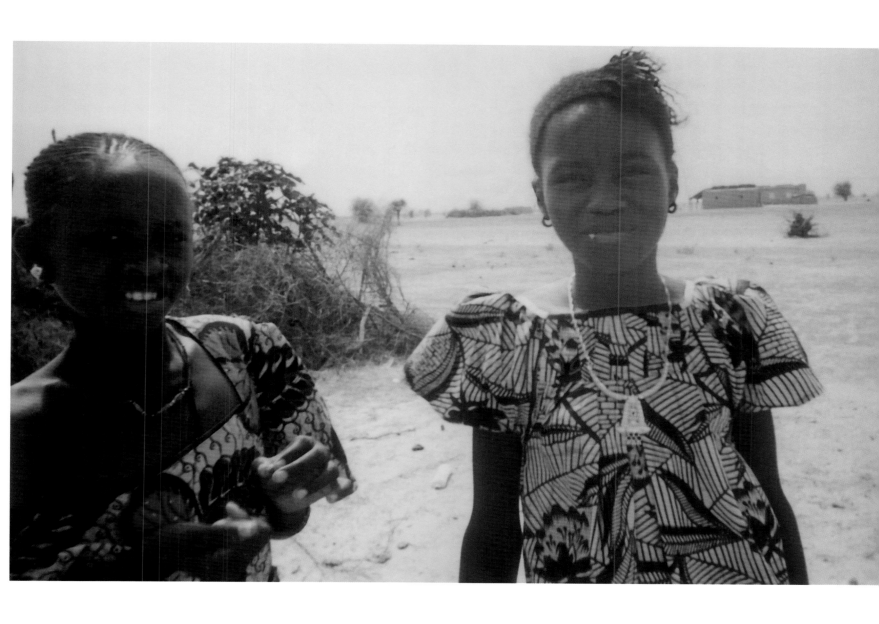

Above: The girl in the center, with the beautiful necklace, is my friend Howa NDia. She bought that necklace from a traveling salesman. The other girl is my younger stepsister.

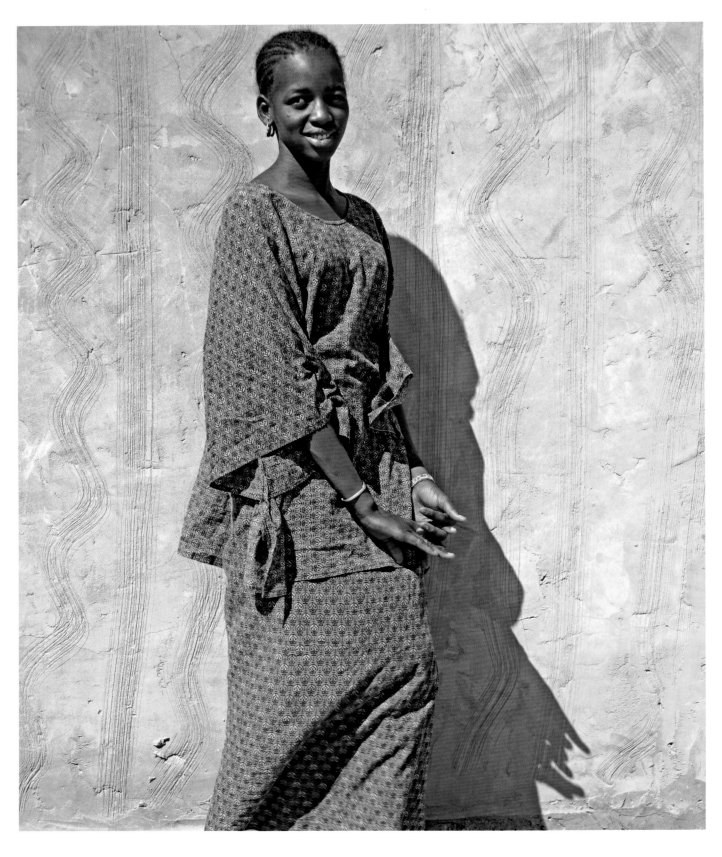

Rougui
Ba

age 10

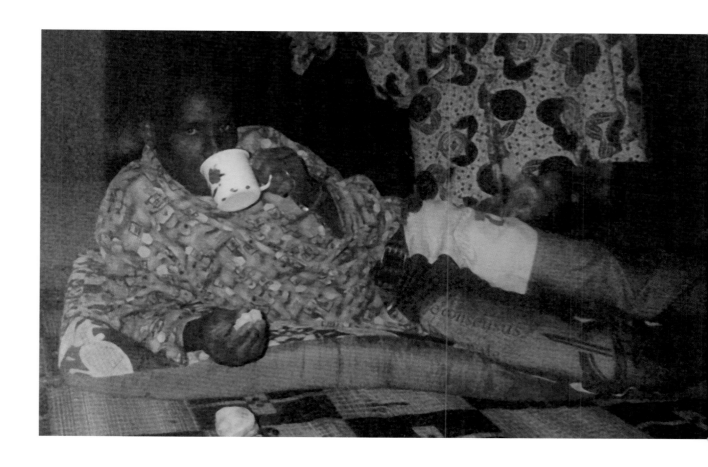

Above: This is my older brother with his wife standing behind him, having coffee and bread after the Ramadan fast. He sells bread in the village. We have the same father, but different mothers.

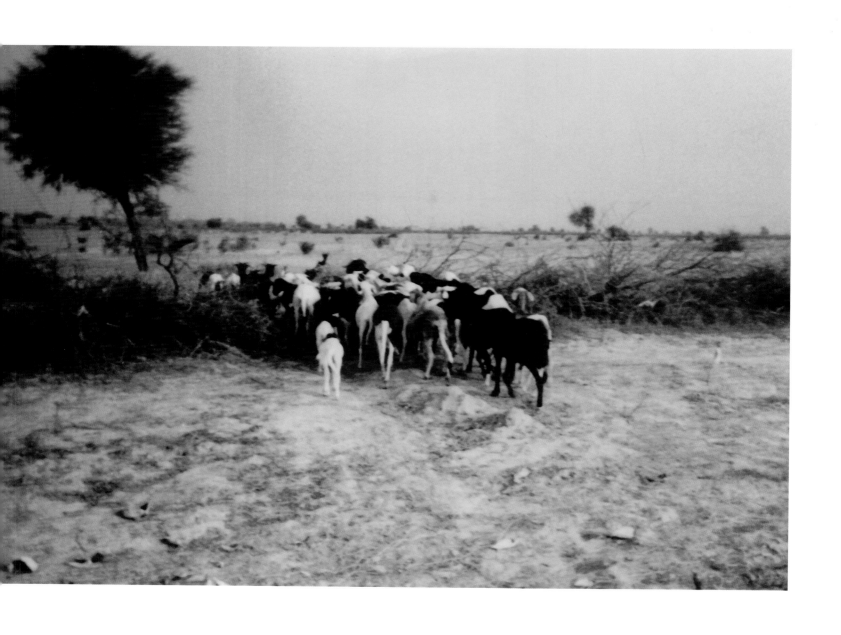

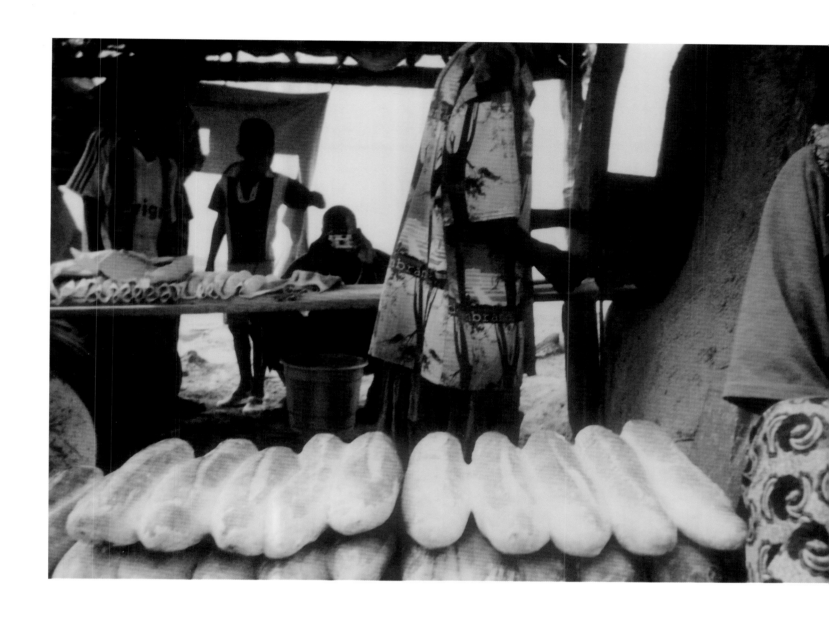

Left: We saw these sheep going into someone's field when we went out to cultivate the watermelons. We chased them away because they should not be there.

Above: My father is the village baker. He sells his bread for 100 CFA [about 22 cents].

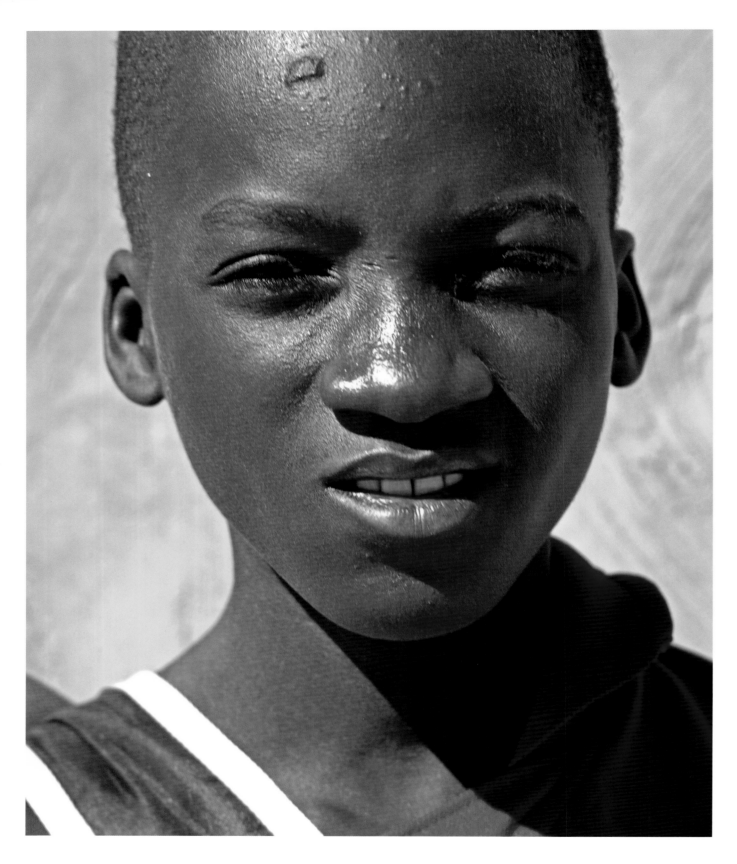

Amadou
Diallo

age 10

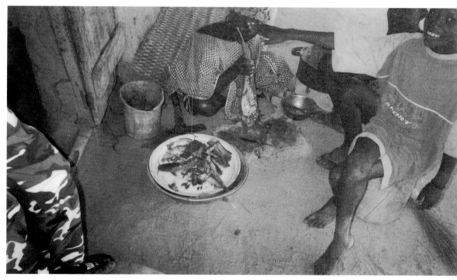

Above: This is the first picture I ever took! It shows a donkey and her baby, who she had just given birth to two hours before.

Below: My mother is preparing lunch, gutting fish she caught in a river. My two brothers, Mamadou Diallo and Seydi Diallo are sitting with her.

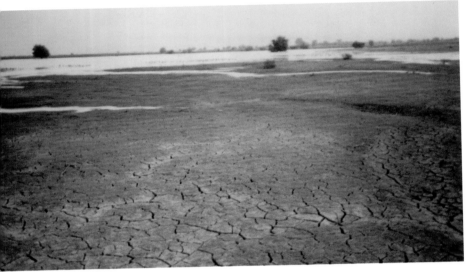

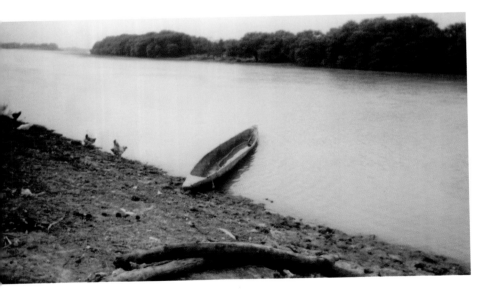

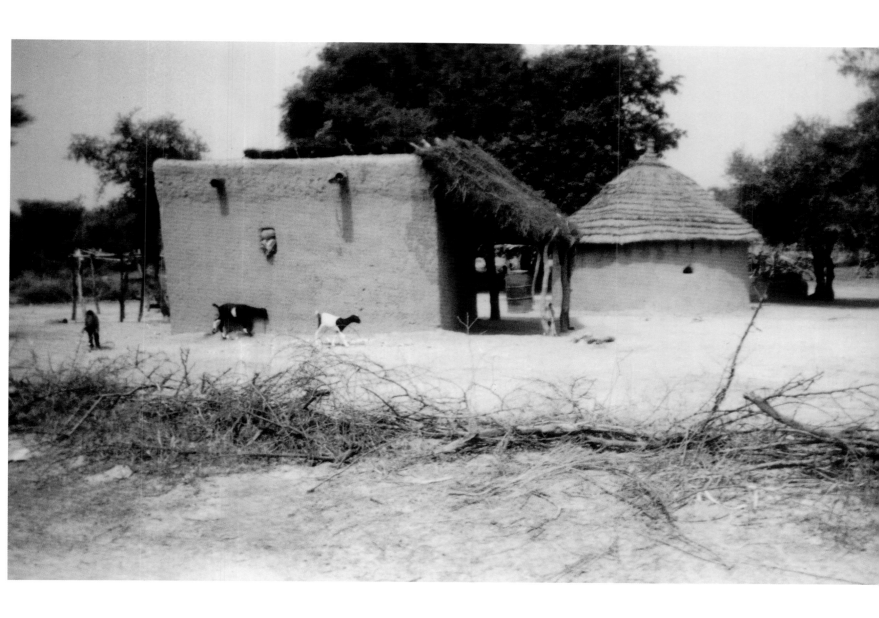

Left (top to bottom): This is a school in a nearby village. My village school is not open yet, but I enjoy going to this one.

During the hot weather, the ground gets very dry and cracks.

This is a boat we use to fish and to go across the river.

Above: Our house.

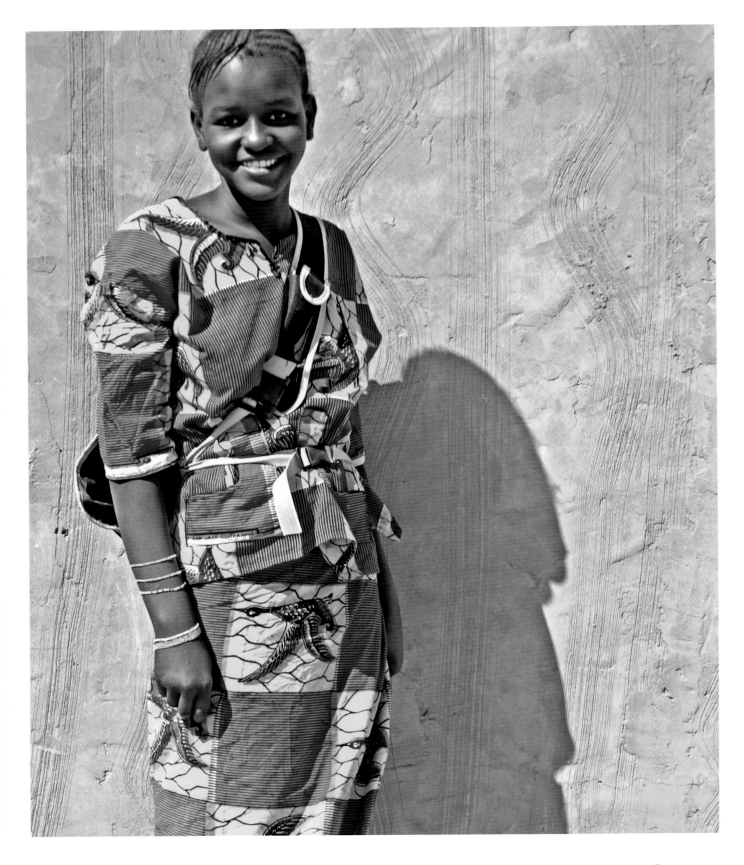

Fati
Camara

age 10

Above: My three friends with plants that grow near the riverbank. I asked them to stand there because I love the green color.

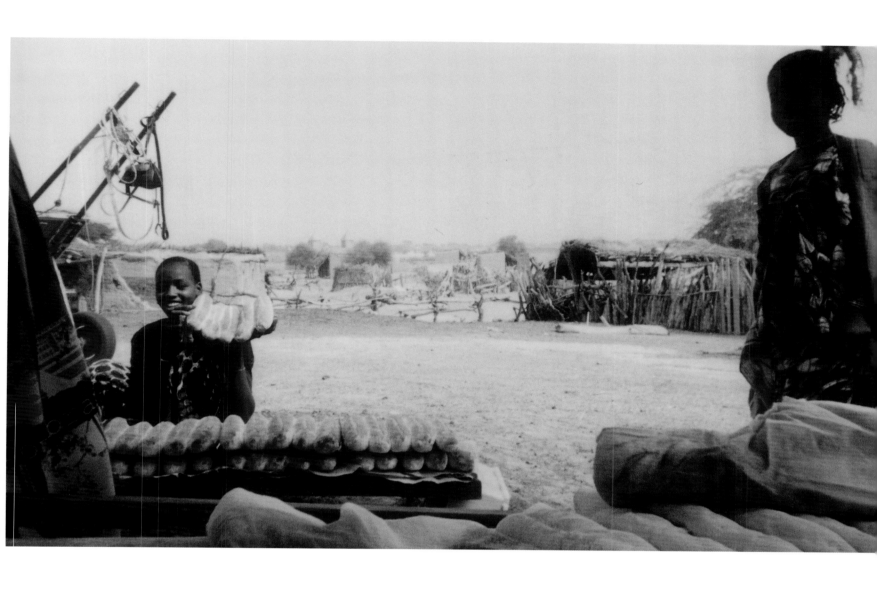

Left (top to bottom): My grandfather's horse is eating after finishing its work. We color the horse's tail with henna for good luck and safety.

This is my little brother, Abu, and my little sister, Fatimata.

Above: This is my compound with the well in the background. They are baking, but it is Ramadan, so because I cannot eat the bread yet, I took a picture of it..

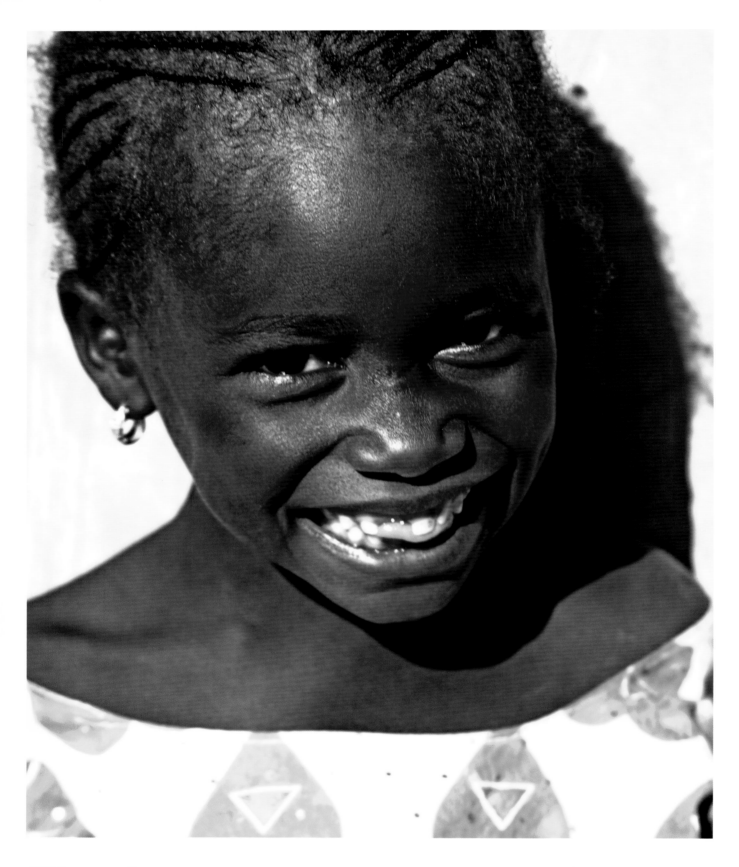

Fatim Ba

age 7

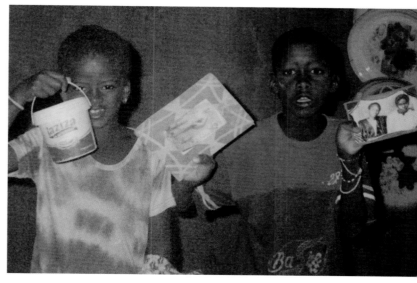

Above: I took this because I liked the tree.

Below: My older brother is on the right holding up photos of my Mom. My big sister is holding up our butter, because we have it. We all have the same mother and father.

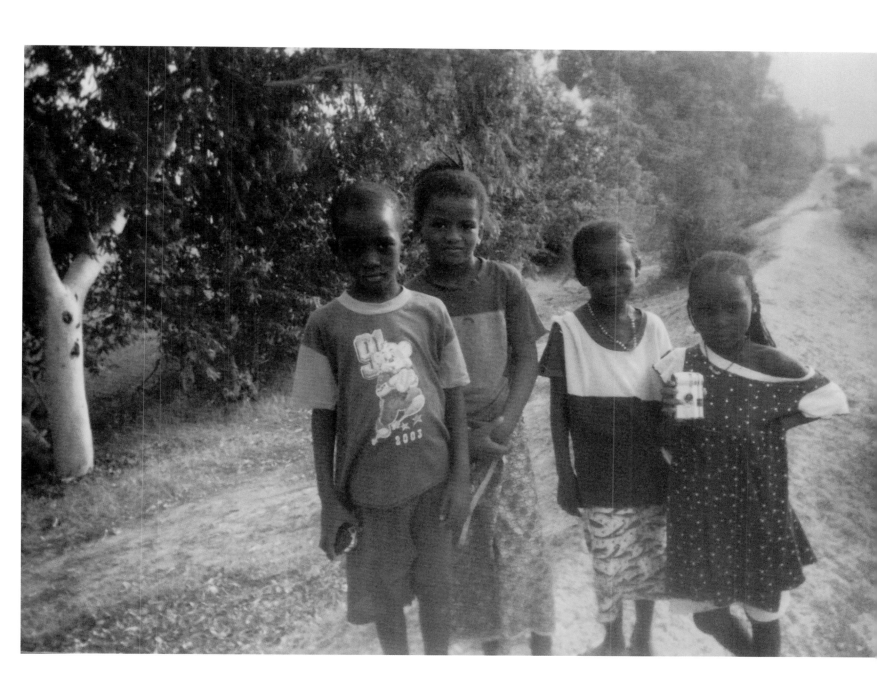

Left: That is the river in the distance.

Above: My older sister and some friends.

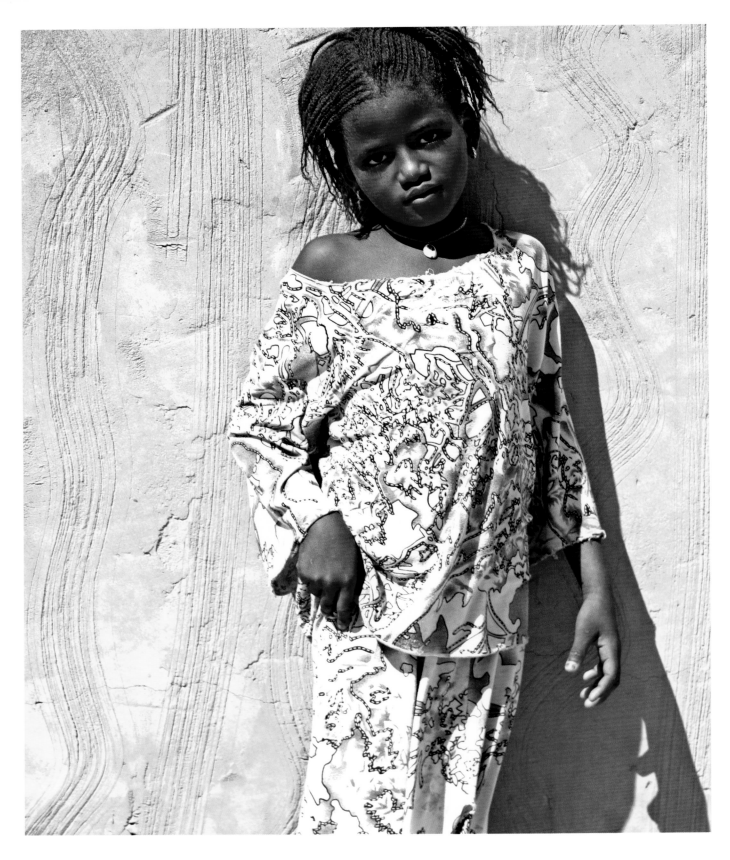

Dulay
Sow

age 7

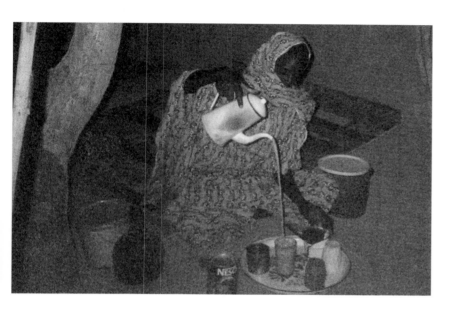

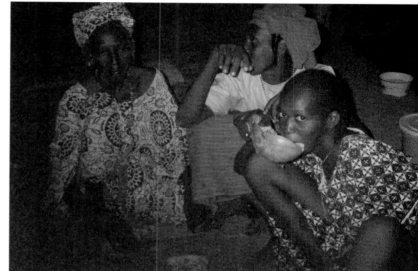

Left: My aunt preparing coffee for after the fast.

Right: My older sister, Kunba Ali, is eating watermelon from my aunt's field to break the fast.

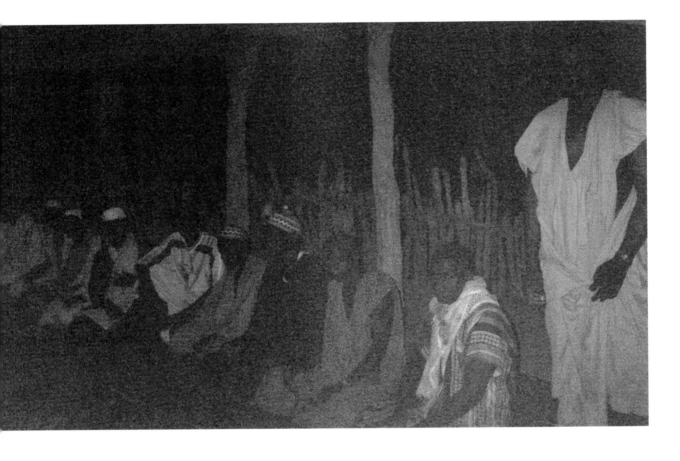

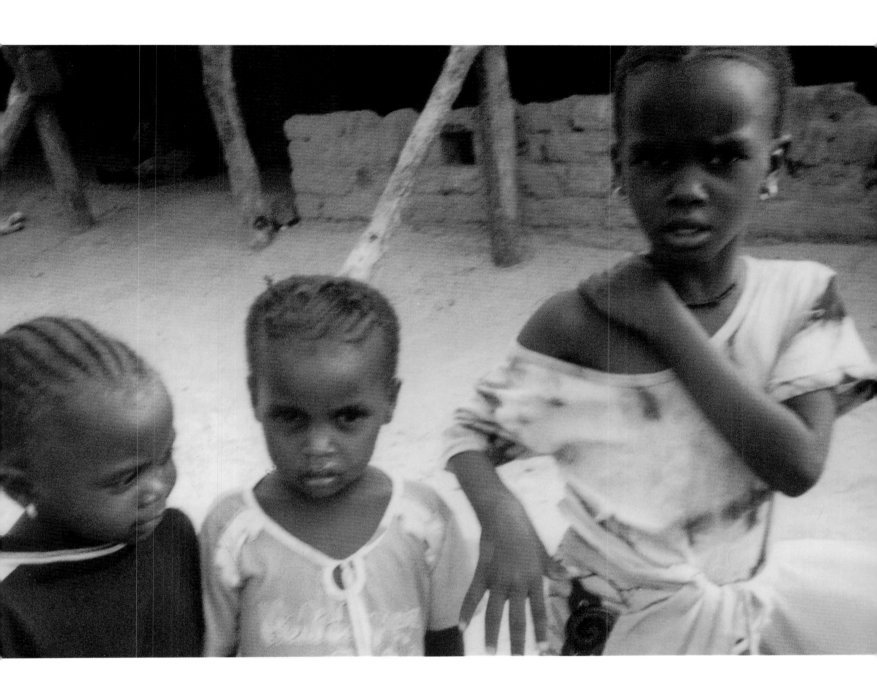

Left: My father (in blue) breaking the fast. The whole village comes together around 8:30 to go to pray in the mosque, and then they have the one big meal of the day.

Above: These three children don't know who their parents are. They all have different last names. They live in our compound and my family is taking care of them.

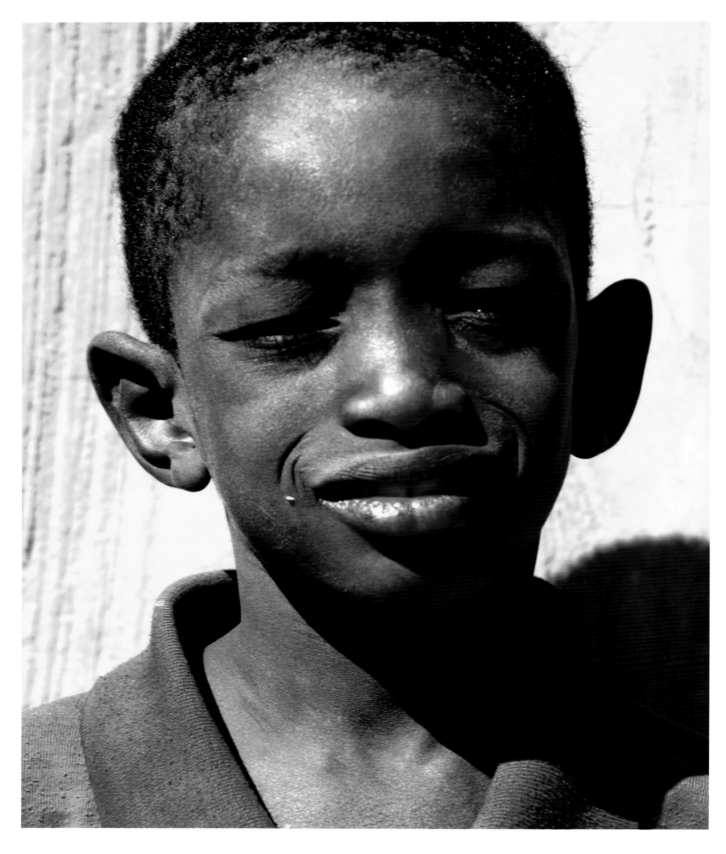

Mamoudou Ba

age 7

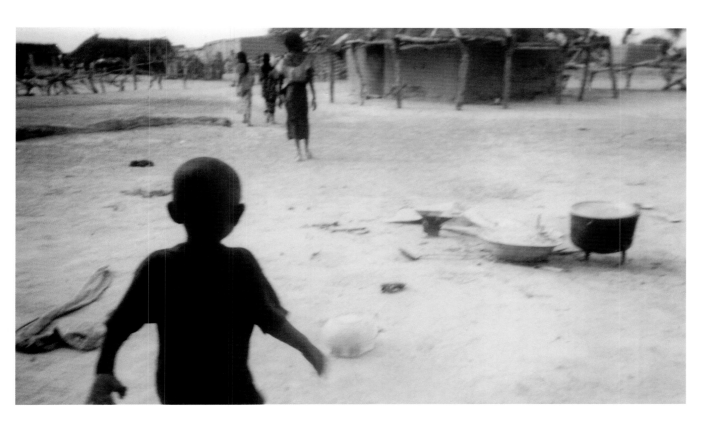

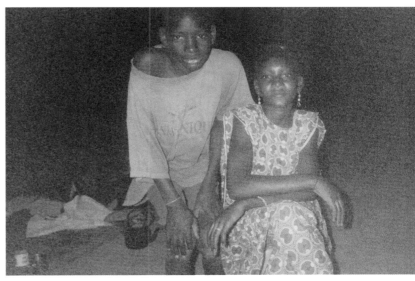

Above: The boy on the left is my little brother, San Ba. He is in our compound, and something is cooking in the pot on the right.

Below: This was taken in the evening. They are my brother and my aunt.

Next Page: This is my older sister, Acha Ba, my little brother San Ba, and Seydo Sow, in our house.

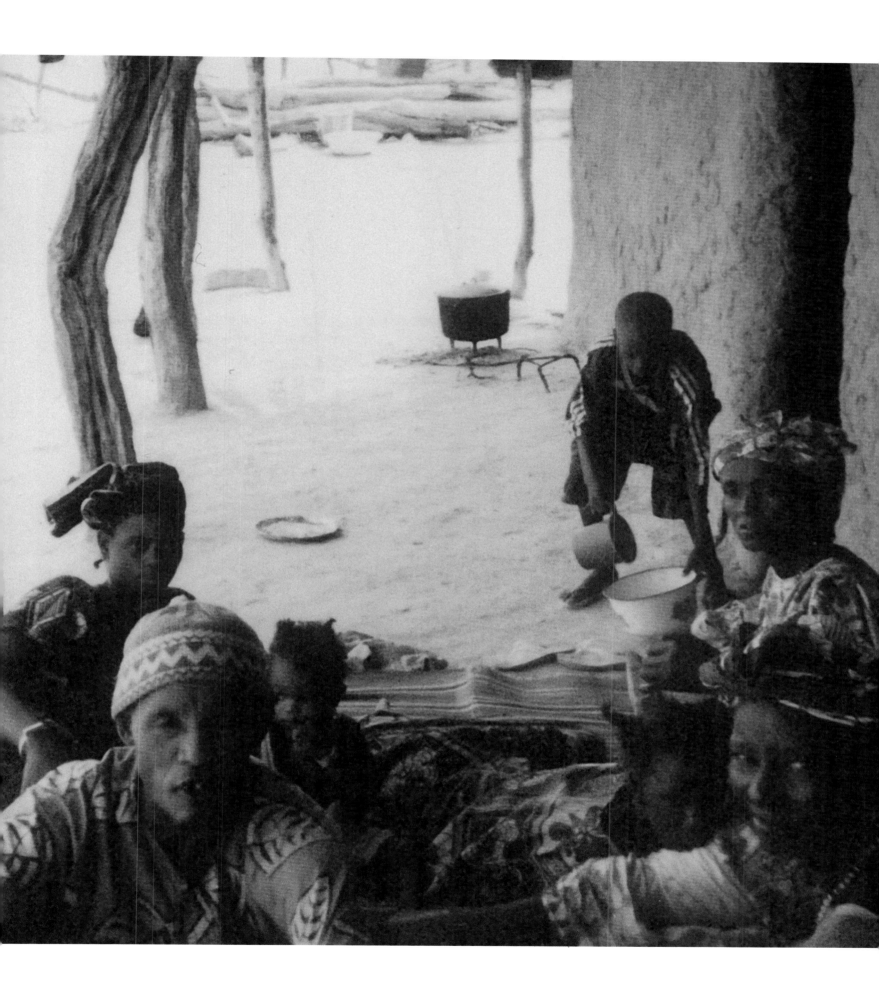

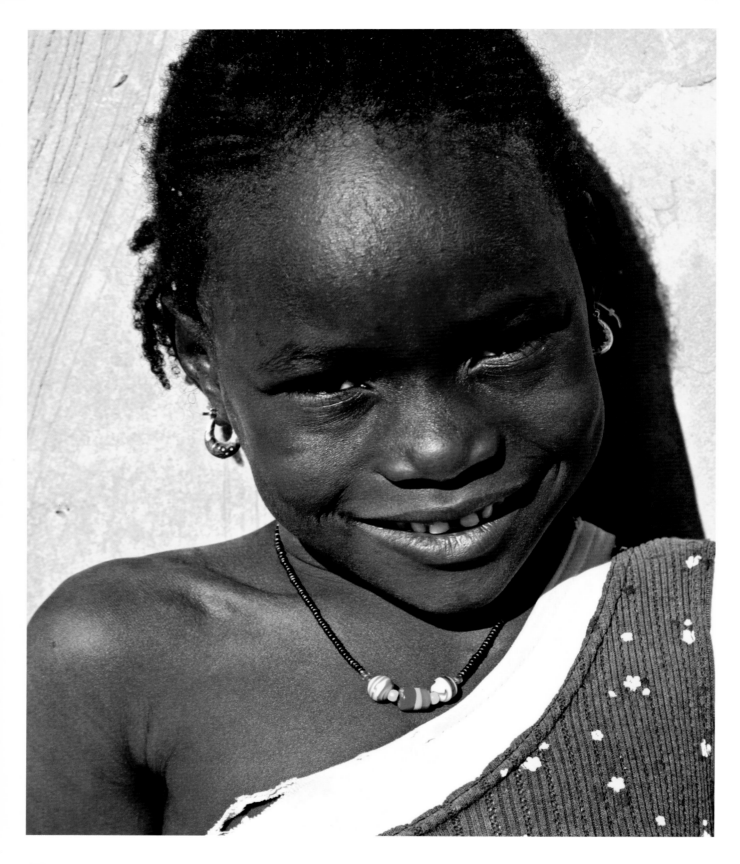

Bineta Ba

age 7

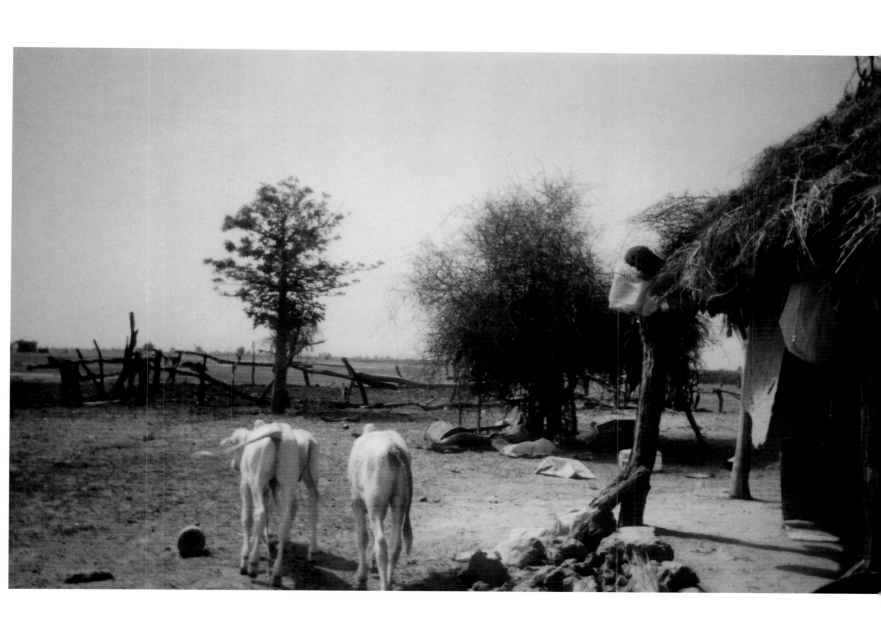

Above: My house, with my Dad's cows.

Left: I took this photo because I liked the chickens!

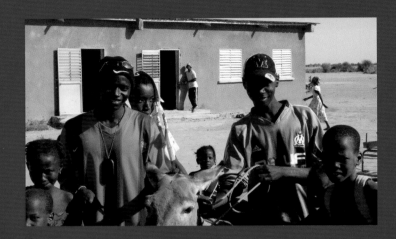

Located in the Walo, an agricultural area, Ngane has an enrollment of 137 students: 94 girls and 43 boys, drawn from five villages whose population numbers approximately 1,700. There were five teachers at the school and the students attended six grades. The director of the school was Hamadin Dianka, and his fellow teachers were: Ibrahima Beye Dieye, Samba Diouf, Fanding Dieye Diouf, Abdoul Aziz Sow. The cooking crew was made up of four women, Kardiata Dioulde Dem, Aissata Demba Mbodj, Aissata Biran Diaw, and Aissata Ba.

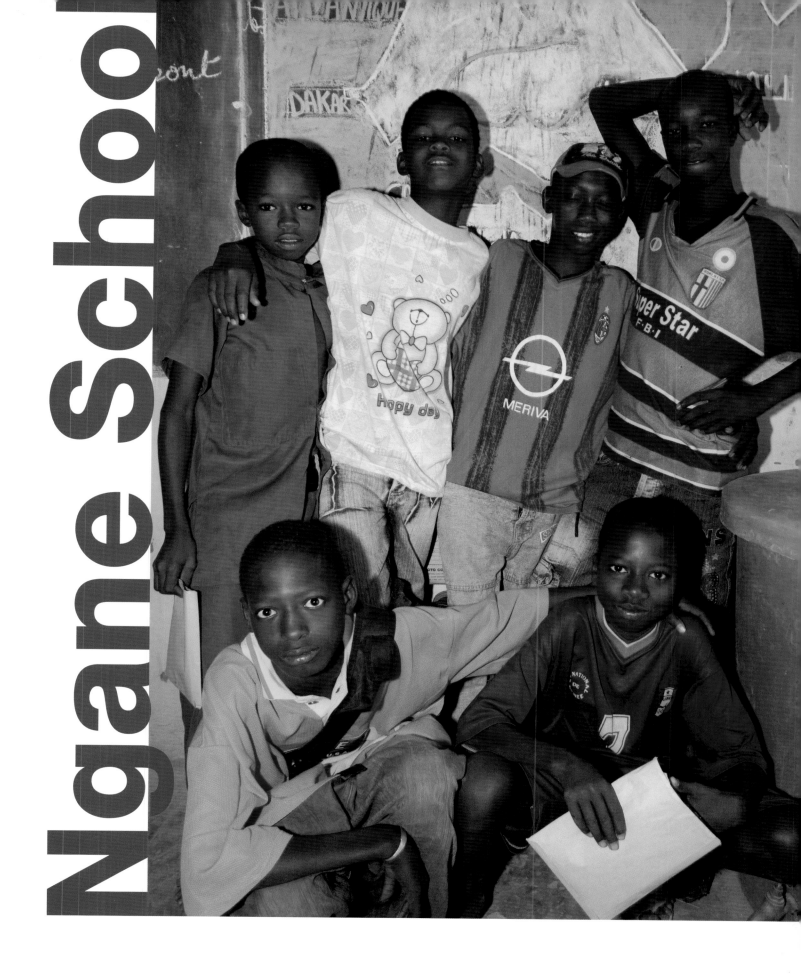

Ngane School

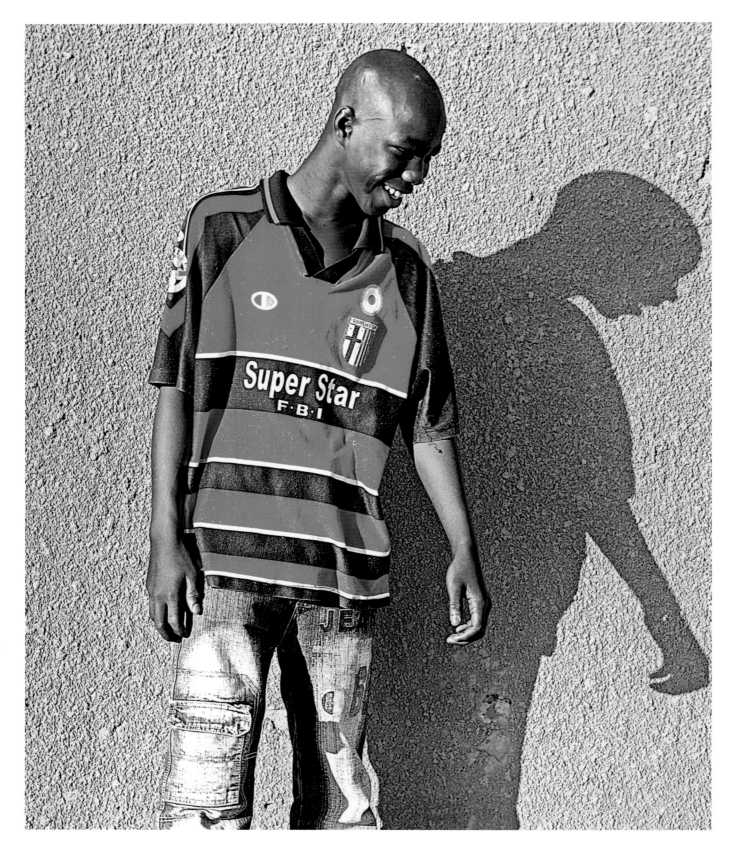

Oumar Housseynou Deme

age 12

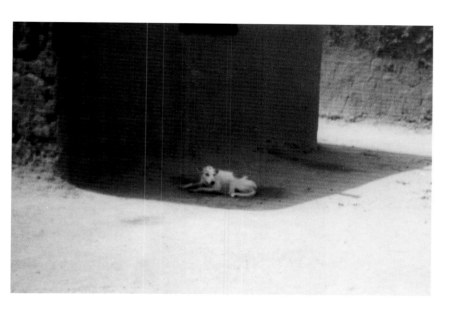

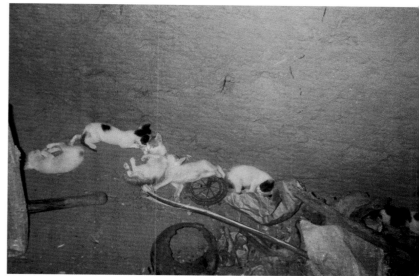

Left: That's my friend's dog, taking a break in the shade. He works hard and I like him.

Right: These are my pet cat's kittens. They're in my house.

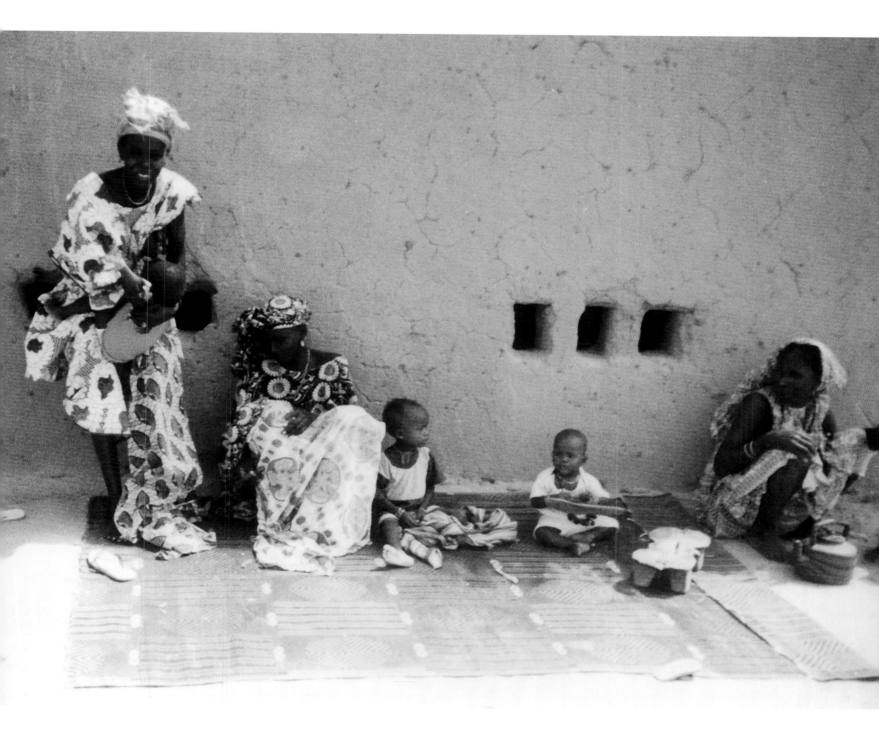

Above: Everyone is at my friend's house.

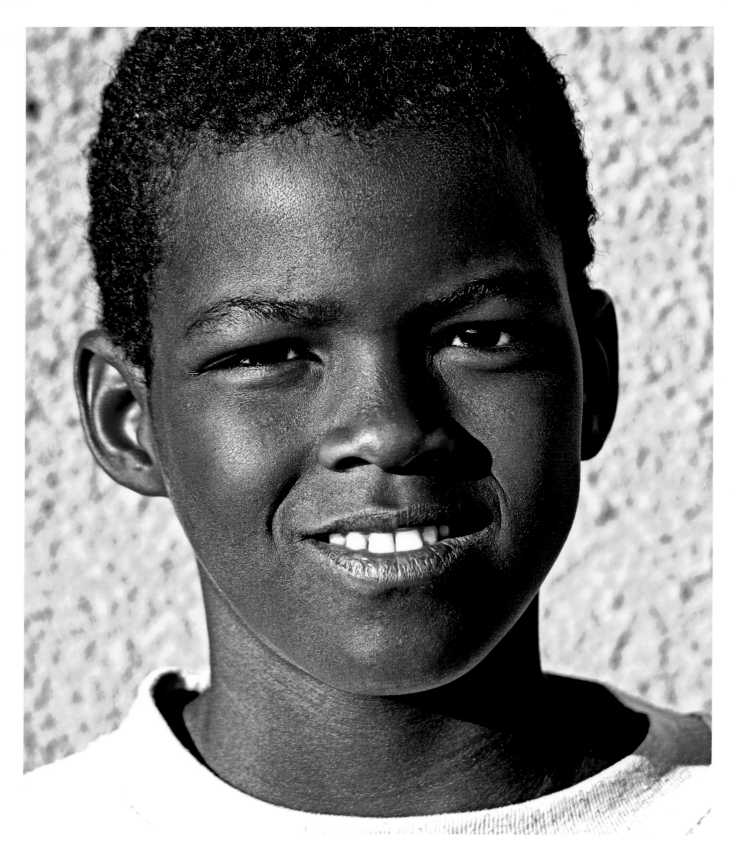

Tidiane
Drame

age 11

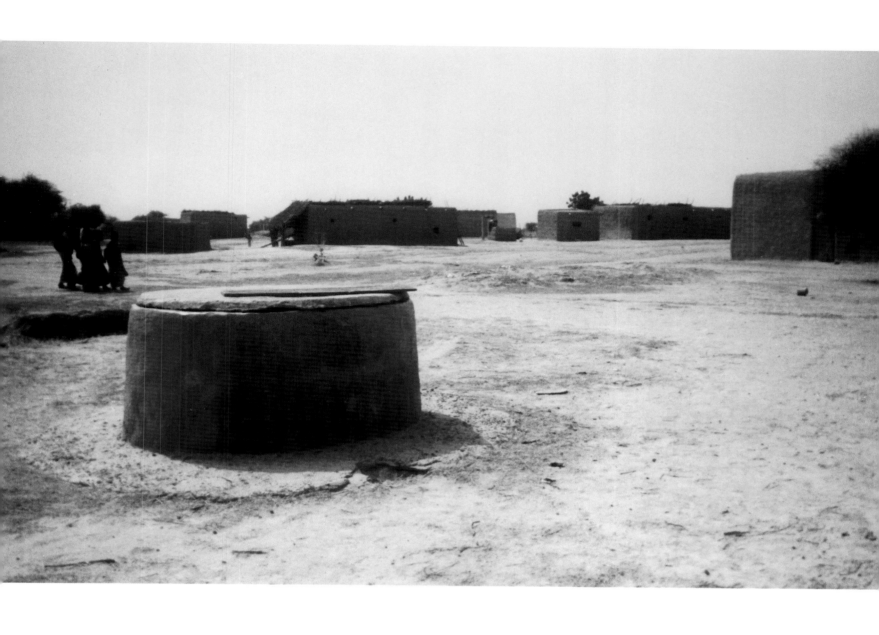

Above: Our village well. It is very important.

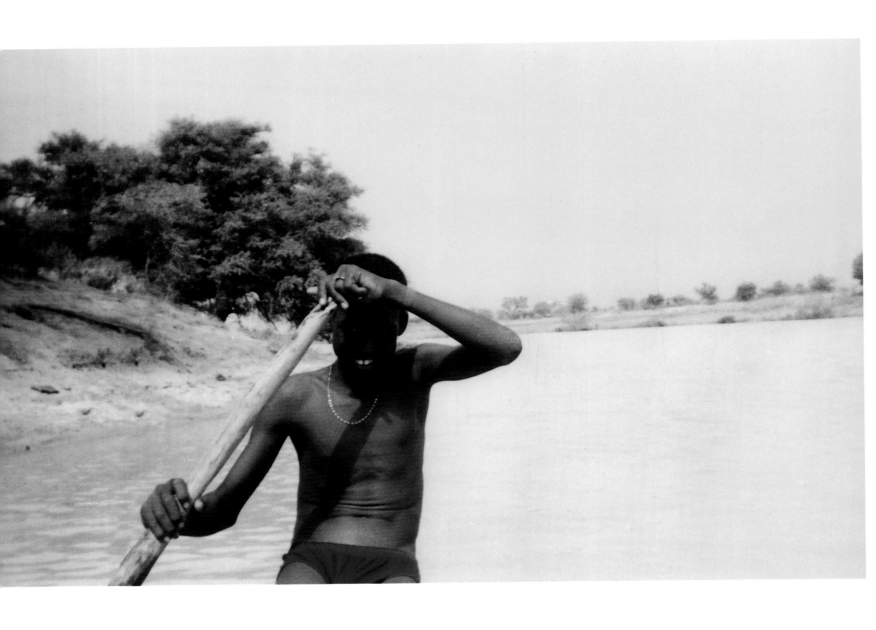

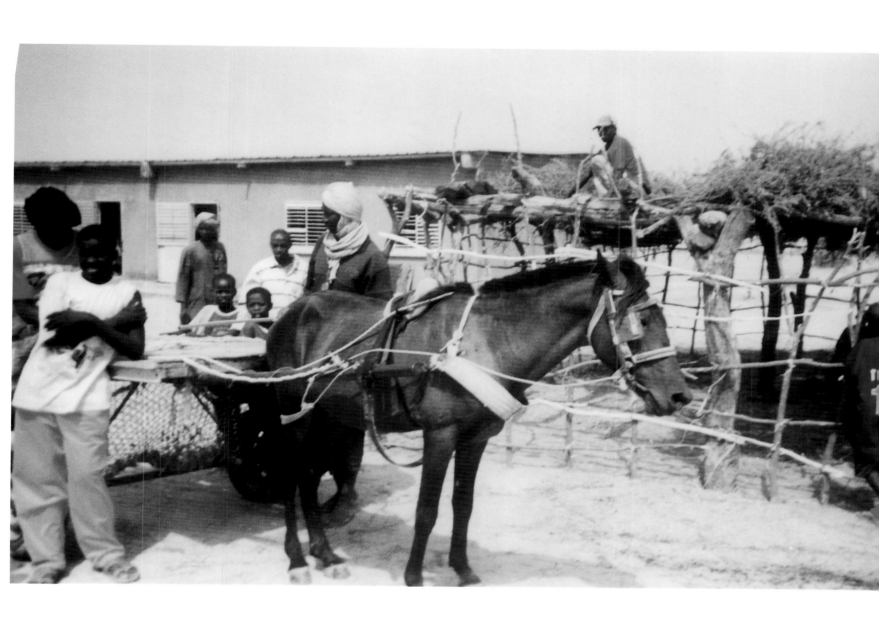

Left: Staying cool on the river.

Above This is at my school. My friend's horse is pulling a cart bringing wood to build a new classroom.

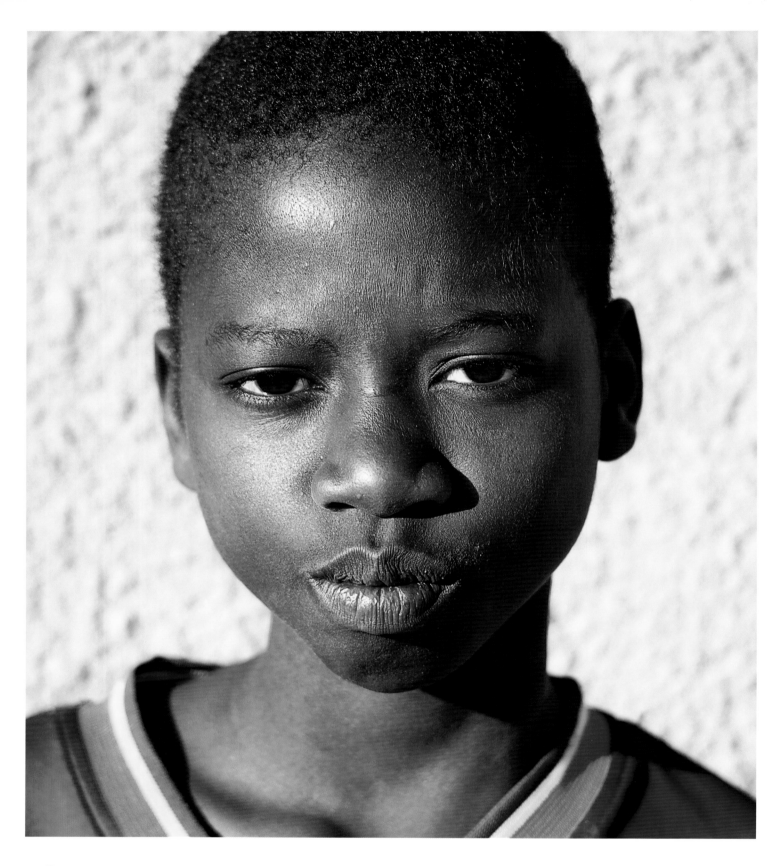

Oumar
Deme

age 10

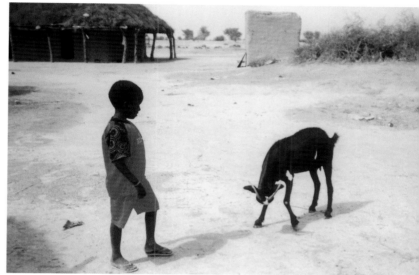

Left: This is me and my little brother.

Right: My little brother and his goat, in our compound.

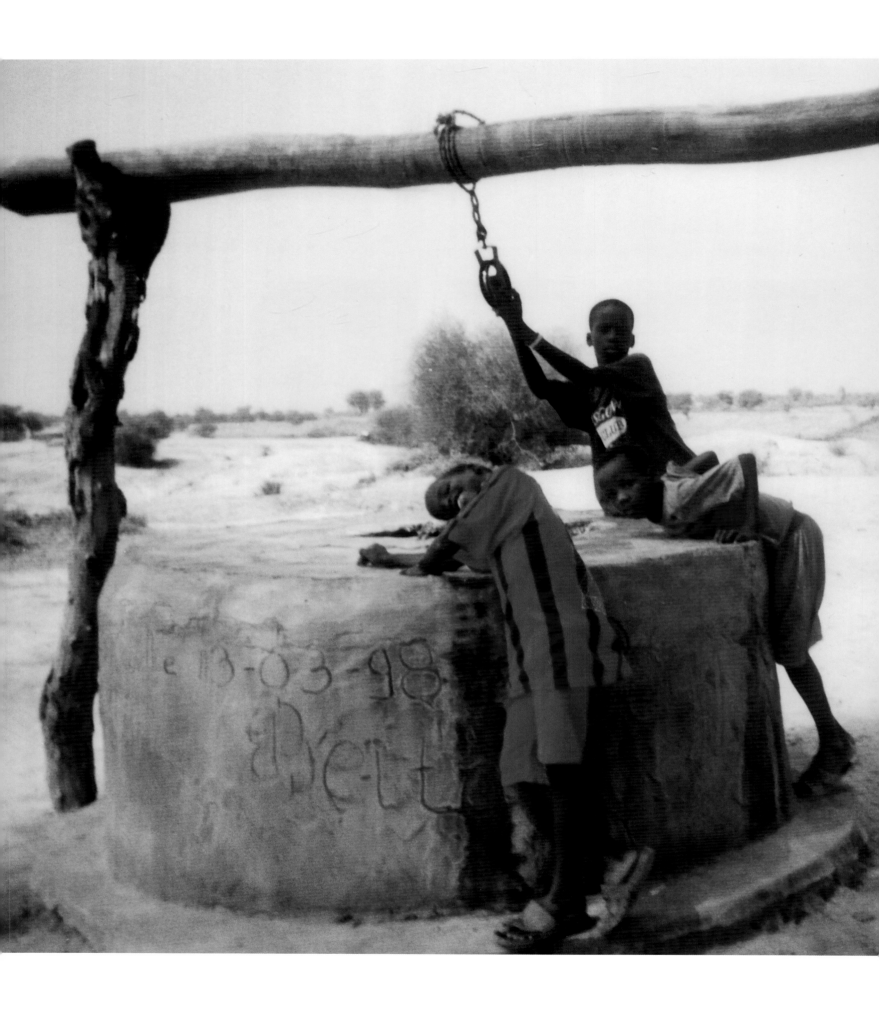

Left: We're at the well getting water for school.

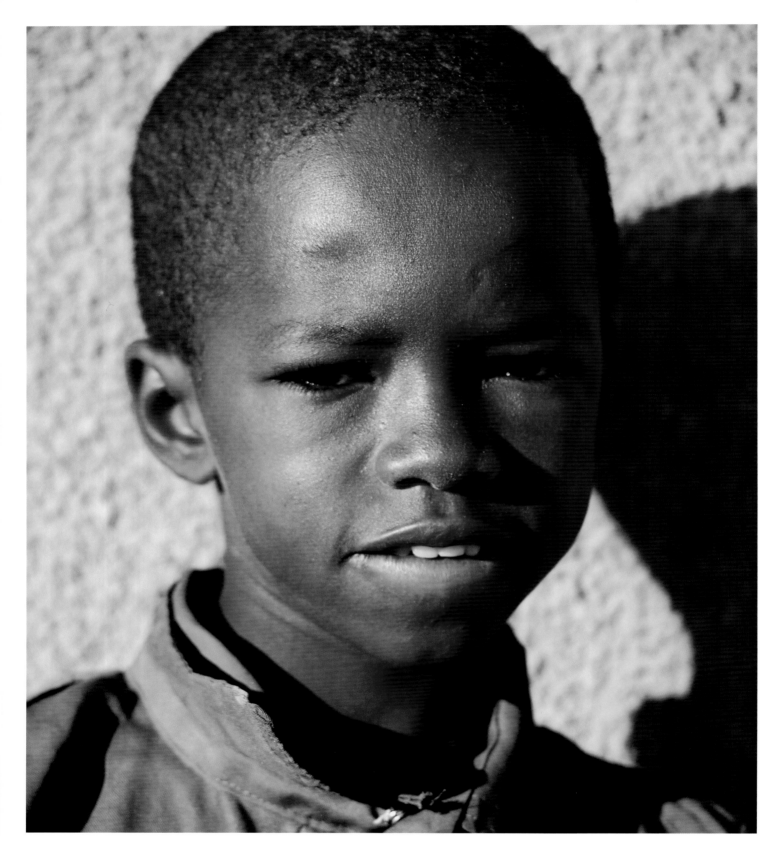

Oumar
Mamadou Aw

age 10

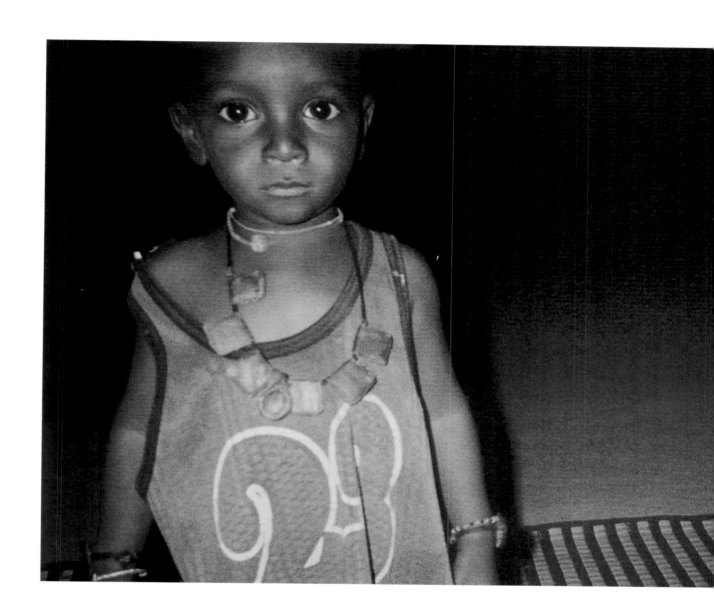

Above This is my little brother, Demba Aw, wearing gri-gri to keep him healthy.

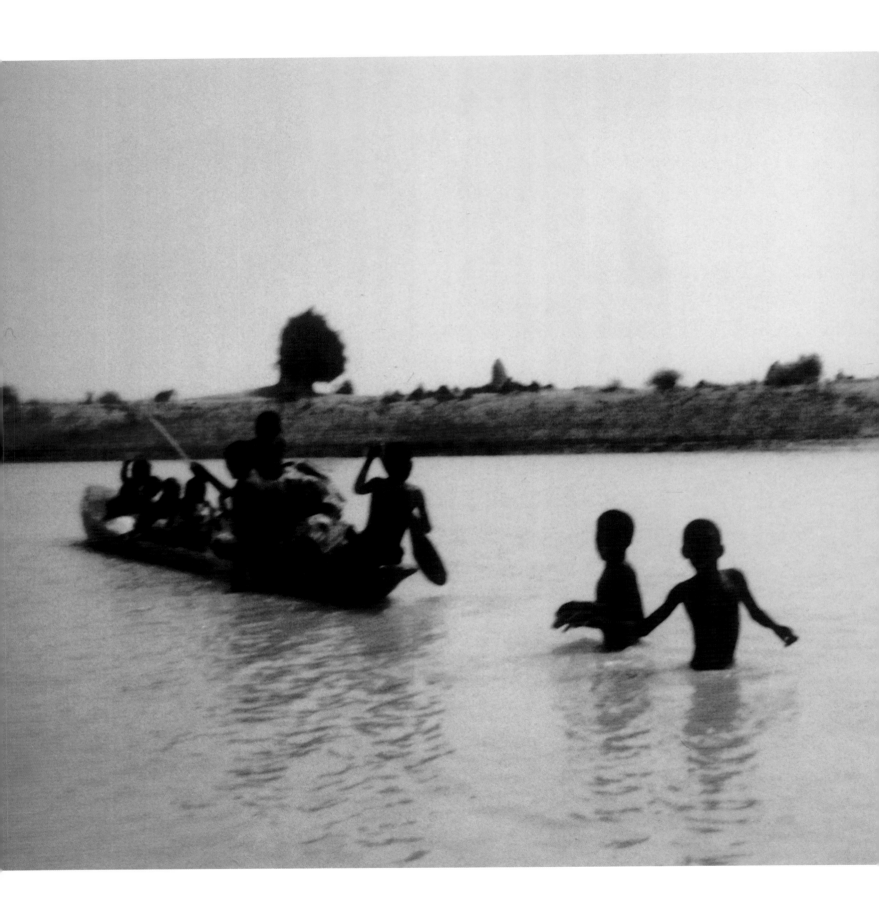

Left: This is my family's pirogue that we use to take people across the river. In front are two of my friends who like to catch fish.

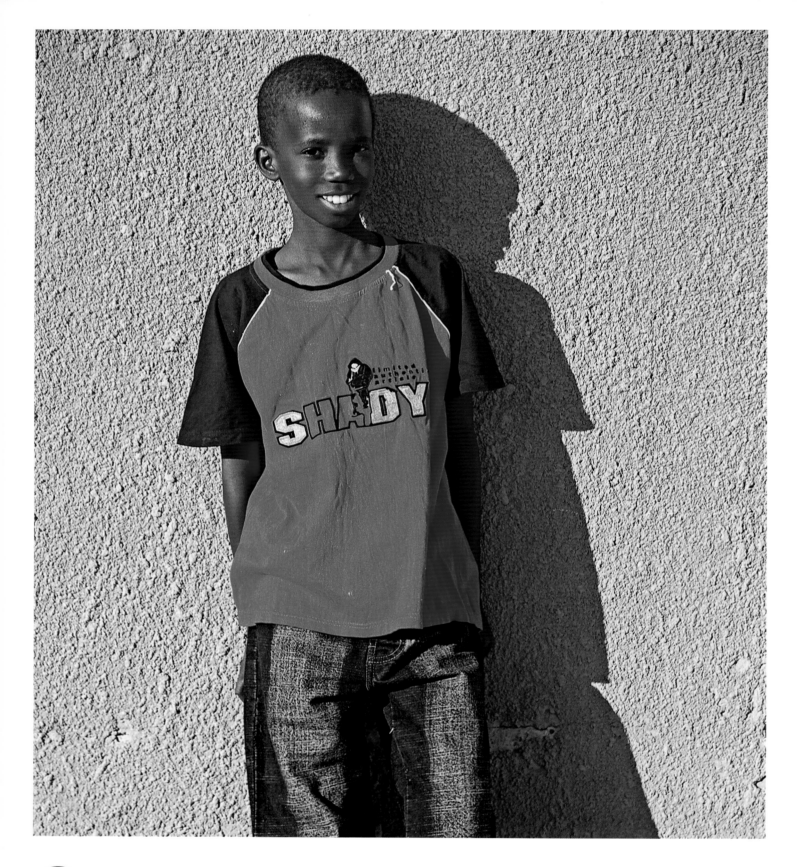

Oumar
Amadou Wah

age 10

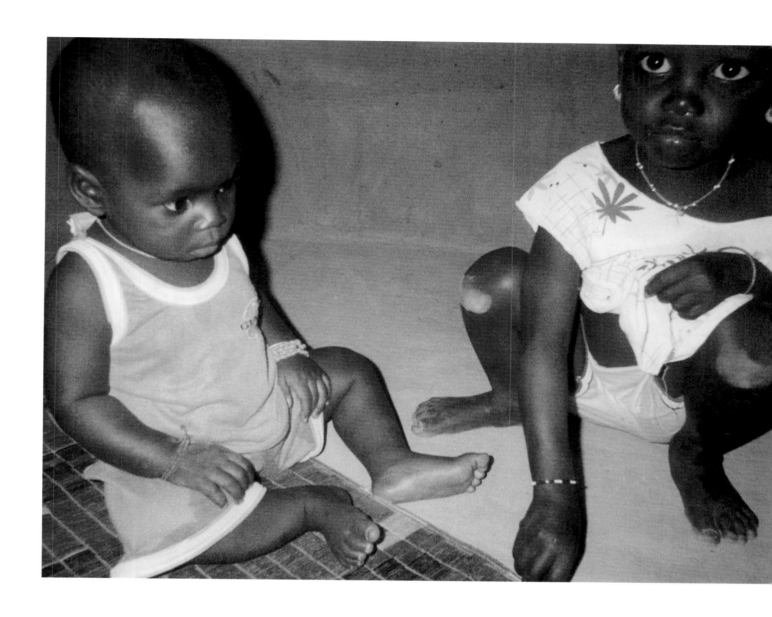

Above: This is my little brother Moussa Sy and my little sister Acha Sey in my house at night.

Left: I asked my friend to pose for me.

Above: These are all the baby sheep at my family's house. My dog is sleeping in the background.

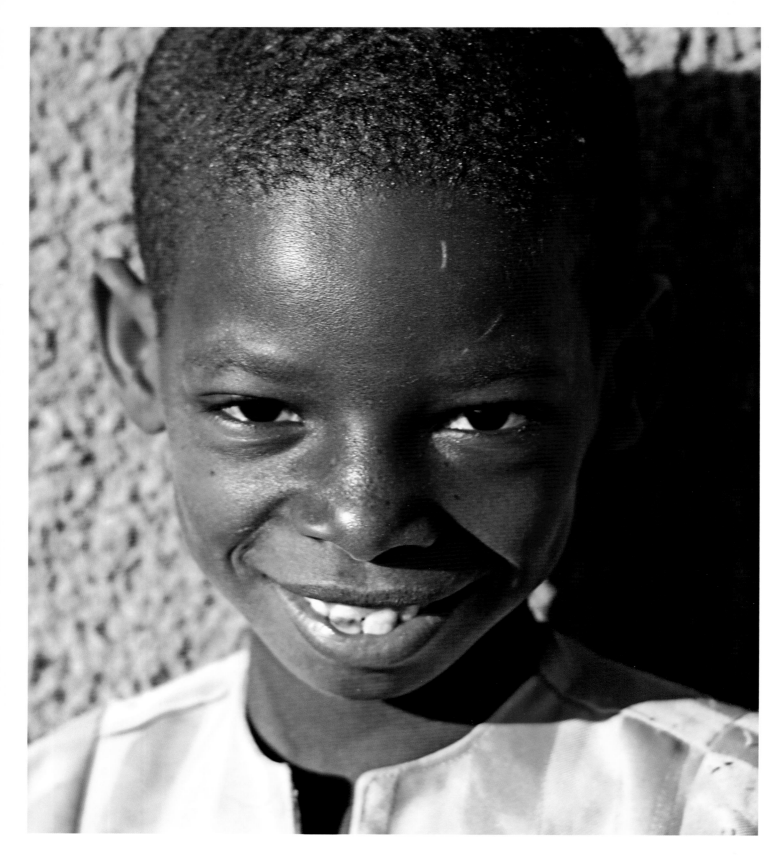

Souleymane Sall

age 10

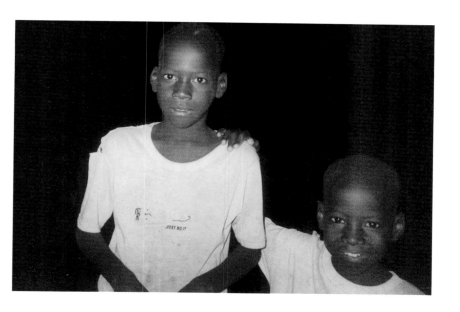

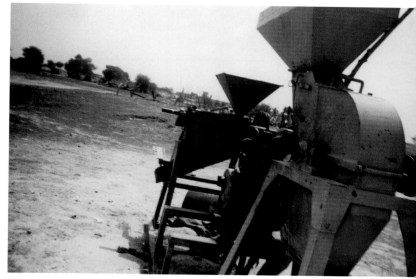

Left: My friend Amadou and his little brother.

Right: This is the machine my family uses to grind rice and millet. It belongs to us.

Next Page: The girl in blue is my sister, Fatu Sall, with her friends.

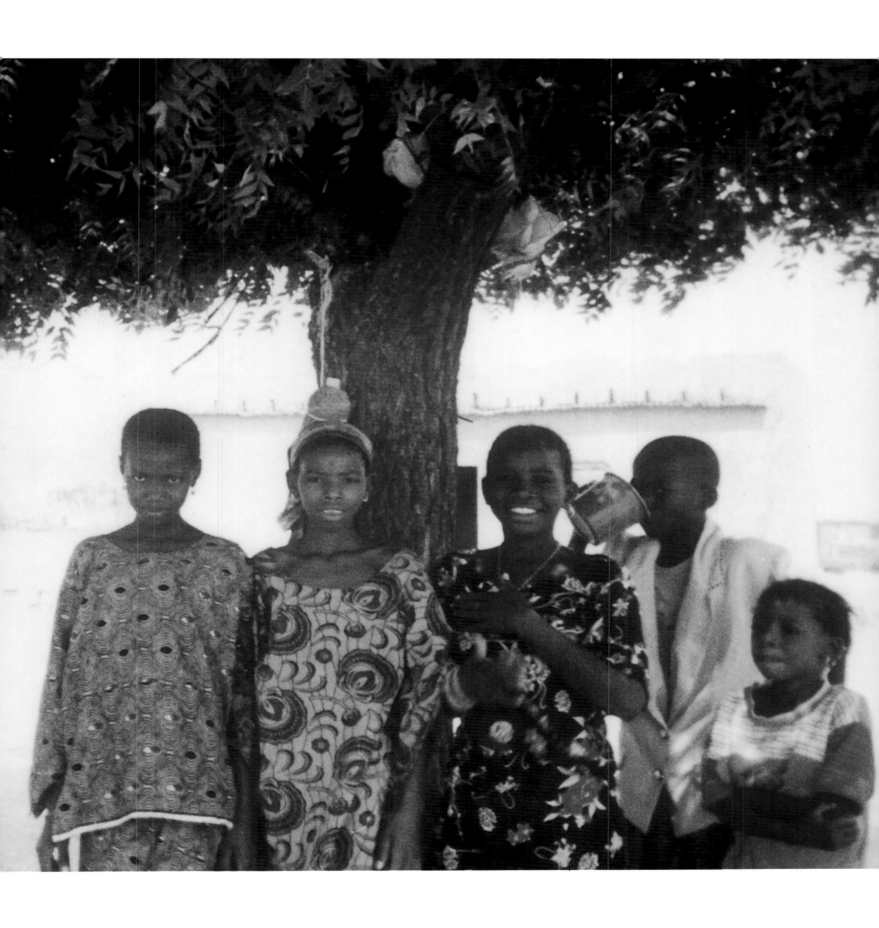

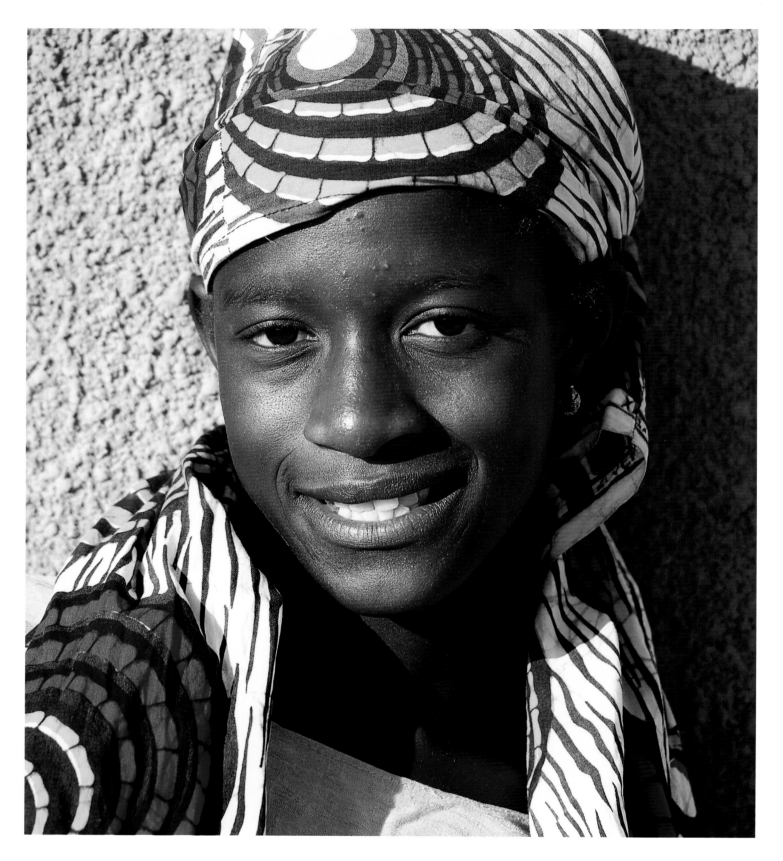

Hawa
Birane Diaw

age 12

Above: This is my house and my sheep.

Next page: This is my house.

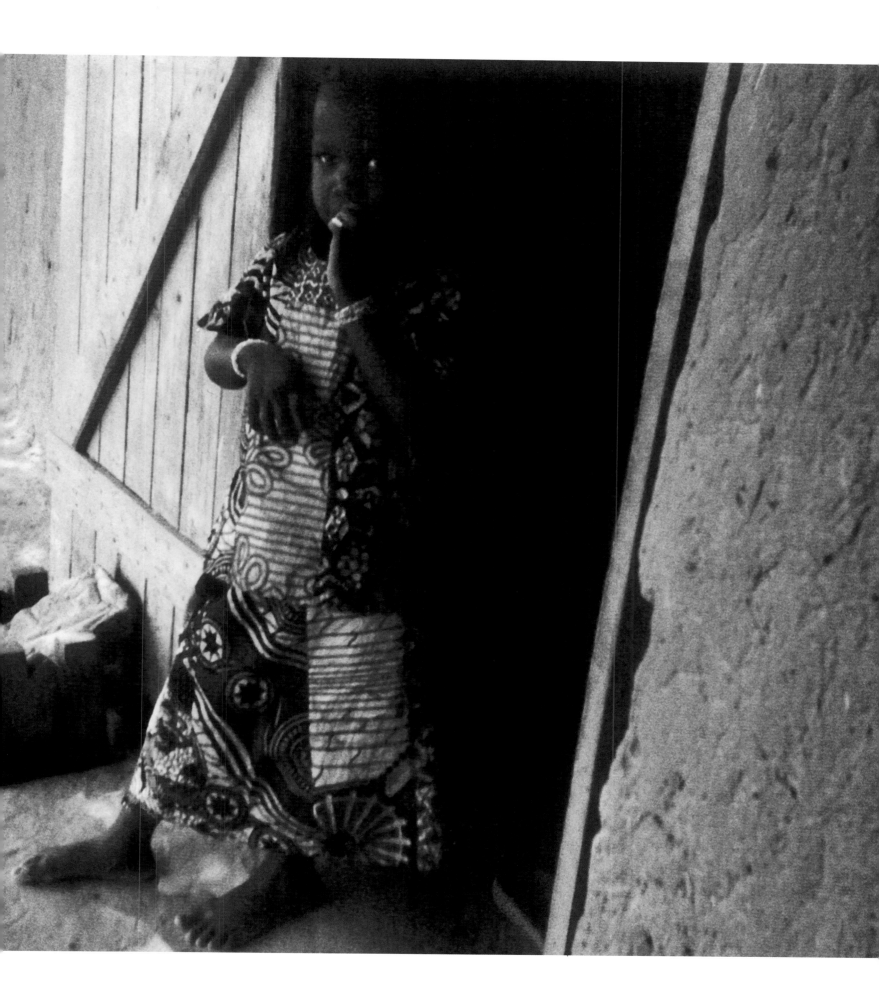

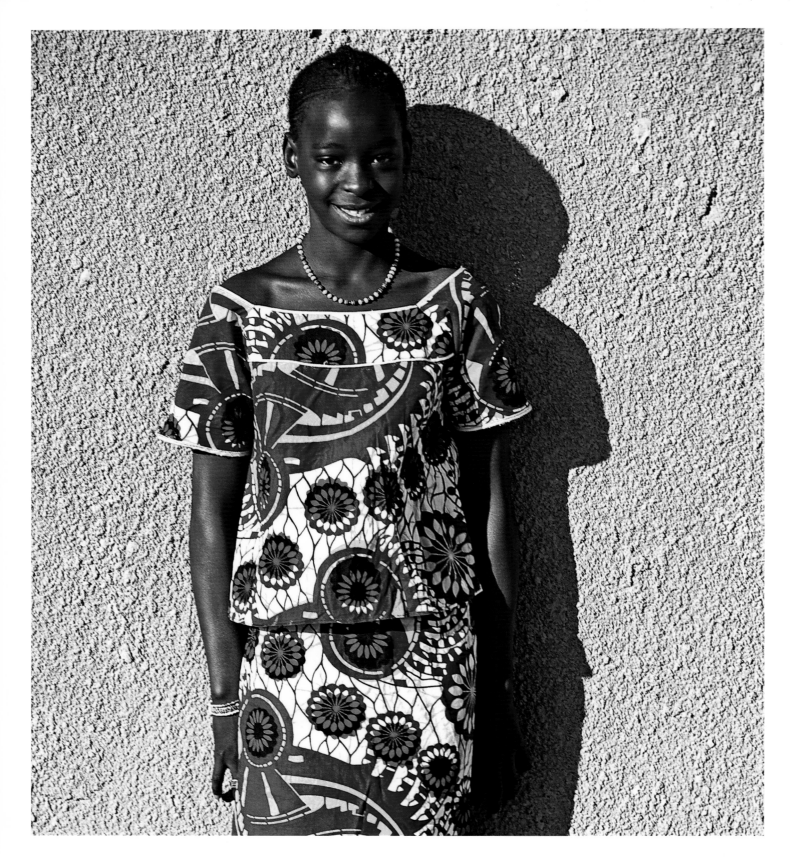

Hapsa Sabalou Diaw

age 12

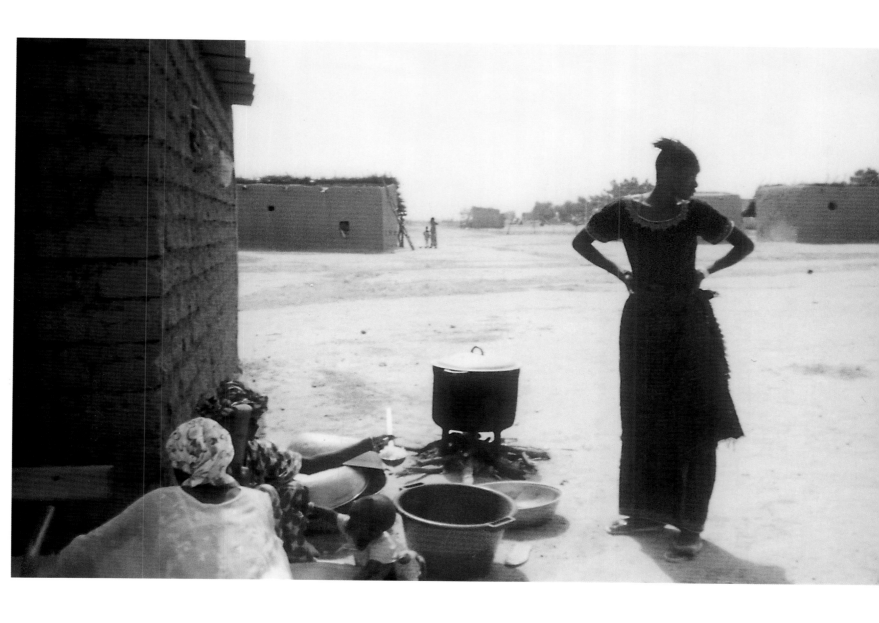

Above: This is Habi Sy at the school canteen. They are cooking meat and lentils for our school lunch.

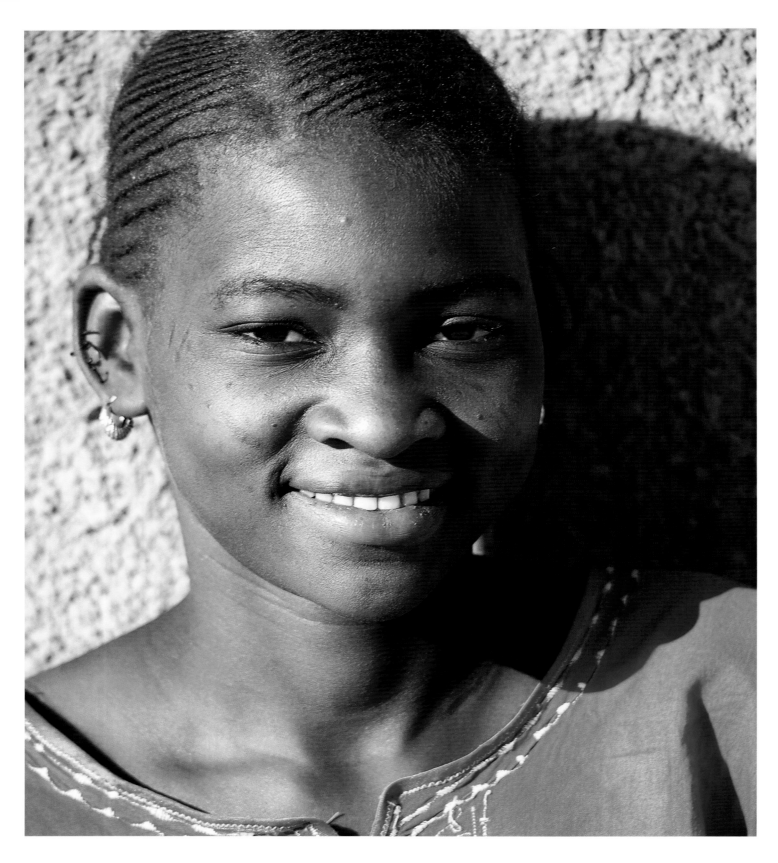

Astel
Pam

age 11

Left: Mariam Ba is my friend's little sister. Here she is feeding her family's horse.

Right: This is my family's horse and our chickens. I like our horse because it is very pretty, works hard, and pulls the charette [*a horse-drawn cart*].

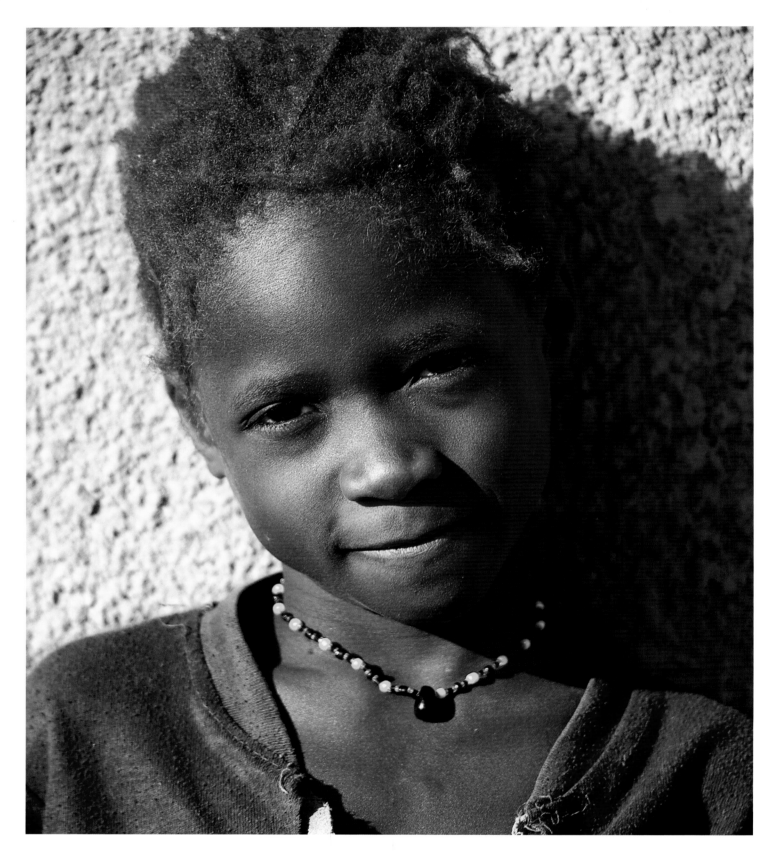

Coumba
Samba Sy

age 10

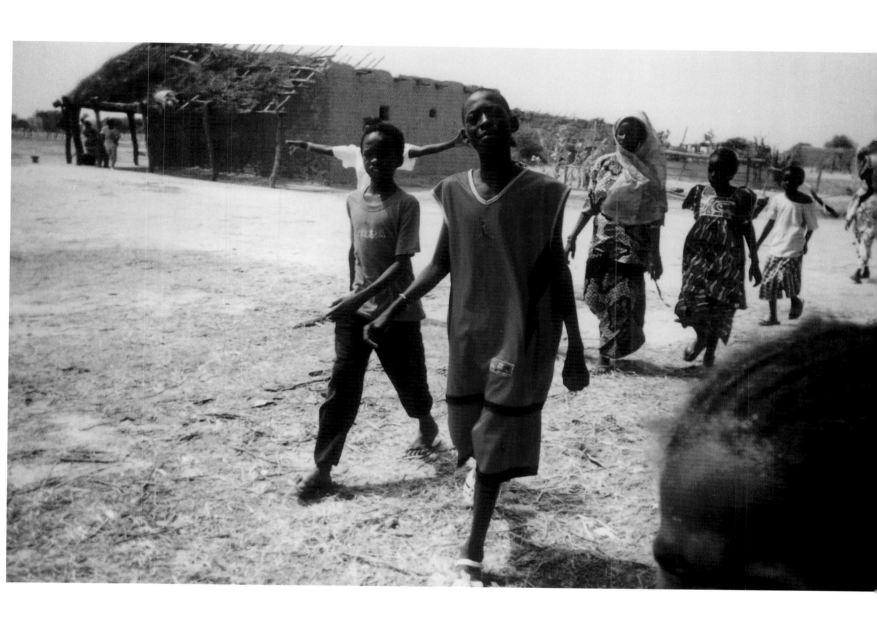

Above: Some of my friends walking in our compound.

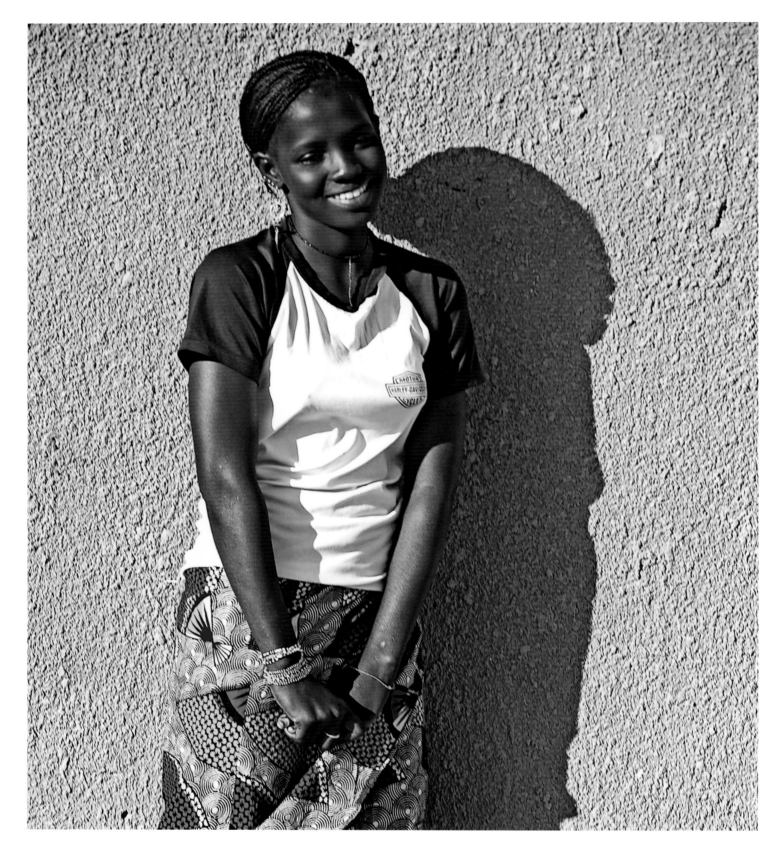

Dieynaba Amadou Deme

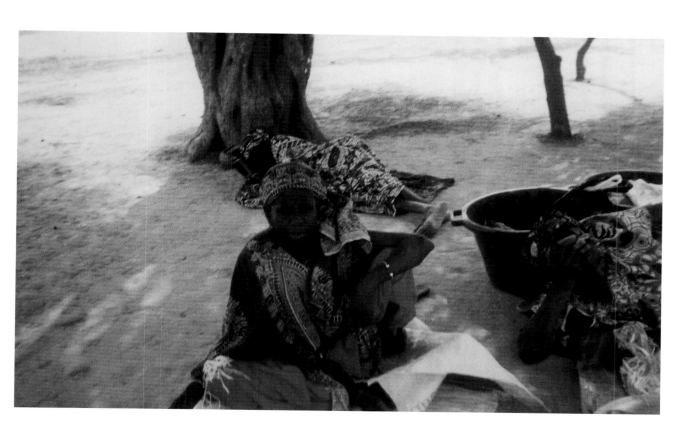

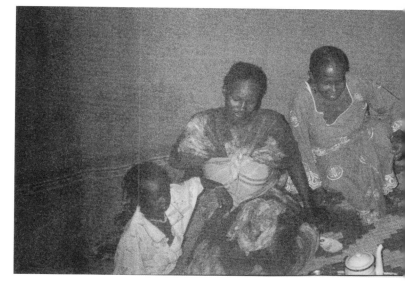

Above: At my friend's house, Isa, Habe and Hadia are preparing to break the fast after Ramadan.

Below: My aunt, little sister and a friend are waiting to break the fast.

Located on the Route Nationale No. 2, the one major highway that crosses Senegal, Gamadji Saare can be considered the most "Westernized" of the schools in the group. A large compound, with buildings positioned around an airy central courtyard, it is supervised by Mame Kady, an energetic woman devoted to the education and advancement of the students in her area. A large school, containing 332 students and ten teachers, it draws its students from six villages with a combined population of approximately 3,000.

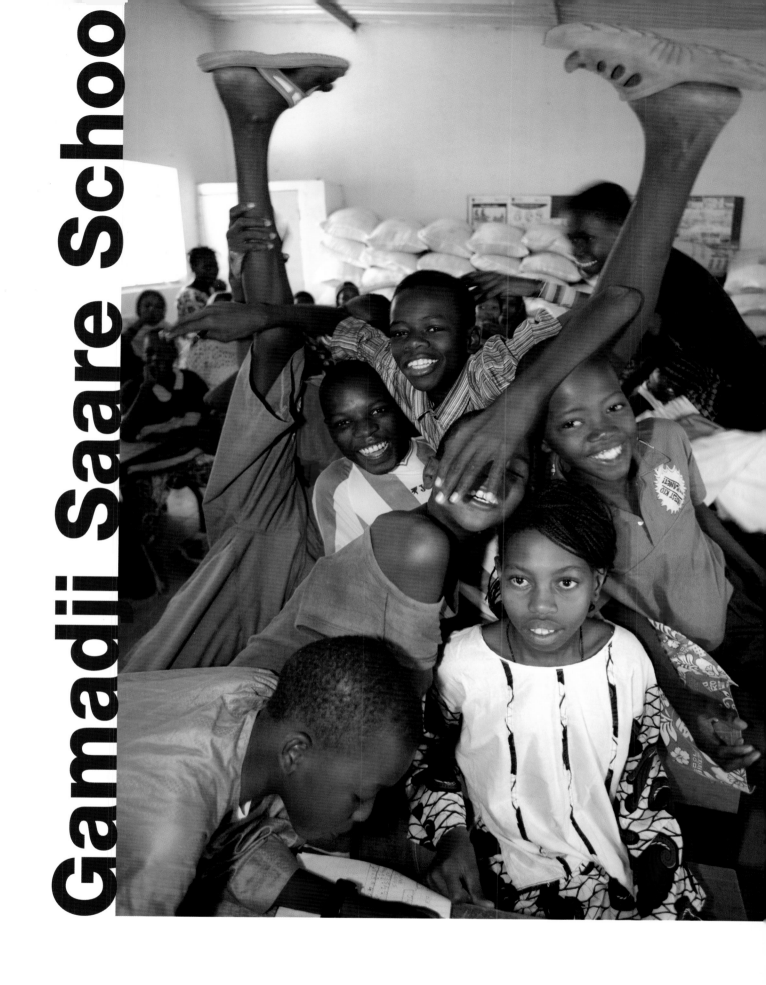

Gamadii Saare Schoo

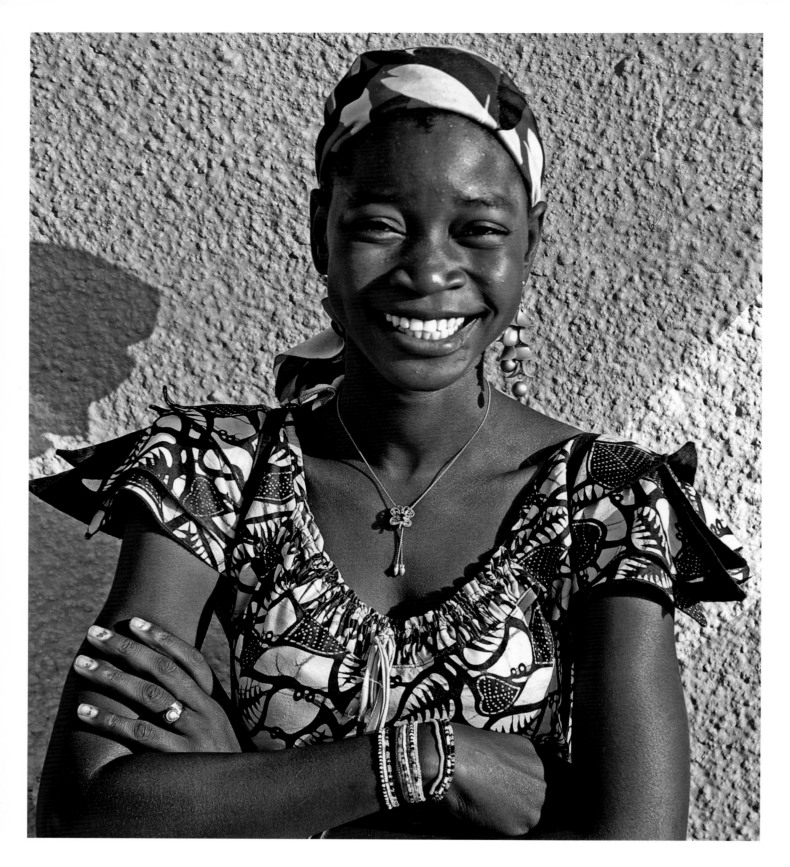

Aissata
Thioune

age 12

Above: A house in our compound

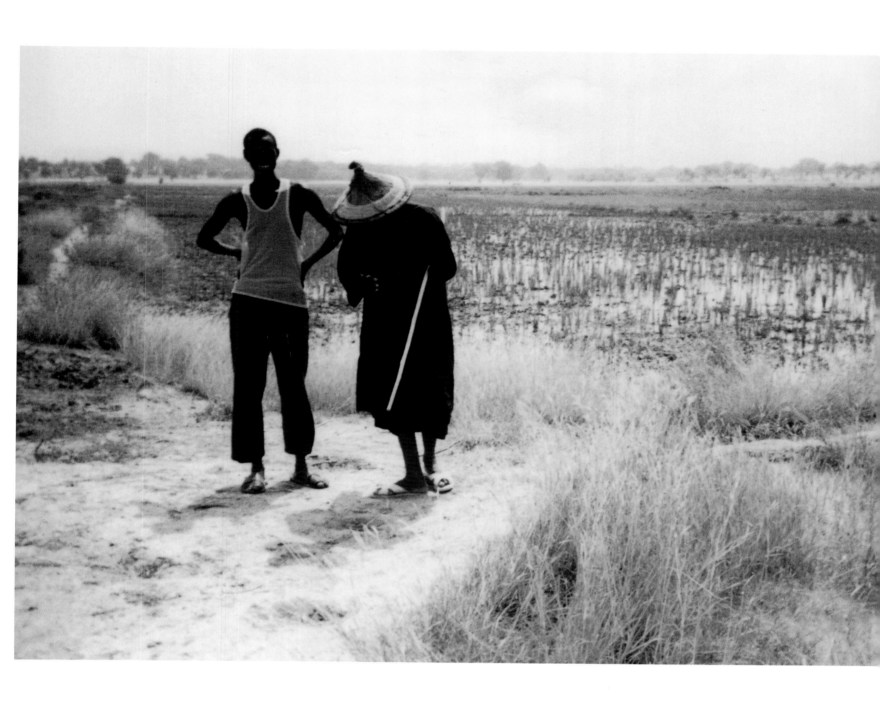

Left (Top to Bottom): This is the cemetery in Gamadji, where the people from the villages find a resting place.

The cows have just come from the river to drink and are now resting in the shade during the heat of the day.

Above: These farmers are cultivating rice, which is part of their culture. They are standing in the rice field.

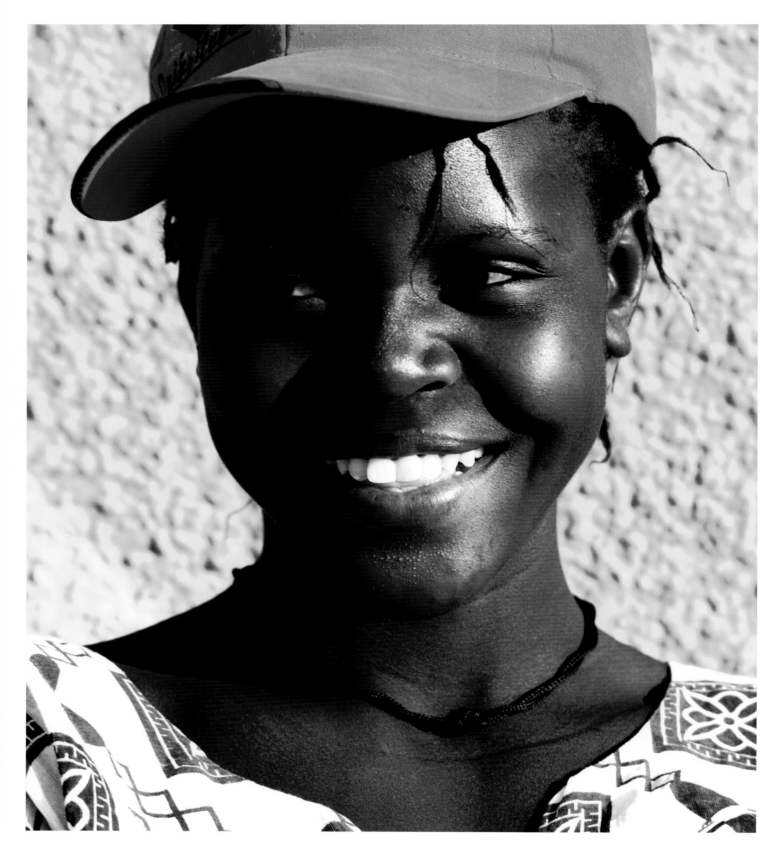

Aminata
Diagne

age 12

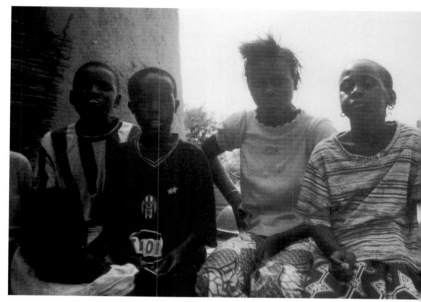

Left: That's my sister!

Right: These are my older brothers and sisters.

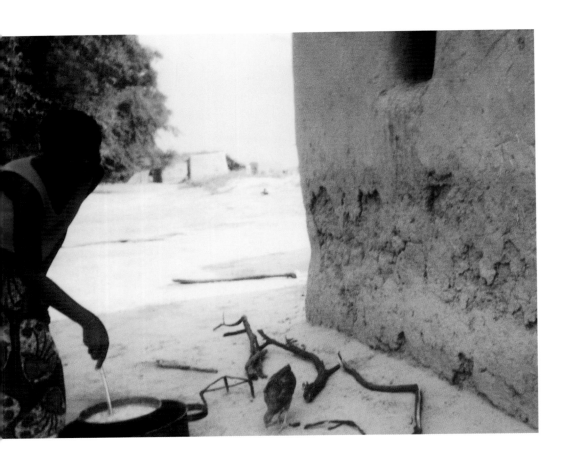

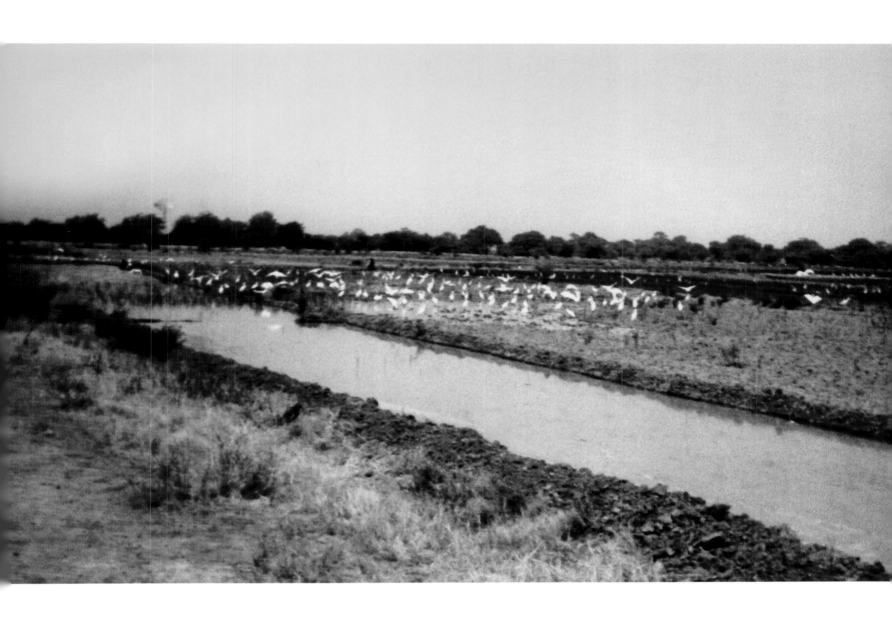

Left: This is me, cooking.

Above: I thought this flock of birds looked beautiful near the irrigation canal.

Malick
Hanne

age 10

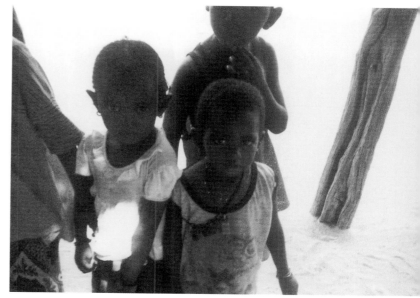

Left: My younger brother is studying from the book he is holding. He is looking at my family.

Right: These are my little sisters.

Next Page: This is the nearby mosque.

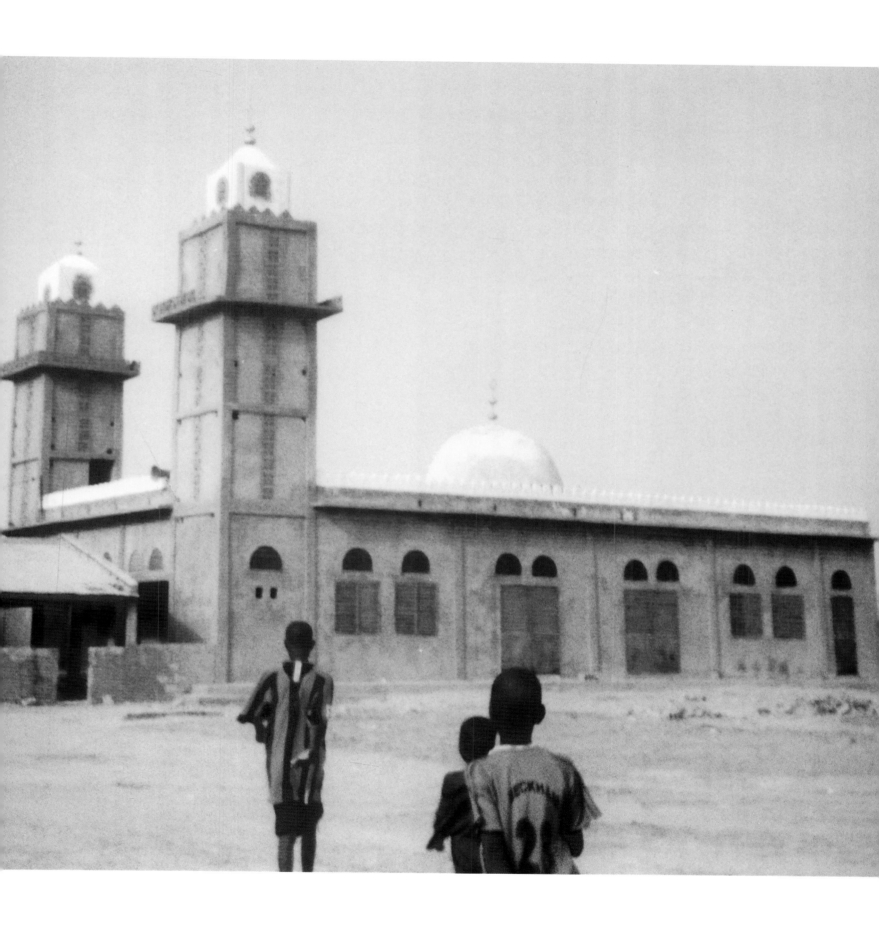

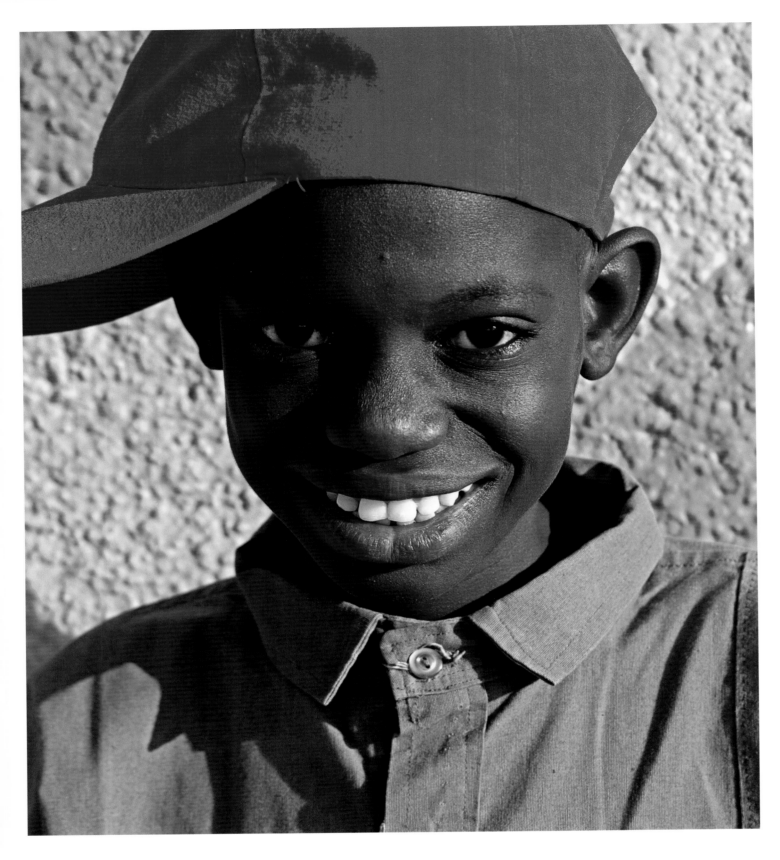

Mouhamadou M'Backo

age 10

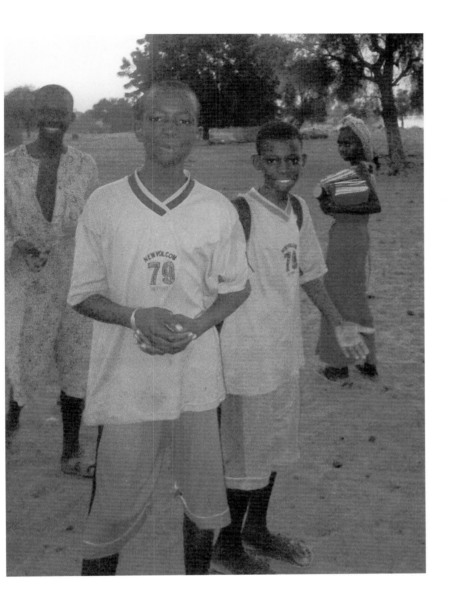

Left: My aunt took this picture of me and my two cousins.

Right: I love this photo. It is my Mom, in our house.

Mountaga
Ndongo

age 10

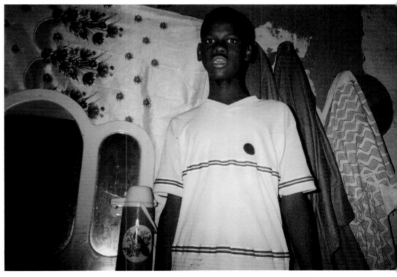

Above: This is a crazy man who walks around everywhere. He insulted me, so I took his photo.

Below: This is me in my bedroom. My friend took the picture.

Next Page: Some of us outside the school.

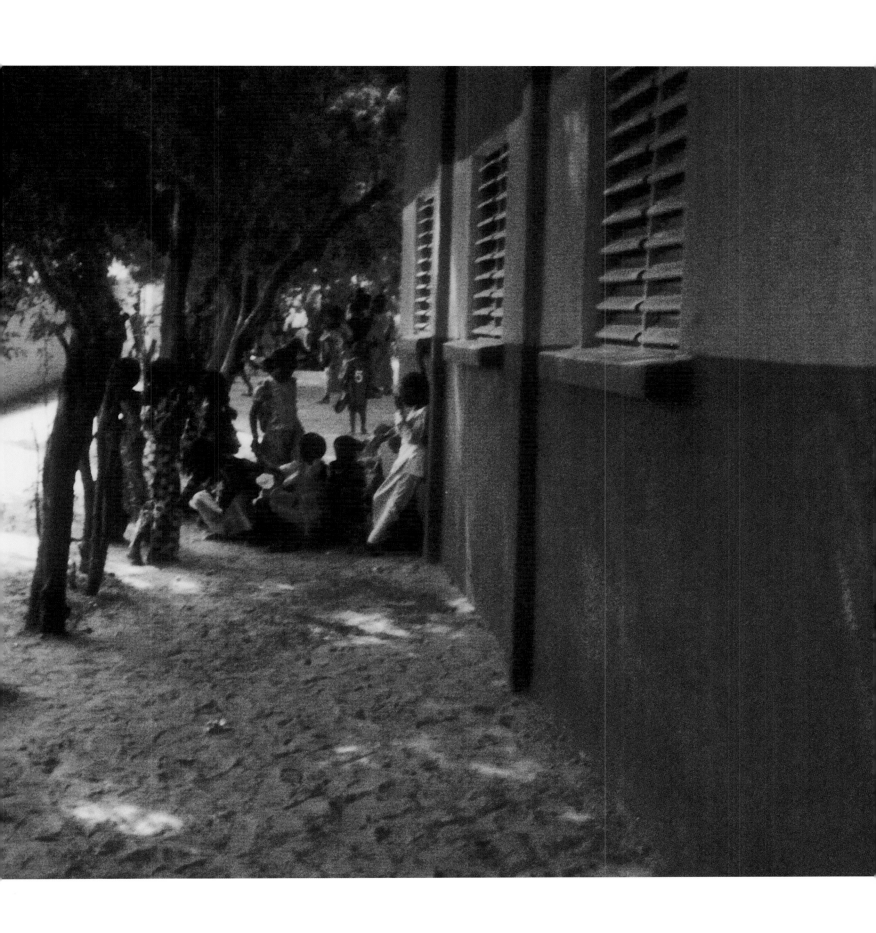

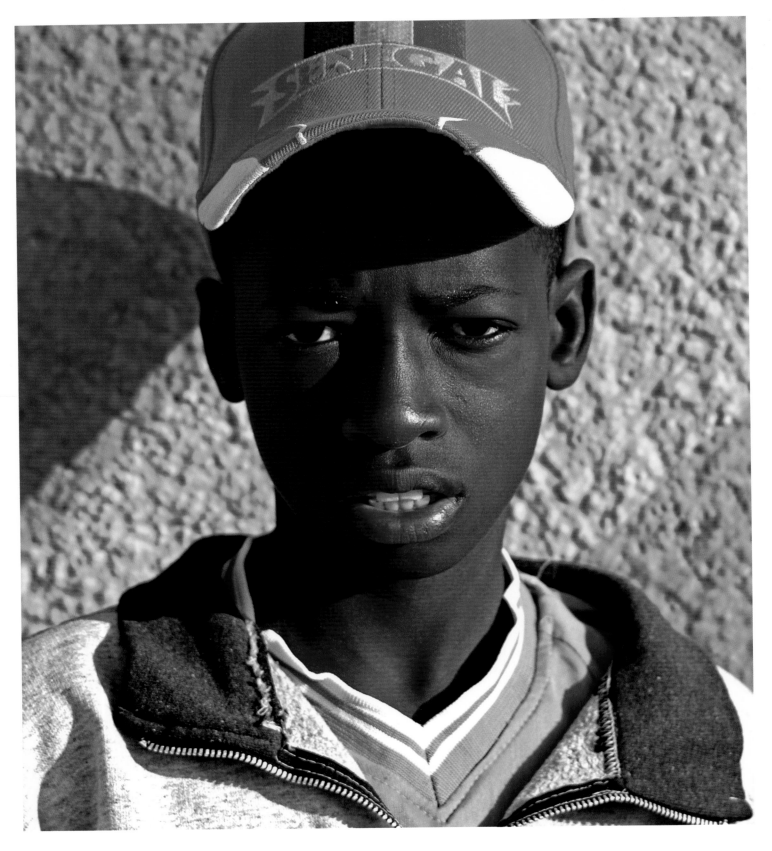

Amadou Sall

age 10

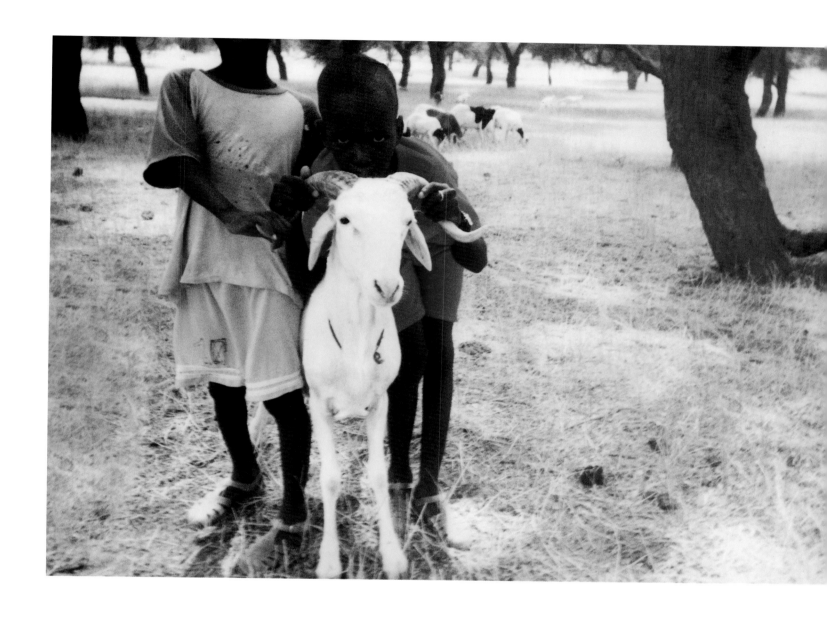

Above: My younger brother and a friend are holding the sheep we ate for korité [*the end of the holy month of Ramadan*].

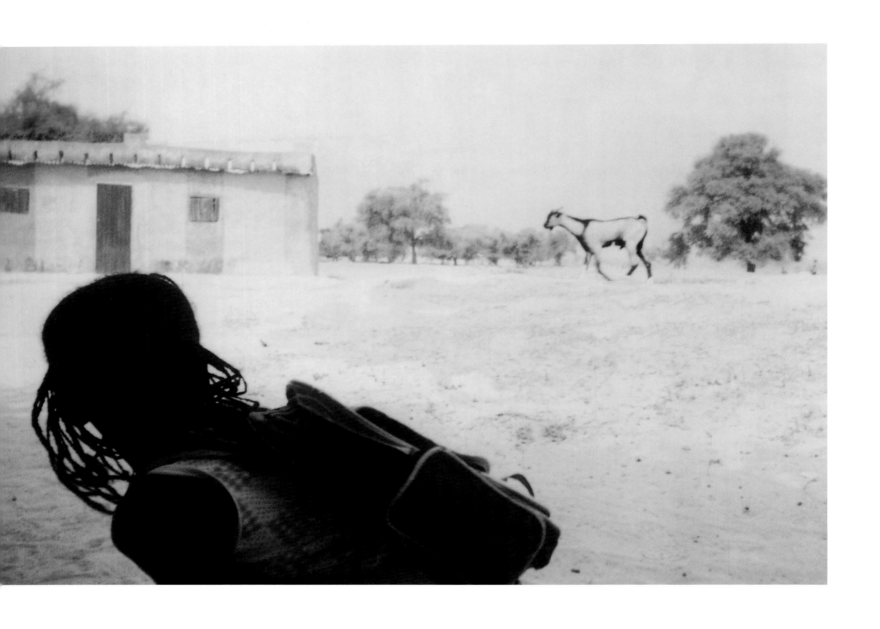

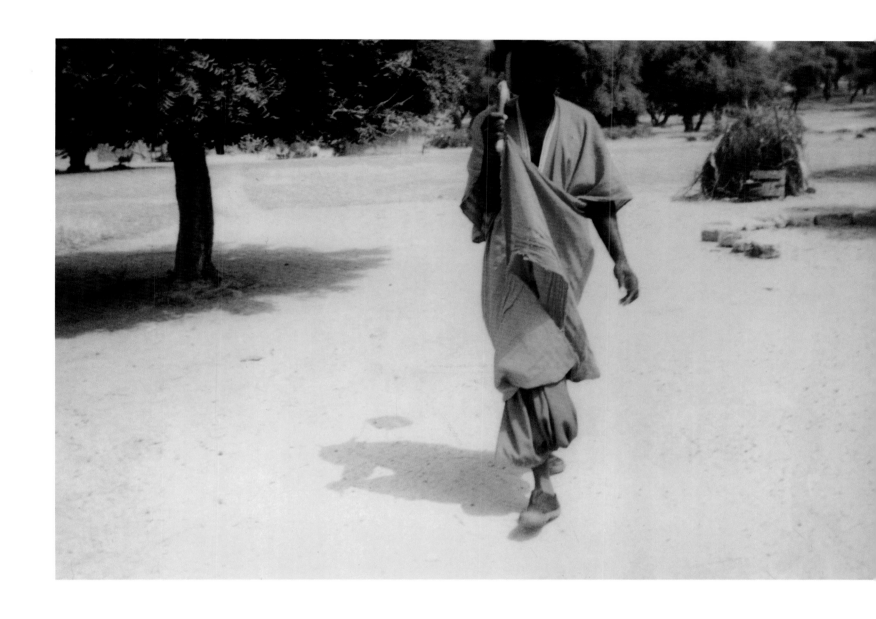

Left: I liked the way this little schoolgirl's hair looked!

Above: A man walking through the compound.

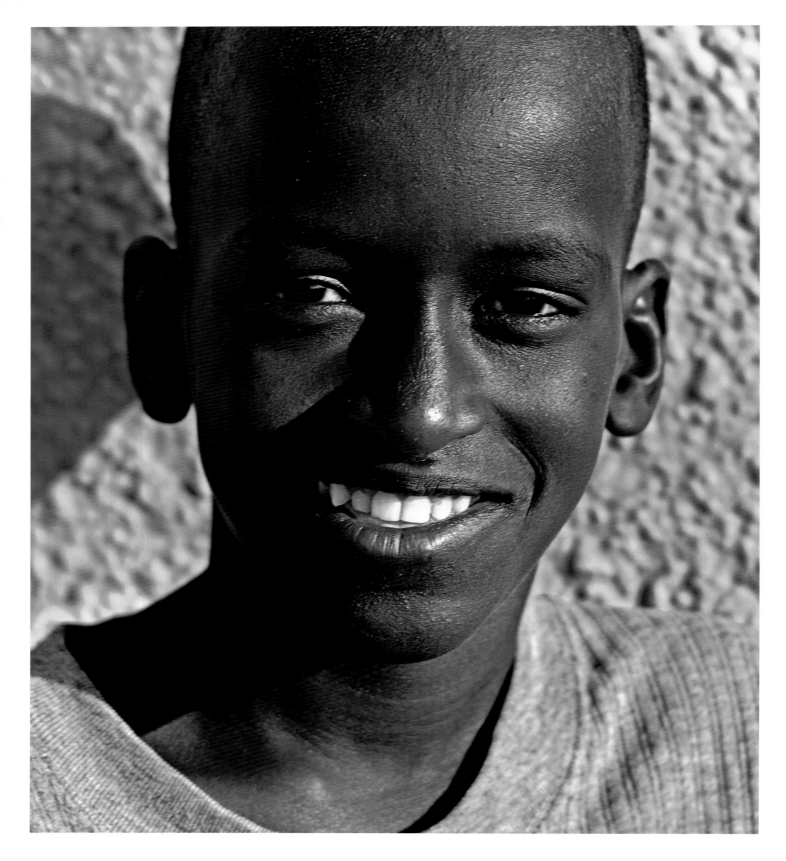

Moussa
Ba

age 10

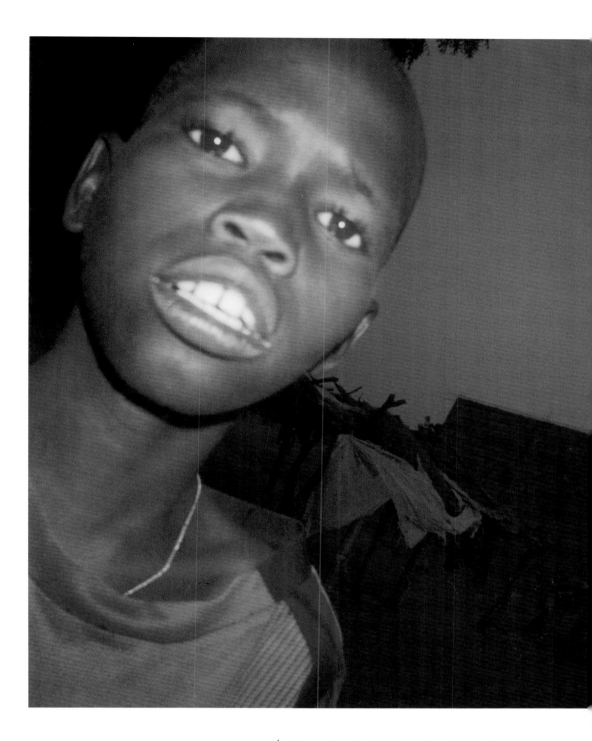

Above: I took this photo of my big brother after school, at my house.

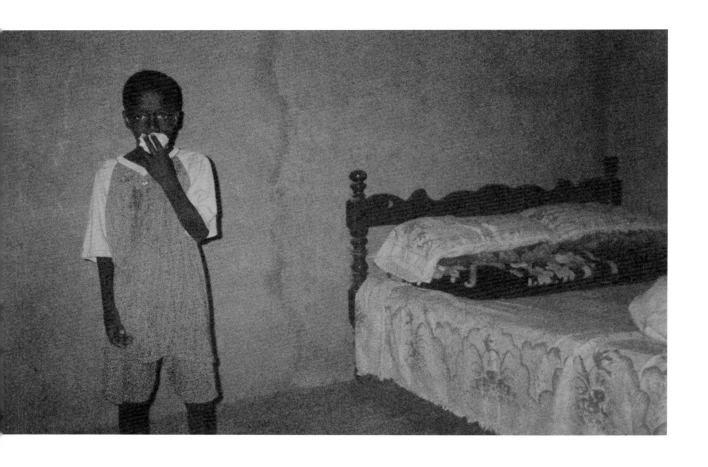

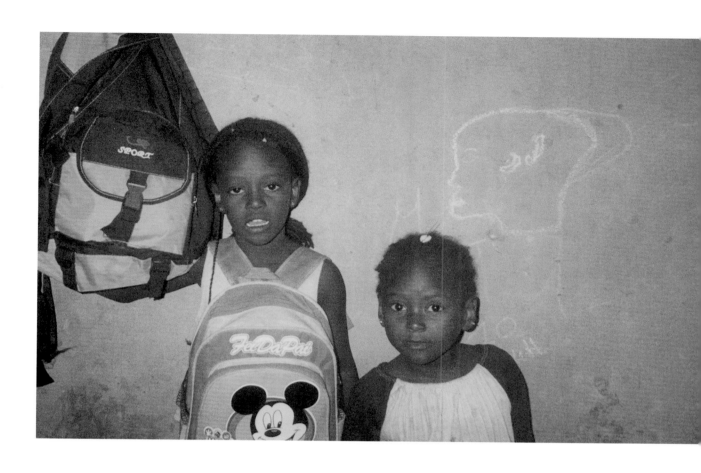

Left: My little brother, eating bread in his room at night.

Above: They are ready for school.

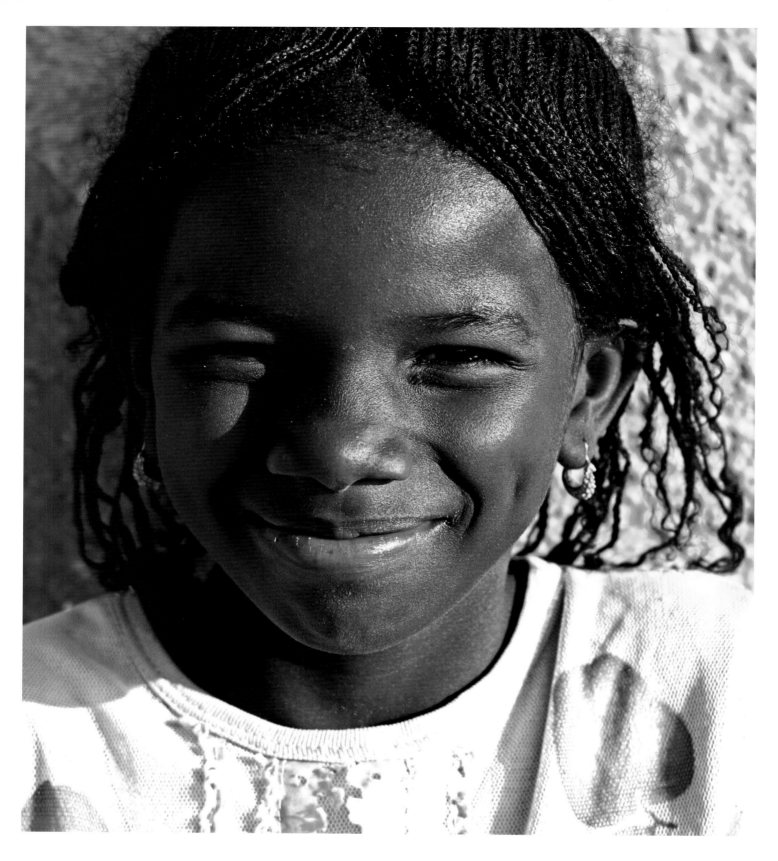

Haby
Ba

age 10

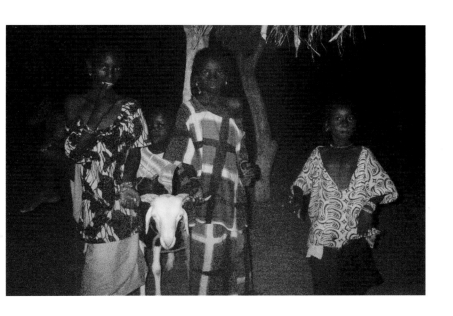

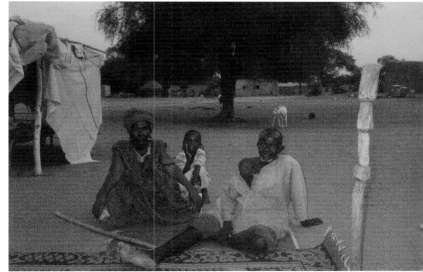

Left: My older brother and sisters, with a sheep we are fattening up to eat on Tabaski [*Festival of Sacrifice, which commemorates the willingness of Abraham to sacrifice his son as an act of obedience to God*].

Right: These are my grandparents and my little sister, at my house, waiting to break the fast.

Above: Some of the children going into their classroom at our school.

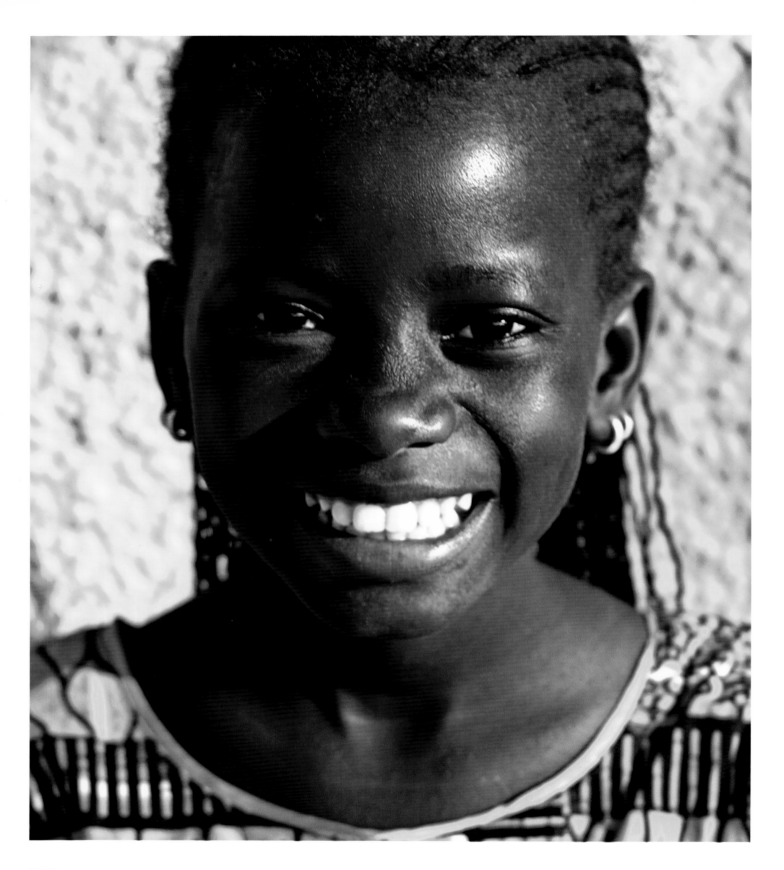

Batteil
Dia

age 9

Left: I told my little sister to "Come quickly, I'm going to give you some water," so she is running!

Right: My two sisters in the family compound.

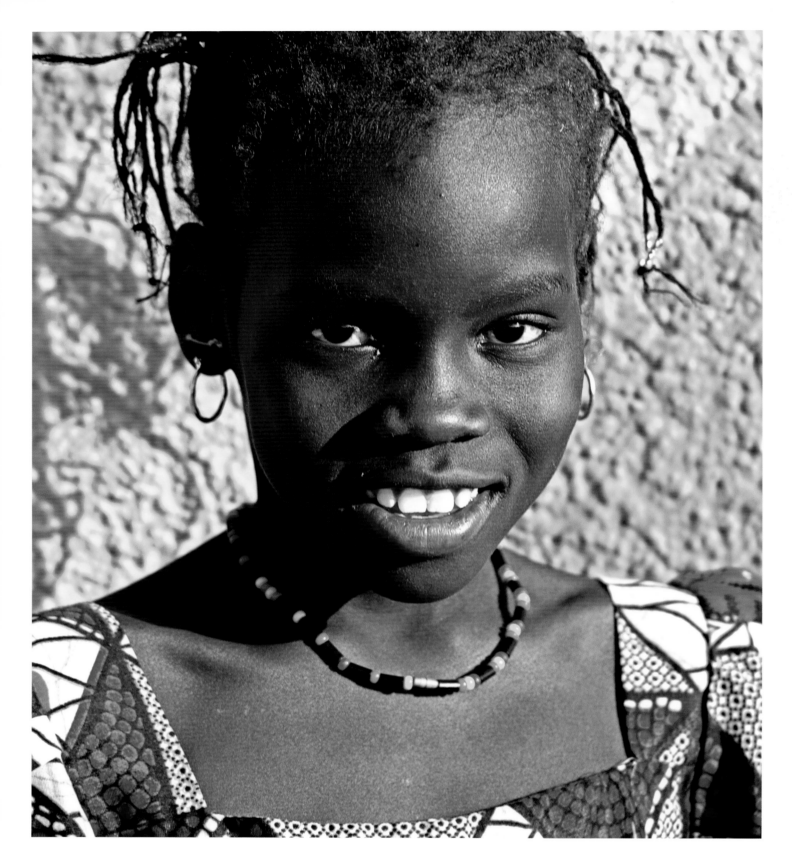

Houleye Ba

age 9

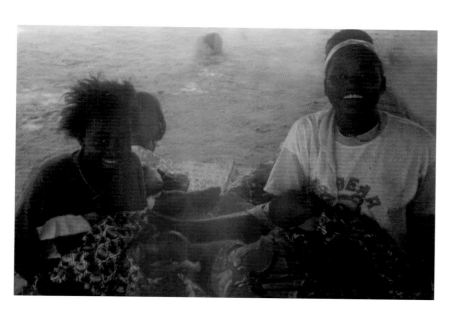

Left: These are my two big sisters with my Mom's babies.

Right: This is my Mom, watching them.

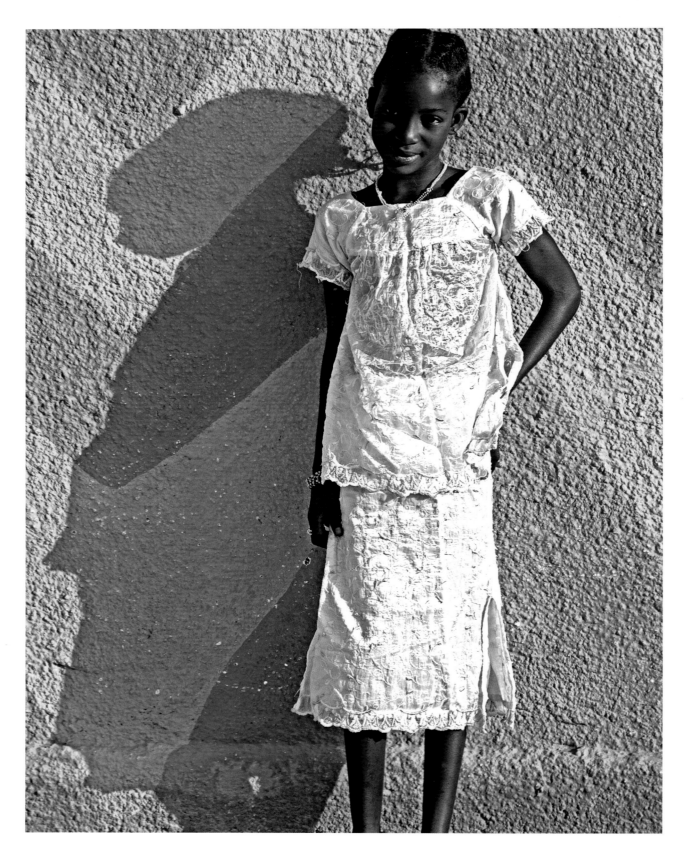

Fatimata
Ngaido

age 9

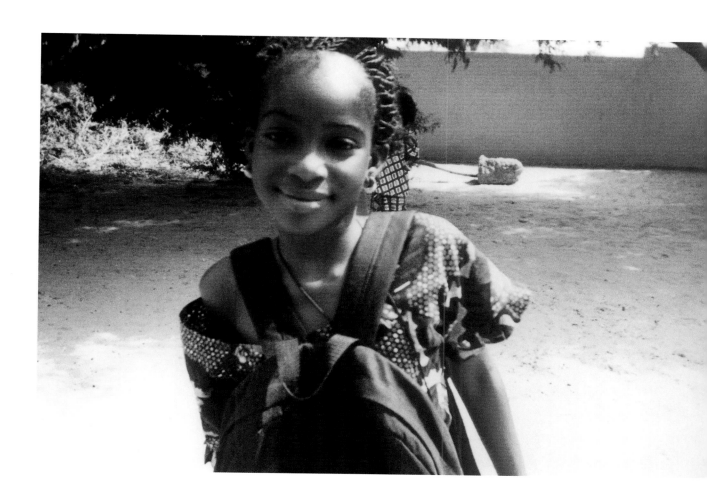

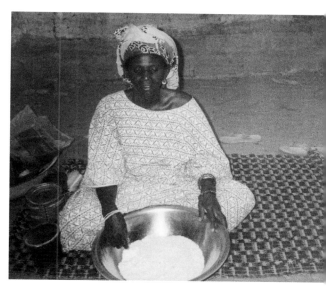

Above: This is me! It is outside my school, after we got out. I have my backpack in front so I can get into it easily.

Below: This is my Mother, who I love a lot. She is cleaning the rice before preparing a meal.

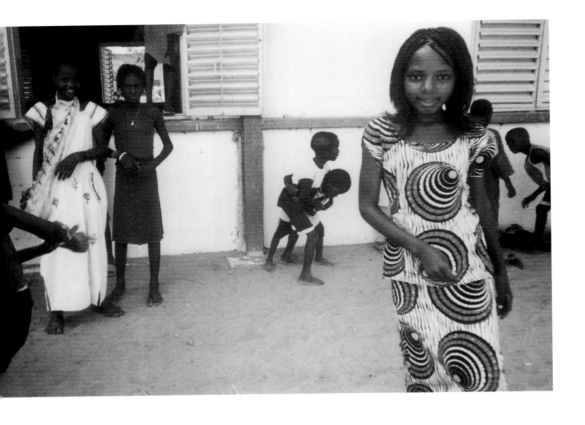

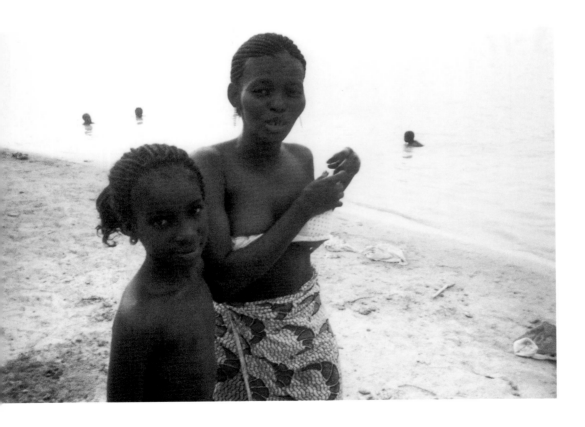

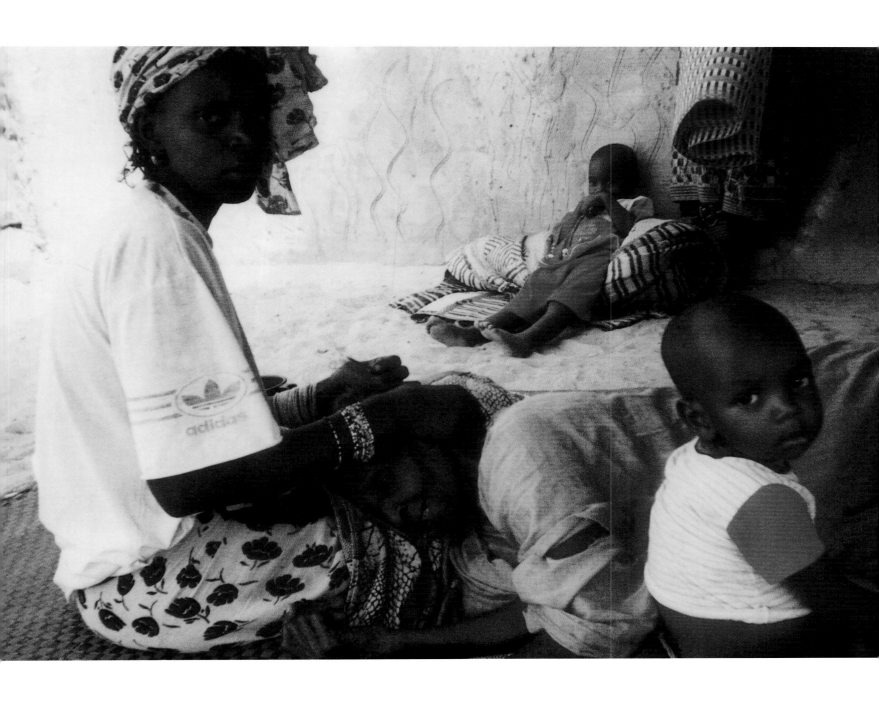

Left (Top to Bottom): Some of the students outside our classrooms in the school yard.

We go to the river to cool off.

Above: Some of my family at home.

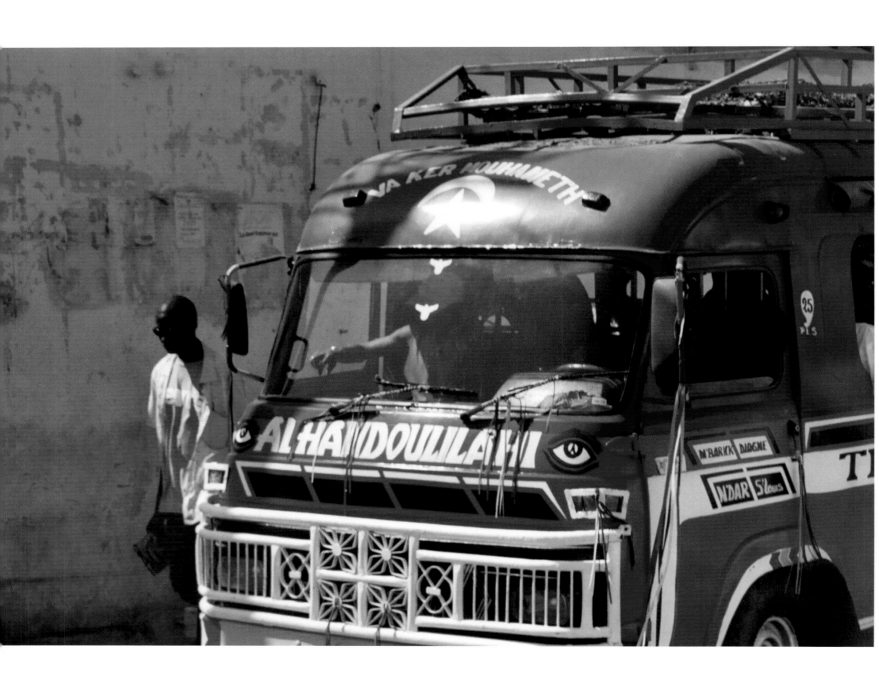

Alhamdoulilahi

"Alhamdoulilahi" – "with God's blessing," "thanks be to God" – the word is heard everywhere and spoken often, with a cadence that places it somewhere between song and prayer. We saw it painted prominently on the buses that shuttled through the traffic in Dakar and came to recognize it as a gracious and useful answer to almost any inquiry. "How are you?" "How is your family?" "How was the trip?" It meant all was well. "Alhamdoulilahi."

As we traveled through northern Senegal we were fortunate to meet Minister Mordou Fall, who had been Inspector General of Podor (superintendant of schools for the region) since 1997. A thoughtful and dedicated man, he enthusiastically endorsed Counterpart's initiatives as he not only felt that much of the Western world needed to be educated about Senegal and made sensitive to the fact that not all African peoples were malnourished, ill, and devoid of hope, but also that the people of Senegal needed to be educated about the importance of education. And this was one of Counterpart's most positive contributions. He called it the idea of "positive emulation." By supporting one school, with one feeding program, villagers would see what could be done, and others would then ask for the same for their children, in their villages. And it seemed to be working. We often encountered children who traversed many miles to attend a school that had a Counterpart canteen. He saw this publication as a tool in that process. The pride parents would feel seeing their children in a book would show them what was possible, and as word spread, other rural areas would be encouraged to participate in the programs as well.

Even Koranic schools – the traditional Islamic religious schools lead by a Marabout, such as Belel Bogal - were included, and with Counterpart's help were encouraged to expand their schooling and introduce vocational training to their students.

The children we met were eager to learn; fluent in their native languages and in French; inquisitive, enthusiastic, spontaneously curious and outgoing. And thanks to the incredibly devoted Counterpart teams, their futures seem to be approaching the brightness of their smiles. Alhamdoulilahi.

THROUGH MY EYES

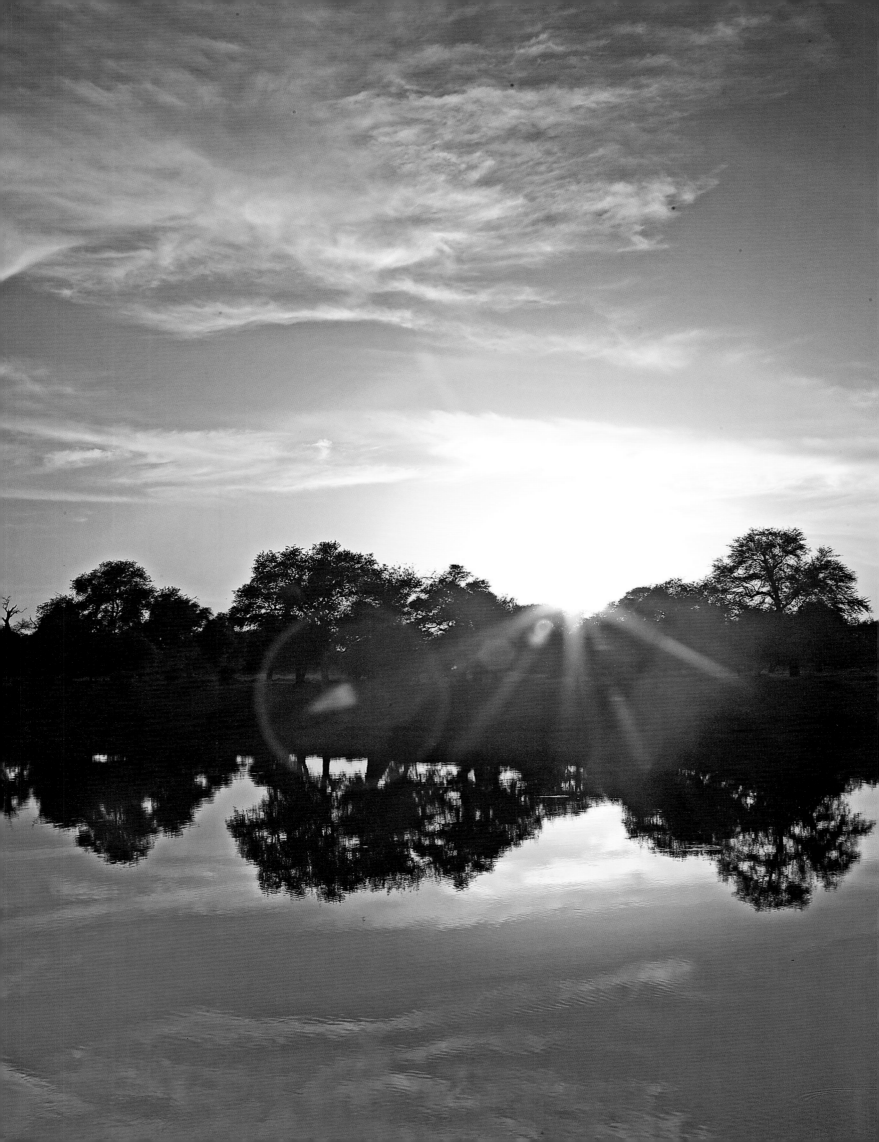

Founded in 1965, Counterpart International is a nonprofit organization dedicated to building a just world through service and partnership.

Counterpart gives people a voice in their own future through smart partnerships, offering options and access to tools for sustained social, economic and environmental development.

We have forged strategic partnerships in the public and private sectors to help people improve the quality of their lives and revitalize their communities in more than 60 nations. Counterpart International provides people access to the tools they need for a life of dignity for themselves, their communities and their countries. Counterpart is known as "the NGO which builds NGOs".

Since 1993 Counterpart has built, developed and strengthened over 10,000 non-governmental organizations in the former Soviet Union alone.

Working with local communities to build their capacity to act on their local problems in the way they want, Counterpart programs include humanitarian and relief assistance, education, healthcare, democracy and governance, food security, enterprise and business development, sustainable tourism and natural resource management.

We have worked in more than 65 countries and currently have a worldwide staff of 350 and a presence in approximately 37 countries in Africa, Central Europe, the former Soviet Union, Asia and the Pacific, Latin America and the Caribbean.

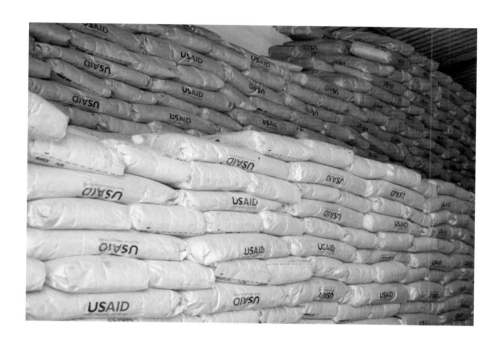

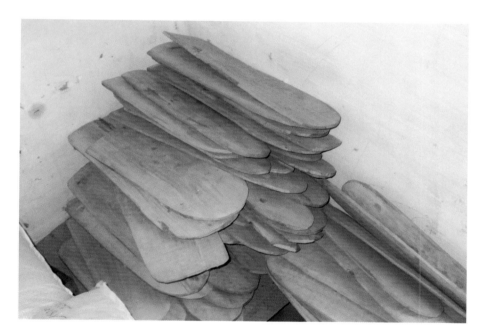

Left: Counterpart headquarters, Ndioum.

Above (top to bottom): Bags of grain and wooden writing tablets, some of the items distributed to the villages by Counterpart.

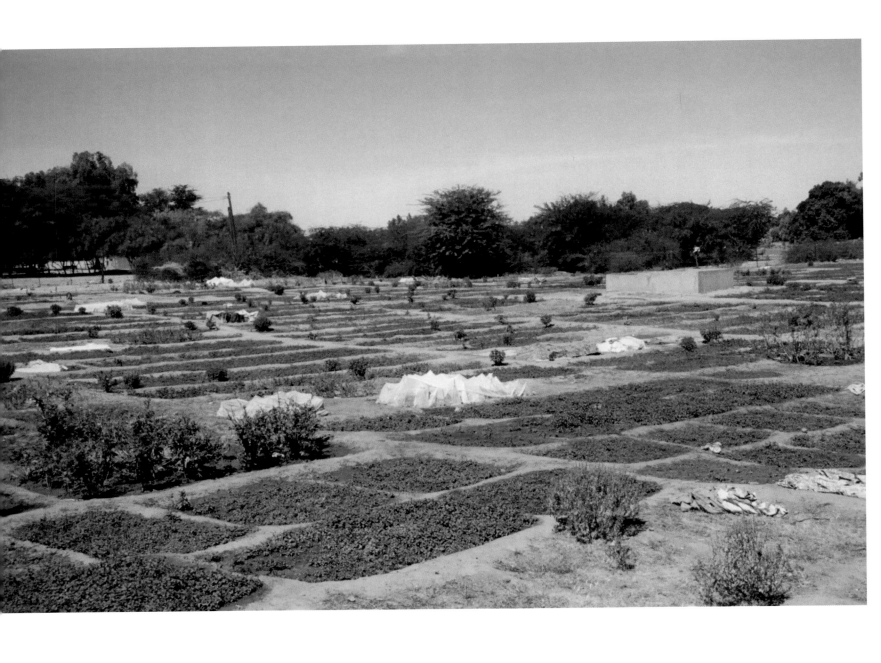

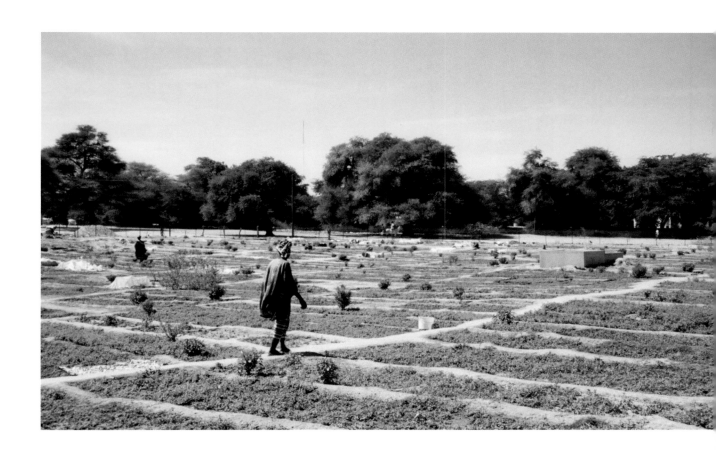

Left and above: Views of the carefully tended Women's Garden.

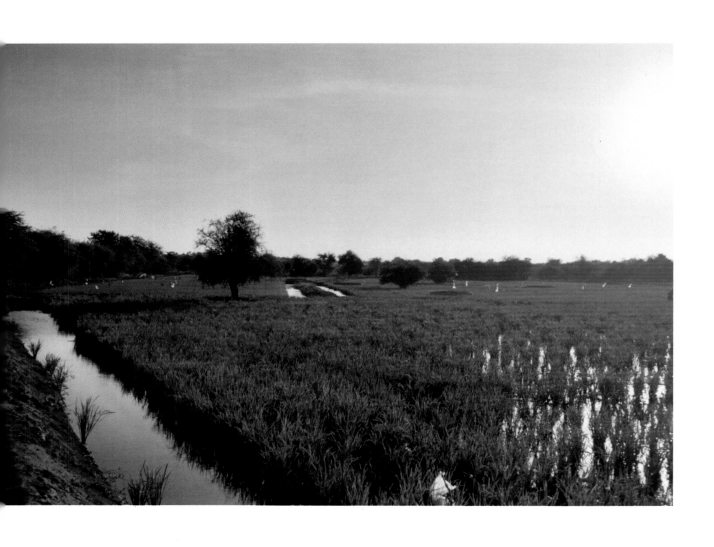

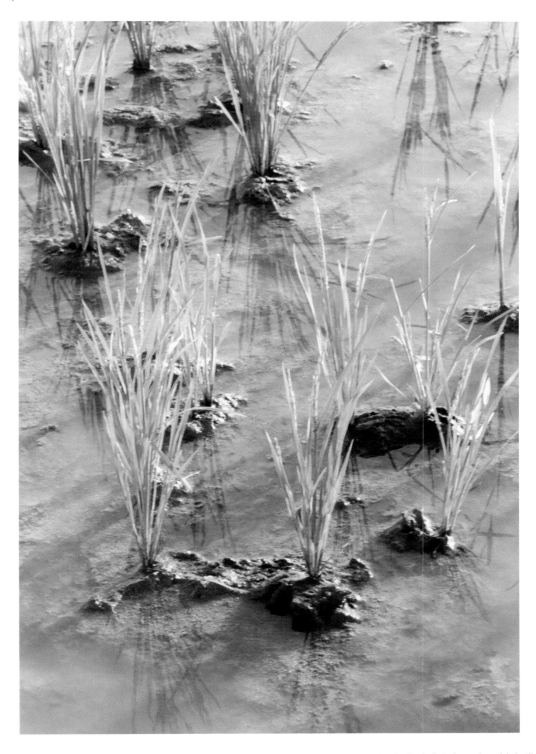

Left: A fish farm in which tilapia are raised year round, within a rice field.

Above: Young rice plants.